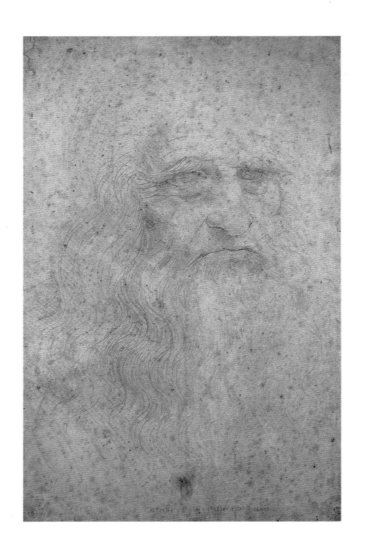

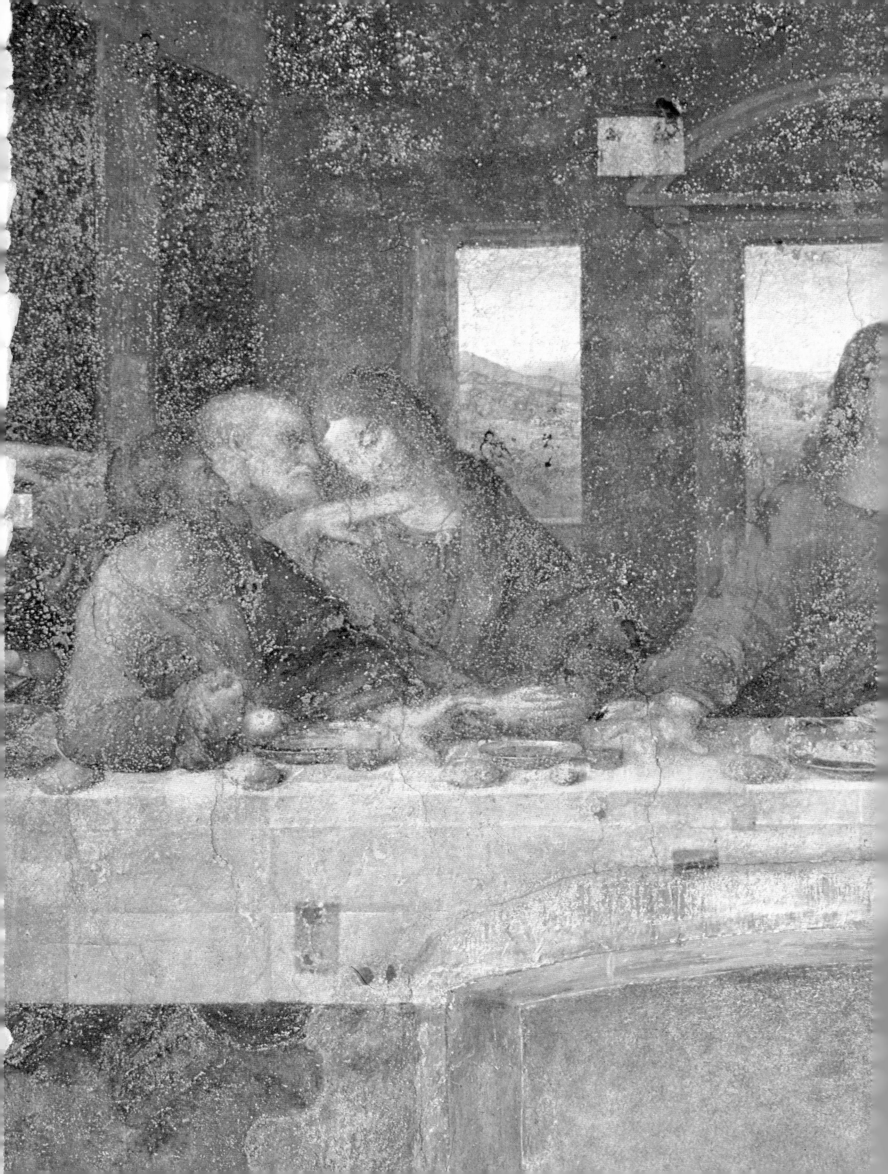

ARDO

Artist, Inventor and Scientist

MARIA COSTANTINO

MAGNA
BOOKS

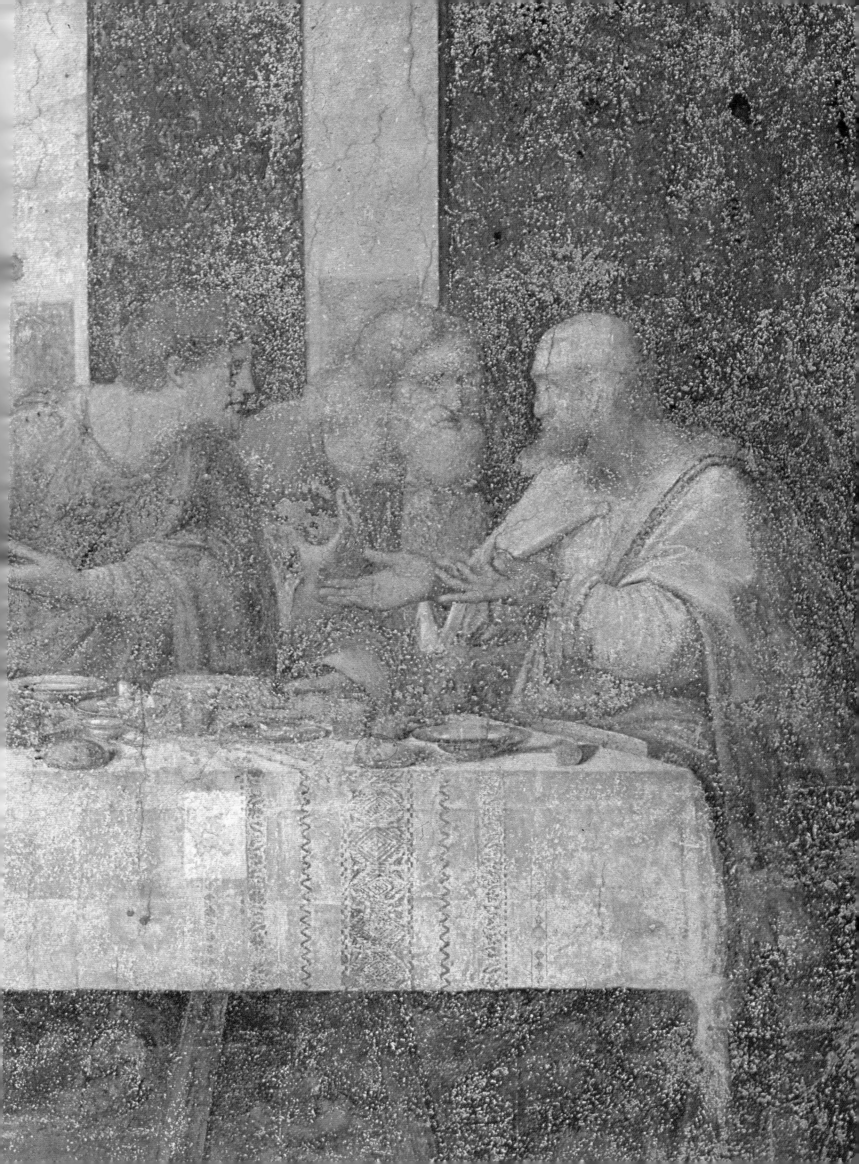

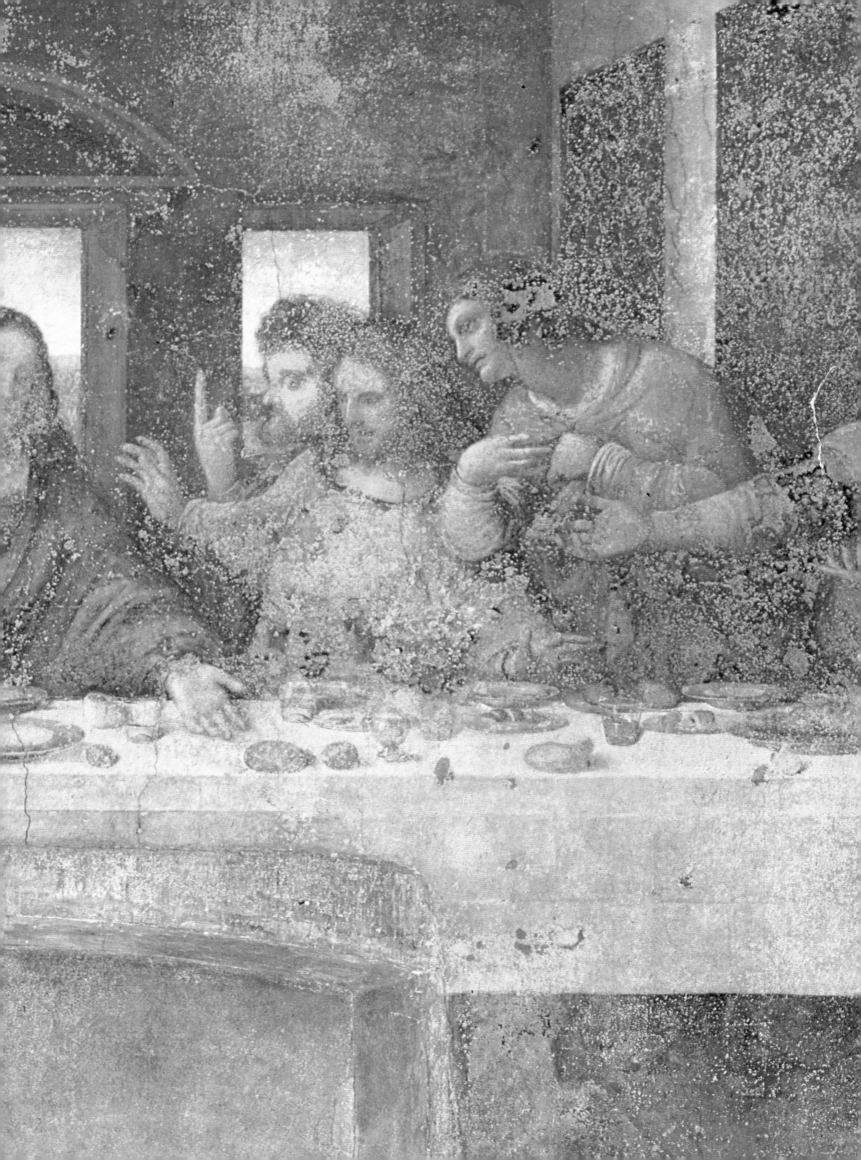

INTRODUCTION

Painter, architect, engineer, draftsman, botanist, and anatomist, Leonardo da Vinci was the archetypal Renaissance man. Acclaimed already in his youth, he was destined to become a legendary figure, and yet it comes as a surprise to many people to learn that only a handful of paintings are attributed to the author of the world's most famous work of art, the *Mona Lisa*.

Throughout his life Leonardo carried with him his notebooks in which he would write down his ideas or sketch impressions. Manuscripts survive containing drafts of letters, rough copies of his proposed treatises on painting and anatomy, as well as shopping lists, accounts, and inventories of books and works in his possession. These lists of his works serve to remind us of the great quantity of Leonardo's works, particularly from his early years, that have been lost. But those that have survived demonstrate Leonardo's ability to practice several arts and his mastery of many different techniques.

BELOW: View of Florence by Leonardo's biographer, Giorgio Vasari.

Born illegitimately at Anchiano, a village close to the town of Vinci on 15 April 1452, Leonardo da Vinci was the son of Ser Piero, a lawyer, and Caterina, a peasant girl.

Around 1469 Leonardo and his father moved to Florence where they rented a house on the Piazza San Firenze, near the Palazzo Vecchio. While his father was employed by the ruling council of Florence, the Signoria, Leonardo entered the workshop of Andrea di Cione, better known to us as Andrea del Verrocchio (c.1435-88). For the next six years Leonardo was employed first as an apprentice, and later as an assistant to his master.

Leonardo was not the only assistant in Verrocchio's studio. During the 1470s Verrocchio was fortunate in having the young painters Pietro Perugino (c.1450-1523), Lorenzo de Credi (1459-1537), Domenico Ghirlandaio (1449-94), Francesco Botticini (1446-97), and Cosimo Rosselli (1439-1507). Verrocchio's studio in Florence was rivalled only by that of the Pollaiuolo brothers. A work of art was not yet the expression of a single personality, but more the product of communal enterprise. Once an apprentice had received sufficient instruction from the

master, he would become an assistant who would often complete entire works from sketches or instructions. In other cases where contracts stipulated that the master paint certain figures, his assistants would handle the less important figures or the background details.

The painting which is traditionally accepted as Leonardo's earliest surviving painted work is the left-hand angel in Verrocchio's *Baptism of Christ* (page 37) painted at some time between 1470 and 1476 for the Monastery of San Salvi in Florence. According to Vasari in his *Lives of the Artists*, Verrocchio gave up painting when he saw Leonardo's work. Vasari would have us believe that the young Leonardo had proven himself to be a far greater painter than his master, but in a commercial workshop such as like Verrocchio's it is more likely that Leonardo, having proved his ability, allowed Verrocchio to concentrate on other works, particularly monumental sculptures.

In 1472, when Leonardo was twenty years old and having paid his guild fees, his name was officially inscribed on the roll of the Guild of St Luke as a painter: 'Lionardo de Ser Piero da Vinci dipintore' (above). While Leonardo was now fully qualified according to guild regulations and legally entitled to establish his own workshop, it seems he chose to remain at least four further years with his old teacher.

During this period Leonardo was responsible for a number of works: arranging pageants for the Medici family in 1469 and 1475; designing festivities to welcome to Florence Galeazzo Maria Sforza, Duke of Milan, in 1471; and it is believed that Leonardo was asked to produce a watercolor cartoon for a tapestry to be woven in Flanders and destined as a gift for the King of Portugal. This tapestry, however, appears never to have reached the weaving stage.

There are also two paintings that have been attributed to Leonardo that are believed to date from this period in

Verrocchio's workshop: *The Benois Madonna* (c.1478) and the *Madonna with a Vase of Flowers* (c.1475). The earliest dated work, however, which can positively be attributed to Leonardo is from 5 August 1473, a landscape drawing of the valley of the Arno (page 12). It is an early demonstration of his interest in the natural phenomena of rivers, lakes, and plants and also displays his mastery of a simple yet assured drawing style.

Around 1474 Verrocchio received a commission to paint an altarpiece for the Chapel of Donato de Medici in the Cathedral of Pistoia. It is possible that Leonardo may have assisted in the execution of this work: one of the predella paintings representing the Annunciation is sometimes accredited to Leonardo. It is more likely, however, that this is the work of his studio-colleague Lorenzo di Credi. Dating from around the same time is a second Annunciation (pages 38-39). Only attributed to Leonardo in 1869, this painting came from the Monastery of San Bartolomeo at Monteolivieto near Florence and was traditionally attributed to another of Verrocchio's pupils, Domenico Ghirlandaio. Others believe that this Annunciation was begun by Ghirlandaio and completed by Leonardo despite the existence of preliminary drawings of the right-hand sleeve of the angel. There are two further drawings by Leonardo which relate to this painting, but each differs in too many small details to be truly considered as direct studies for this painting. The first is the finished drawing of a lily from around 1475, such as held by the angel; the second is a study of drapery around the legs of a seated figure akin to that worn by the Virgin.

Around the same time Leonardo also appears to have been at work on a portrait of *Ginevra de Benci* (page 42). Portraits of women were frequently commissioned on the occasion of marriage, and in January 1474 Ginevra was married to Luigi di Bernardo Niccolini. Nevertheless there is still a certain amount of doubt surrounding this

11

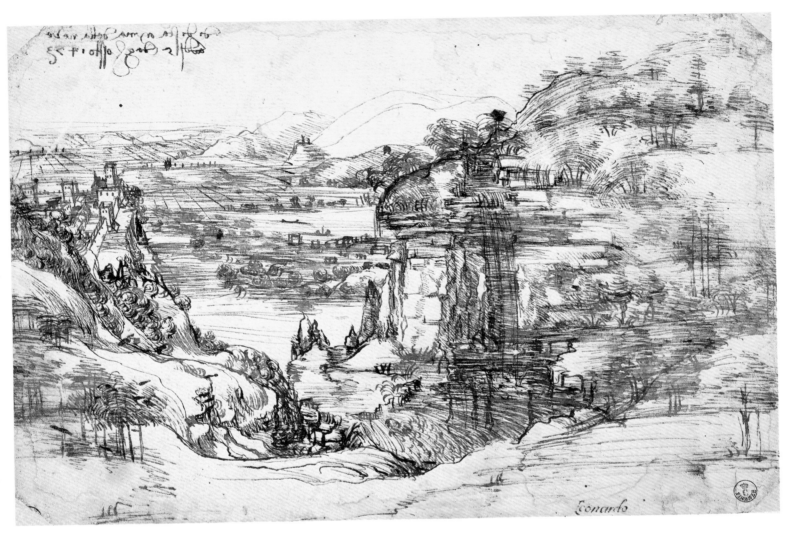

painting, partly because the painting seems much more accomplished than other works datable to the 1470s, such as the *Annunciation* (pages 38-39). The portrait only came to light in 1733 in the collection of the Prince of Liechtenstein, which means definitive statements about it are impossible. Vasari says that Ginevra was painted while Leonardo was in Florence for the second time between 1500 and 1506, but by then Ginevra would have been in her forties. Furthermore the portrait has been cropped, but there is a silverpoint drawing of a pair of women's hands which would fit very nicely into the missing portion and which are closer in style to those in the *Lady with an Ermine* of 1485, than to works of the first years of the sixteenth century.

In 1477 Leonardo left Verrocchio's studio. The previous year Leonardo had been in trouble with the law: an anonymous note dropped in the *tamburo*, a box outside the Palazzo Vecchio, accused Leonardo and three other young Florentine men of engaging in homosexual acts with a 17-year-old artists' model, Jacopo Saltarelli. While no witnesses came forward, the case went before a magistrate twice in two months. Leonardo, in desper-

ation, successfully petitioned the head of the Florentine guilds, Bernardo di Simone Cortigiano, at whose intervention Leonardo was acquitted on condition that he was never again the subject of such an accusation.

Having left Verrocchio's studio, it appears that Leonardo was ill suited to the business-like atmosphere of Florence. The minutes of the Signoria show how a commission for an altarpiece for the chapel of San Bernardo in the Palazzo Vecchio had been at first awarded to Piero Pollaiuolo on 24 December 1477. Seventeen days later the commission was transferred to Leonardo and on 16 March 1478 he received a first payment of 25 florins. For unknown reasons it appears Leonardo had difficulty fulfilling the contract and he abandoned the altarpiece at a very early stage. On 25 May 1483 the Signoria resolved to transfer the project once again to another painter, Domenico Ghirlandaio, but it was not until 1485 that the altarpiece was completed: it had finally been finished by a fourth artist, Filippino Lippi.

In 1478 Leonardo drew a sketch (right) of a hanged man, Bernardo Baroncelli, who had taken part in the

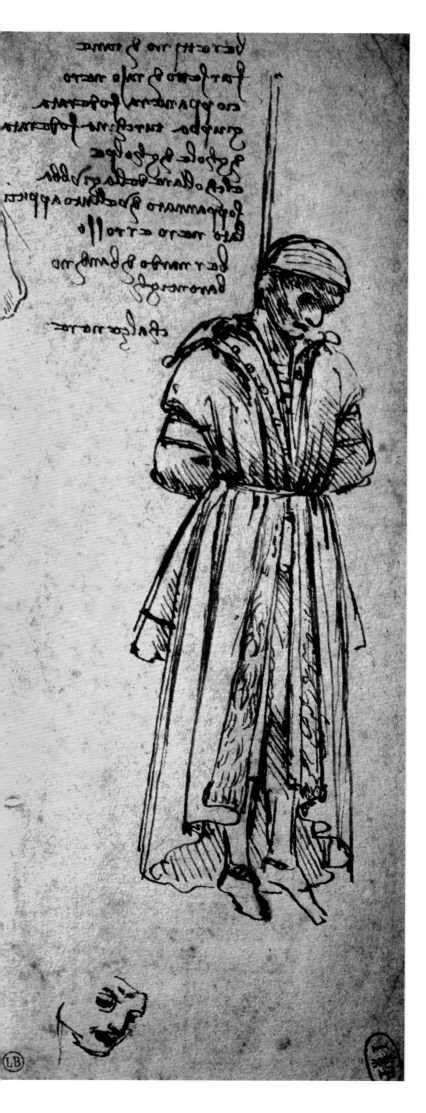

LEFT: In 1479 Leonardo made this drawing of the hanging of Bernardo Baroncelli who had conspired to assassinate Lorenzo de' Medici.

murder of Giuliano de Medici while he was attending mass in Florence Cathedral. The notes on the drawing record the style and color of Baroncelli's clothes:

a tan-colored cap, a doublet of black serge, a black jerkin, lined and the collar covered with black and red stippled velvet. A blue fox coat lined with fur of foxes' breasts. Black hose. Bernardo di Bandino Baroncelli.

In spite of Leonardo's inability to carry out the San Bernardo altarpiece, he received a further commission in March 1481 for the *Adoration of the Magi* for the monastery of San Donato at Scopeto near Florence. Leonardo's lawyer father duly drew up the contract which stated that Leonardo had agreed to deliver the finished painting in 24 months. Shortly after the contract was signed Leonardo was advanced money for materials and in July he was allowed a further 28 florins. On 28 September three monks delivered a cask of wine to Leonardo's house. Yet he was still unable to fulfill the contract: Leonardo left Florence without completing the *Adoration of the Magi*. The preparatory monochrome painting is preserved in the Uffizi gallery and many preparatory drawings have also survived. Leonardo was not to return to Florence for 18 years. In the meantime the monks of San Donato commissioned an altarpiece of the same subject from Filippino Lippi which was delivered in 1496.

The only other painting which may be dated with any certainty to Leonardo's early days in Florence is the *St Jerome* (page 52), now in the Vatican Museum in Rome. According to one story, this painting was discovered in two pieces, one of which was being used as a table top.

Many explanations have been offered as to why Leonardo left Florence in 1481. Some say it was his restless spirit that drove him on to Milan. Others say that unlike his old master Verrocchio, Leonardo did not enjoy the direct patronage of the Medici family. In 1481 Pope Sixtus IV had summoned the finest artists in Tuscany to decorate the Vatican. Following consultations with the Medici, Botticelli, Ghirlandaio, Signorelli, Perugino, and Pinturicchio were summoned to Rome. But not Leonardo.

The Medici had not, however, completely ignored Leonardo: in 1478, during one of Ludovico 'il Moro' Sforza's visits to Florence, Lorenzo de Medici is said to have recommended Leonardo as the artist to undertake the monumental sculpture the Duke of Milan was planning to erect as a tribute to his father, Francesco Sforza.

A year earlier Leonardo also appears to have been working under the patronage of Lorenzo 'il Magnifico' de Medici in the gardens of the Piazza San Marco, where Lorenzo was busy establishing his academy. In order to establish his academy for the study of classical art and

BELOW: Lorenzo de' Medici (1449-92) surrounded by humanist thinkers at his Platonic Academy at the Medici villa, Careggi.

antiquity, Lorenzo appropriated land adjacent to the monastery of San Marco and had marbles from Greece and Rome imported in order that his students could contemplate the ideal beauty of art. According to Antonio Gaddiano in the Codice Maggliabecchiano, Leonardo was set to work in the gardens of the Piazza San Marco where the Academy was to be established. In a note in the Codex Atlanticus (288), on a sheet of calculations and a drawing of a pair of scales, Leonardo mentions the gardens and the work on which he could have been employed:

The Labours of Hercules for Piero F Ginori
The Gardens of the Medici

But Milan was Leonardo's destination.

In an undated letter of self-recommendation to Ludovico Sforza, Leonardo wrote that he had plans for portable bridges, water-raising devices, battering rams and devices for scaling high walls; plans for cannon, warships, catapults and armored cars. At the end of the letter

Leonardo assured Il Moro that in addition he could 'execute sculpture in marble, bronze, or clay, and also paintings,' and that he could undertake the bronze equestrian statue of Ludovico's father. Where Leonardo gained this technical knowledge is uncertain, especially as when he left Florence he had listed in his notebook the works he had in his possession:

A head, full face, of a young man
 with fine flowing hair
Many flowers from nature
A head full face, with curly hair
Various St Jeromes [Most likely including the Vatican *St Jerome*]
Many designs for knots
A head of the Duke [possibly Francesco Sforza]
Four studies for the panel of Sant'Angelo
A small composition of Giuliano da Fegline
A head of Christ done with the pen
Eight St Sebastians

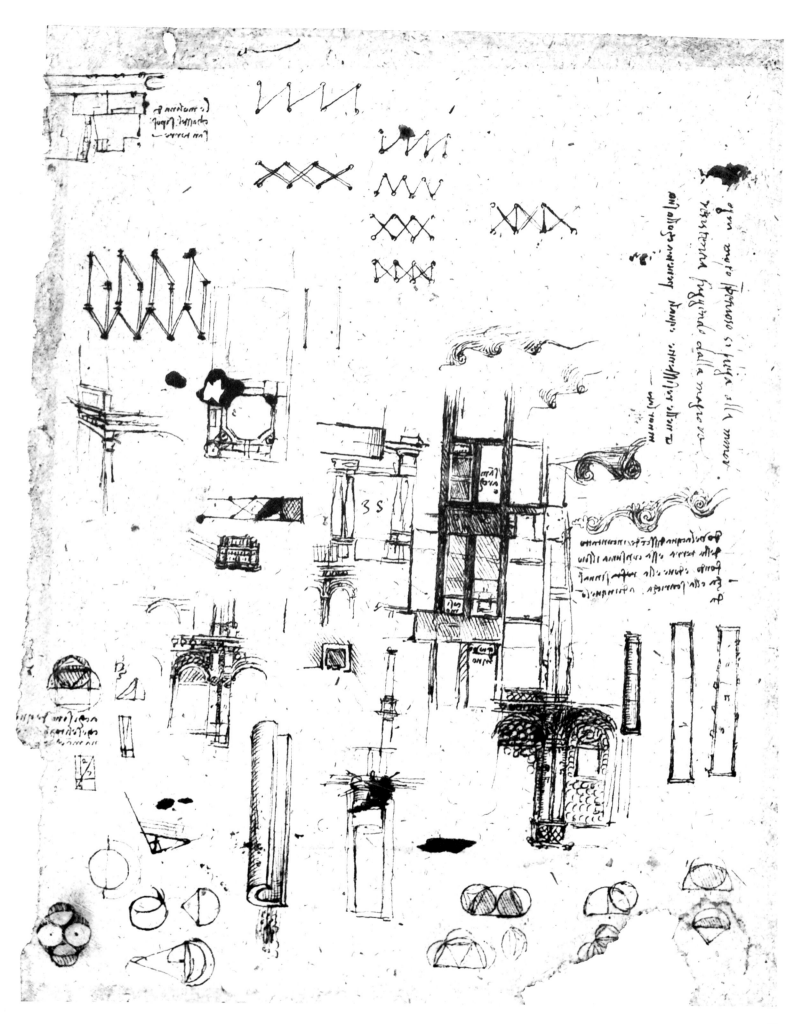

15

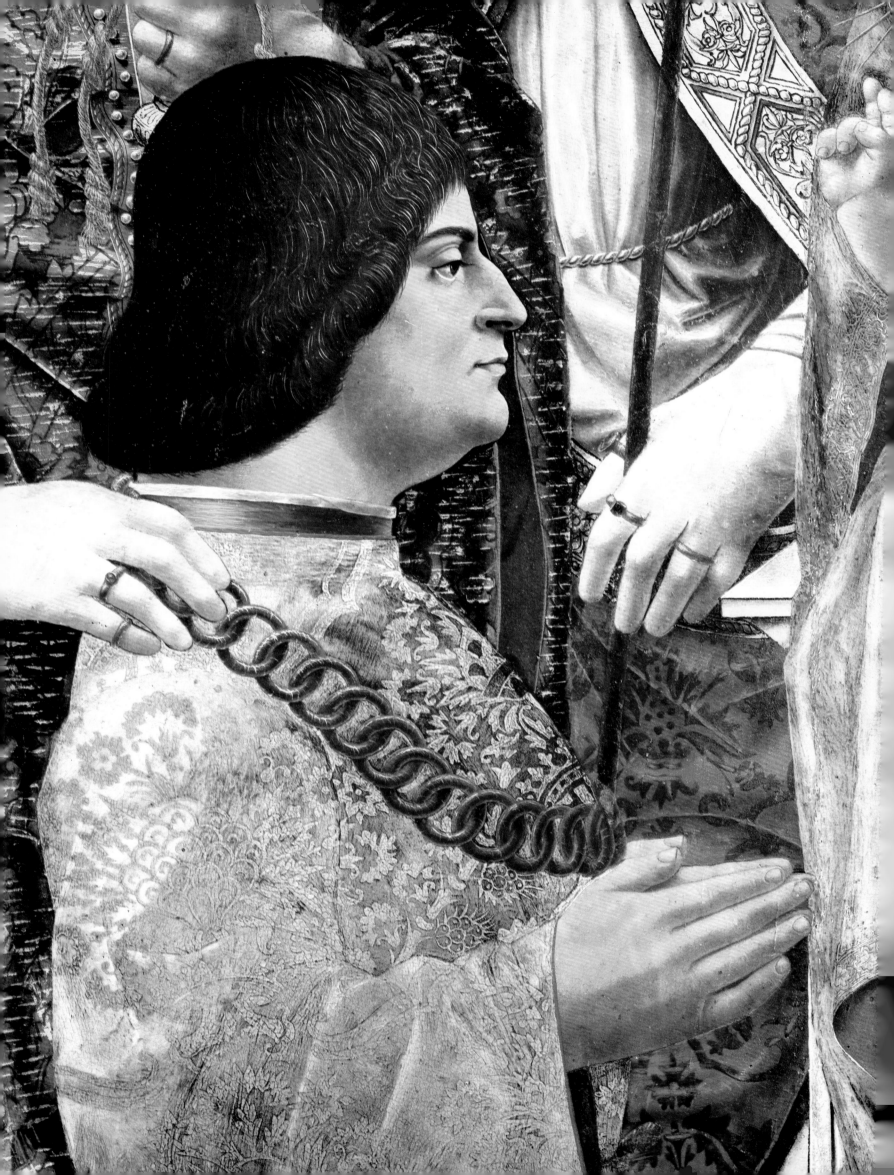

Many angels
A chalcedony [a kind of crystal]
A head in profile with fine hair
Some bodies in perspective
Some machines for ships
Some machines for waterworks
A portrait of Atalante [Migliorotto] raising his head
The head of Gian Franco Boso
Many throats of old women
Many heads of old men
Many complete nude figures
Several arms, legs, feet, and poses
A Madonna, finished
Another almost [finished] in profile
The head of Madonna ascending to Heaven
The head of an old man with a very long neck
A head of a gypsy
A head with a hat on
A representation of the Passion, made in relief
A head of a girl with tresses gathered in a knot
A head with the hair dressed

Only two items on this list – 'some machines for ships' and 'some machines for waterworks' – could possibly support Leonardo's claims of technical or engineering skills as set out in his letter to Ludovico.

The probable date of Leonardo's arrival in Milan is given as some time in October 1481. At that time, Gian Galeazzo Sforza, the rightful Duke of Milan, was only 15 years old, and his uncle, Ludovico, Duke of Bari, was acting as regent and was virtual ruler. Leonardo was thirty years old when it appears Lorenzo de Medici sent him to Milan to present Il Moro with a lyre. According to Vasari, Leonardo was unsurpassed as a musician on this instrument and was evidently greeted with great applause when he played a lyre in the shape of a horse's skull which he had made himself.

Soon after his arrival in Milan, Leonardo was receiving commissions: on 25 April 1483 Leonardo and the da Predis brothers, Evangelista and Giovanni Ambrogio, signed a contract with Prior Bartolomeo Scorlione, Giovanni Antonio Sant'Angelo, and other members of the Confraternity of the Immaculate Conception, agreeing to

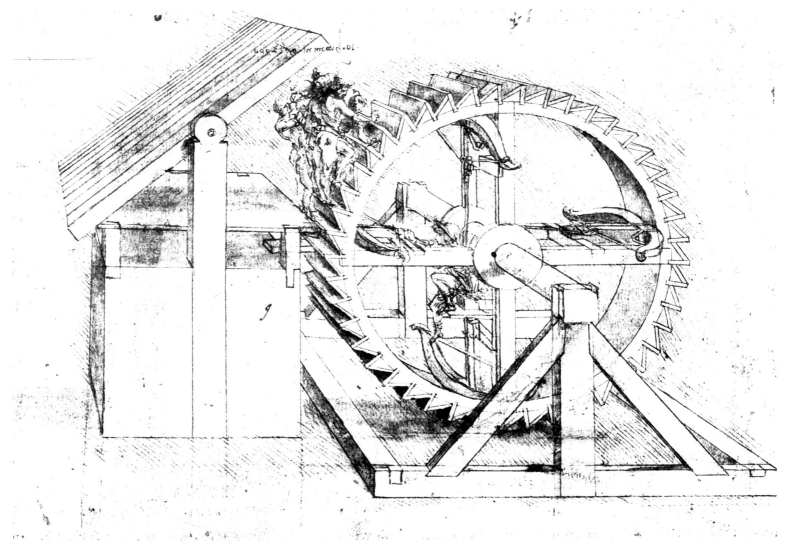

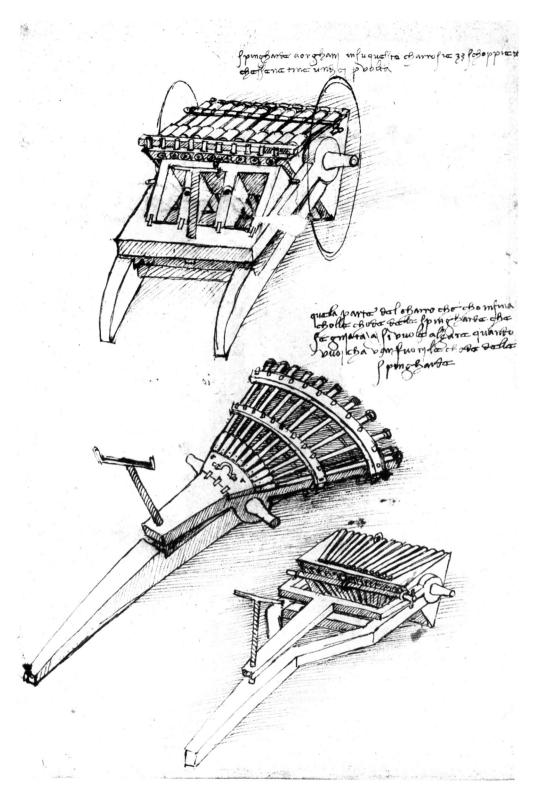

LEFT: In order to overcome the slow rate of fire of Renaissance firearms, in 1481 Leonardo devised various arrangements of 'scoppietti' or light cannons in ranks and tiers to increase their deadly efficiency.

RIGHT: Leonardo's drawing for a giant crossbow on wheels, c. 1485-88, features some advanced designs: a laminated bow for extra flexibility, worm and gear mechanisms for drawing back the bow as well as various release mechanisms.

produce an altarpiece with an elaborate carved frame for the Brotherhood's chapel in the church of San Francesco Grande in Milan. The central panel to be painted by Leonardo was to be of the Virgin and Child with a group of angels and two prophets, probably the *Madonna of the Rocks* (page 53) in the Louvre. Because the elaborate carved frame by Giacomo de Mario cost the entire 800-lire fee, it seems likely that the painters agreed to sell Leonardo's central panel to someone else when further money from the Confraternity was not forthcoming. Following a later court ruling of 4 April 1506, which ordered Leonardo to fulfill the terms of the original contract, it appears that a second version of the *Madonna of the Rocks* (page 74) was completed and installed in San Francesco Grande by 18 August 1508.

Two further paintings also date from Leonardo's early years in Milan. From around 1482 to 1483 are the unfinished *Portrait of a Musician* (the only portrait Leonardo ever painted of a man and believed to be a portrait of Franchino Gaffurio, the choir-master of Milan cathedral) and *Lady with an Ermine* (page 54), a portrait of Cecilia Gallerani, who had been Ludovico's mistress since 1481.

Around 1495 it is recorded that Leonardo painted a portrait of Lucrezia Crivelli, another of Ludovico's mistresses in the 1490s. It is possible that the painting known as *La Belle Ferronière* (page 56) is this portrait.

It appears that no further paintings were produced by Leonardo before his next major work, the *Last Supper*, begun in 1495. In the meantime Leonardo was engaged in work on the equestrian statue of Francesco Sforza, the

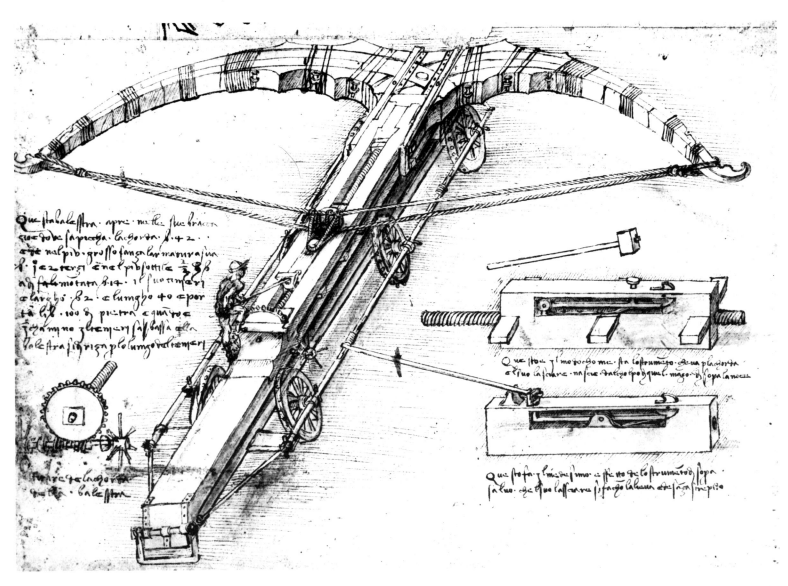

first Sforza ruler of Milan. It is believed that Leonardo was involved in this project for some sixteen years.

Leonardo's first ideas for the monument seem from surviving drawings (page 59) to have been for a rearing horse, but by 1490 a new design of a walking horse appears to have been adopted. Possibly the change was inspired by the statue of Marcus Aurelius in Rome or a classical statue of a horse in Pavia which Leonardo had seen in the same year. By the winter of 1492-93, a full-scale model in clay had been made, but the final bronze casting never took place. In November 1494 Ludovico re-directed the bronze intended for the statue to Ferrara to be made into cannon to help his father-in-law, Ercole d'Este, to repel the invading French troops. The clay model languished until 1500 when it was used for target practice in Milan by invading French archers.

It was in the same period that Leonardo produced his first designs for the now-famous flying machine the scythed chariot (page 97) and the armored car (page 97). These are simply a few of the hundreds of elaborate and beautiful drawings in Leonardo's notebooks from this period when his interests centered on mechanics. He made designs for weapons to increase the deadly effi-ciency and the rate of fire of catapults and other artillery weapons; he devised machine guns and mechanical bows capable of hurling flaming missiles over a great dis-tance. On land he envisaged military bridges, forts, and defensive works, while at sea he designed assault craft, floating battering rams, diving suits, and a mysterious scheme for destroying enemy ships by piercing them below the water line.

Leonardo's designs for weapons can be divided into three broad categories: catapults, cannon, and muskets, and he seems to have had a particular interest in designs that multiplied a single force. Renaissance firearms had several limitations, the chief being their inaccuracy and slow rate of fire. One of Leonardo's solutions was to organize a series of light cannon or 'scoppetti' into a fan pattern. The ten-barrelled gun whose aim could be altered by means of a screw-jack would have been most effective against ranks of infantrymen as the machine would saturate the enemy with fire. Other designs show guns with arrangements of three ranks of eleven barrels each: while one rank was being fired, another could be loaded.

Until the refinement of the cannon, the principle artil-lery weapon was the catapult, or ballista, as the larger versions were called. These had been used by the Romans who called their machine the 'scorpio.' Leonardo's drawing for a huge ballista features some advanced designs: a laminated bow for extra flexibility, a worm-and-gear mechanism for drawing the bow back and release mechanisms which were operated by strik-ing with a hammer or were lever activated.

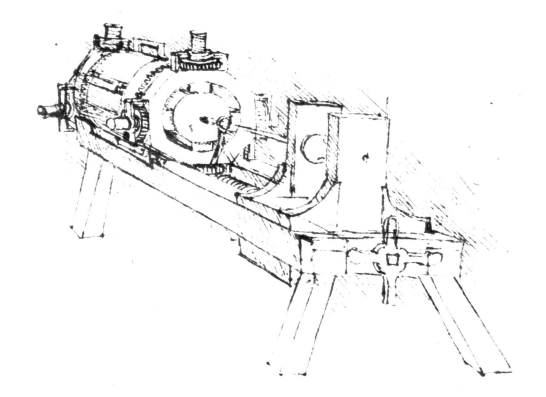

Guns and artillery and their fire power was an ongoing area of study for Leonardo who was, in many respects, well in advance of contemporary thinking in his studies. He was concerned with designs for breech-loading guns rather than muzzle-loading ones, multiple-fire capabilities and advanced gun-making techniques, as well as what he called the most deadly machine – a huge mortar which fired shrapnel shells that exploded on impact, scattering their deadly fragments.

Not all of Leonardo's designs from this period were for machines of destruction. There are designs that were intended to be applied to general use in industry, for hammering, boring, shaping, for raising weights, for grind-ing, and digging. Leonardo's own inventory divides his machines into two major categories: those for improving mechanical work and thus productive; and those with a military use and thus destructive.

One of Leonardo's earliest designs is for a file- or rasp-maker. The machine was designed to strike the teeth of a file evenly on to the face of a metal blank. Once started the machine required no further human intervention except for re-cranking the weight back to its start position. The machine could thus produce a larger number of finished files of greater uniformity and at a lower price.

Other designs aimed at solving the problem of translating rotary motion into a reciprocating or piston-like

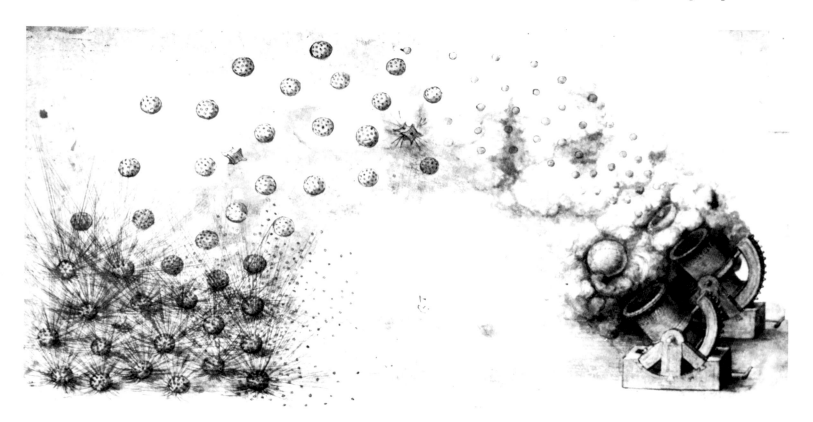

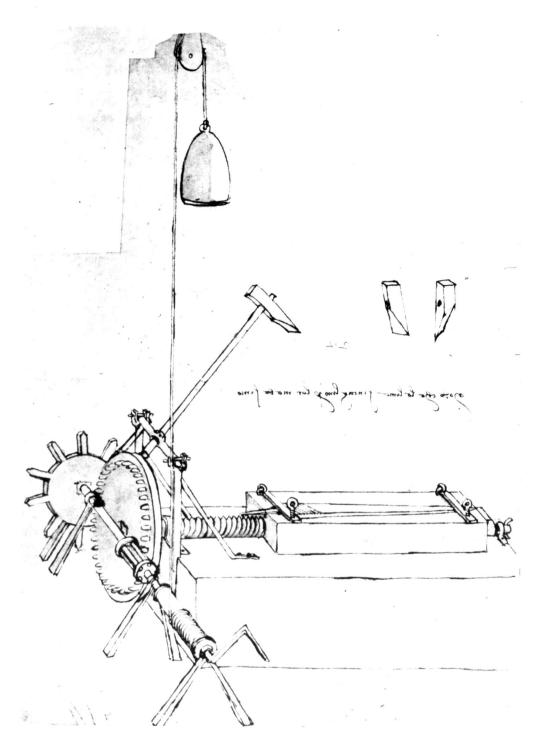

action (and vice versa). So clear are Leonardo's designs that it would be possible for those of us unfamiliar with these types of machines or drawings to mistake them for their modern counterparts.

No matter how mundane an occupation might have been, it did not escape Leonardo's keen observation and while it is true that some of his most grandiose schemes and designs never left his notebooks, Leonardo did, however, understand the impact that new technology and machines would have on his society. Leonardo wrote many 'prophecies' or riddles that were recited at court gatherings and designed to be solved by the assembled guests, and in these clever word games he not only pointed out the problems of his own age but also commented on humanity in general, comments that are regrettably holding true today:

Creatures will be seen upon the earth
who will always be fighting one another

There will be no bounds to their Malice,
by their fierce limbs a great number of
trees of the immense forests of the world
shall be laid level to the ground.

(Codex Atlanticus 370r)

During 1487 and 1488 Leonardo was also working on the model for the 'triburio,' the central cupola planned for the dome of Milan Cathedral. His notebooks also bear testament to his interest in structural problems: Manuscript B in the Institut de France, contains a series of drawings from around 1488 of churches or 'temples,' the majority of which are variations on centralized plans – squares, polygons, circles or combinations of all these. Leonardo's studies are presented using solid exterior views in perspective, plan and section. It is not certain whether these plans were for a specific project, but some are believed to be ideas for a Sforza mausoleum.

BELOW: Leonardo's design for a windlass is presented in a composite drawing (left) and in an exploded view (right).

RIGHT: A study for the triburio of Milan Cathedral, c. 1487.

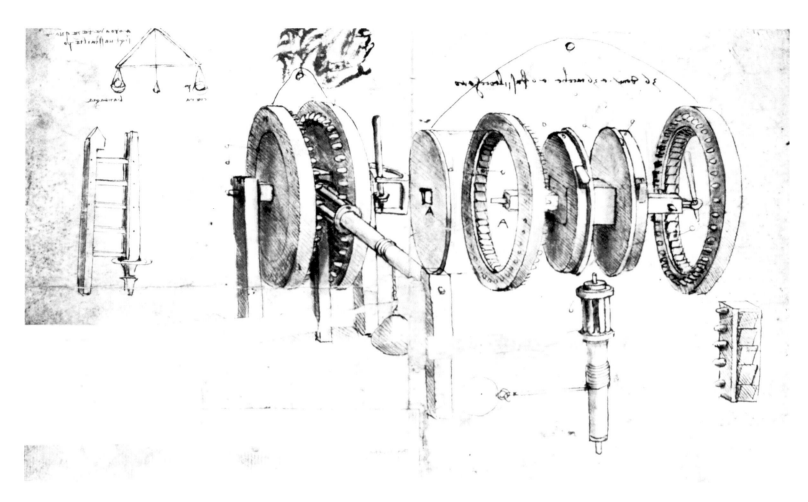

In 1483 an outbreak of plague in Milan may have inspired Leonardo to draw up plans for the re-modeling of the city. His drawings demonstrate a plan for a city on two levels: the lower streets were to be set aside for use by carts, animals, and the lower classes of citizens, while the upper level was to form a promenade with hanging gardens for the pleasure of the nobility. Archways provided lighting and ventilation to the lower level and every hundred meters or so, a staircase was to be provided to link the two levels. Having also noticed that city-dwellers were in the habit of leaving their garbage in corners, Leonardo planned stairwells as circular and staircases as spirals.

During the 1490s Leonardo's patron Ludovico Sforza adopted as the court church the Dominican Santa Maria delle Grazie in Milan. At his direction, the east end of the church was reconstructed by Donato Bramante, later to be the architect of the new St Peter's in Rome. Ludovico envisaged the church as a family mausoleum – a memorial to his wife Beatrice d'Este was erected there after her early death in 1497 – and as a dynastic monument to the family. Each Tuesday and Thursday Ludovico also dined in the refectory with the Abbot and it was for this room in 1495, on the end wall facing the abbot's table, that he commissioned Leonardo to paint

The Last Supper (pages 60-64), Leonardo's first wall painting for which he was paid 2000 ducats.

For the painting of the *Last Supper* Leonardo created his own medium of tempera on stone, a medium that was later to prove unstable as the paint began to detach from the ground of gesso, pitch, and mastic. Further damage was to befall the painting when a doorway was installed in 1652, cutting through the lower central part of the tablecloth. Additional damage was caused by over-zealous restoration, carried out by Michelangelo Belotti in 1726 who erroneously believed that Leonardo had used oil-based paints and subsequently by Giuseppe Mozza in 1770, who set about an extensive repainting program that was not really in keeping with Leonardo's original scheme. Then, in 1821, Stefano Barezzi attempted to remove the painting from the wall. While a fresco can be removed (since it is painted on plaster which is laid on top of the wall surface), Leonardo did not use the fresco technique and his painting could not be detached. Barezzi only discovered this after he had damaged the tablecloth and one of Christ's hands.

In 1796 Napoleon's troops entered Milan and despite his personal orders to the contrary, the refectory was used as a haystore, powder magazine, and quarters for troops and prisoners. The most recent catastrophe to

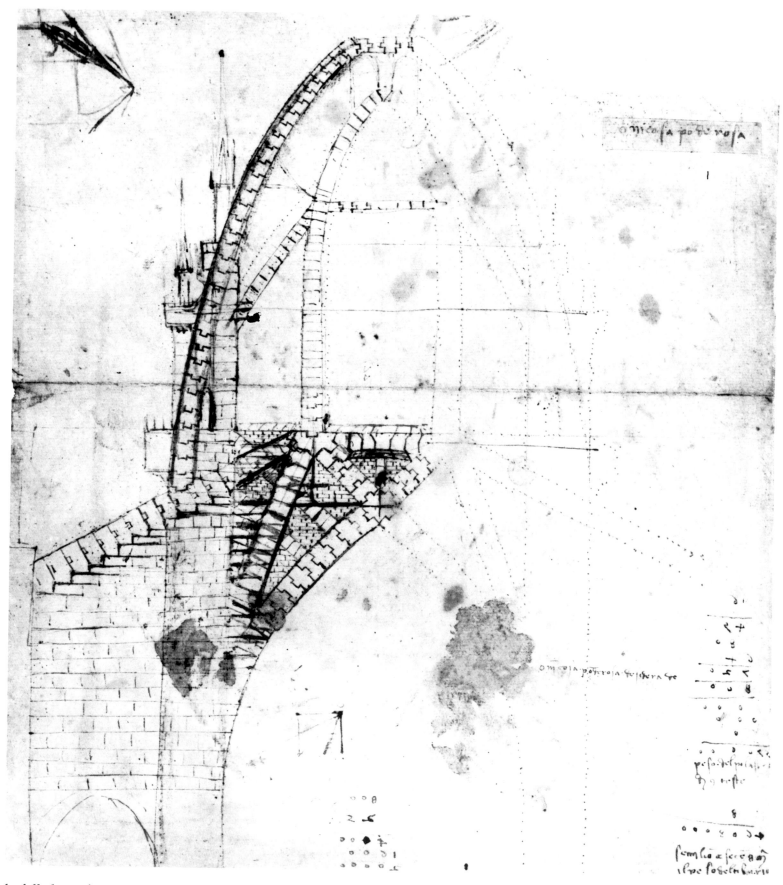

befall the refectory was in August 1943 when one wall and the roof were destroyed by a bomb. Luckily sandbags had been set up to protect the painting and the *Last Supper* survived the blast. We can only hope that modern scientific techniques can halt the damage caused by nature itself, humidity.

There is a further strange tale linked to this one of the most famous of all paintings. The New Year of 1497 saw the pregnant wife of Ludovico Sforza, Beatrice d'Este celebrating by dancing and drinking. The next day she miscarried and was dead. For many superstitious Milanese, Beatrice's death and the *Last Supper* were inextricably linked: in the early stages of development, Leonardo's painting had accompanied a *Crucifixion* by Montofano which also contained the donor portraits of Beatrice, Ludovico, and their two children. When this painting was painted over, Beatrice's death was seen as a portent of evil yet to come. Perhaps they were right: by September 1498, Ludovico 'il Moro' Sforza was no longer Duke of Milan.

If the *Last Supper* is Leonardo's best-known commission from the 18 or so years that he spent in Ludovico's court, the *Salle delle Asse* (Room of the Boards) at the Castello Sforzesco in Milan must be the least well known (page 67). Although it has not decayed to the same extent as the *Last Supper*, it was very heavily restored at the beginning of the twentieth century. The square room is situated in the northern tower of the Castello and formed an introduction to a suite of private rooms intended for Ludovico and Beatrice. The whole scheme, which uses foliage as a decorative device, is exceptional for the way Leonardo subtly contrived to incorporate his patrons' emblems and devices into tree forms.

In 1498 came Ludovico Sforza's downfall. France and Venice had allied to create a seemingly unbeatable foe and to spare Milan and possibly to save his dukedom, Ludovico invited the French king, Louis XII, to Italy. When the French entered Milan, Leonardo left the city for the relative safety of the Melzi family's home of Villa d'Adda at Vaprio and returned only when it appeared that a war had been averted. On his return to Milan Leonardo met the French king and his aide Cesare Borgia, the son of Pope Alexander VI. In Milan Borgia offered Leonardo the post of military engineer, but Leonardo declined the offer. Instead he traveled to Mantua and the court of Isabella d'Este, sister of Beatrice. There he completed a preliminary sketch for a portrait of Isabella. By March 1500 Leonardo was in Venice where the maritime republic sought his advice for defending itself against possible attack by Turkish troops.

By Easter 1500 he was back in Florence. Shortly after his return he was commissioned by Francesco Gonzaga of Mantua to draw the Villa Tovaglia, so that a copy of it and its gardens could be constructed in Mantua. The Villa Tovaglia near Val d'Ema, south of Florence, had been built between 1480 and 1490 for Agnolo de Lepo del Tovaglia. Around the end of the century Francesco Gonzaga had been a guest at the Villa where the architecture and gardens had so pleased him that he wished to duplicate them in Mantua.

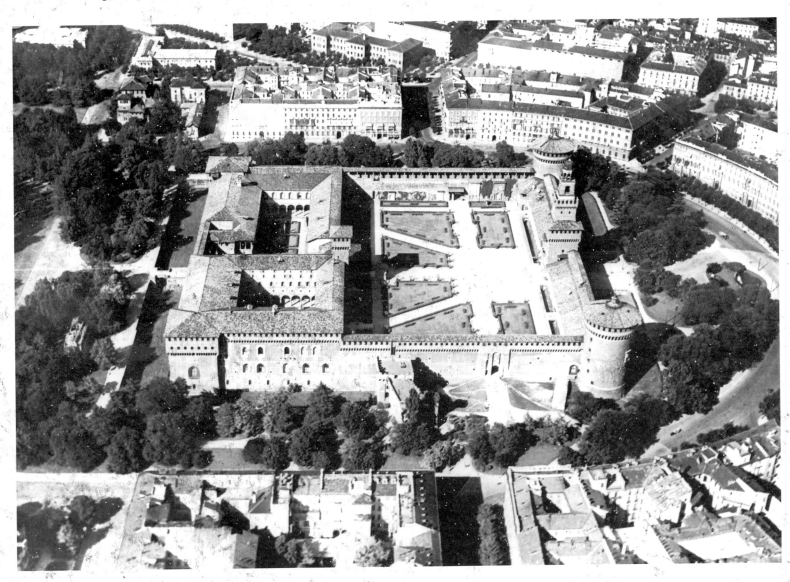

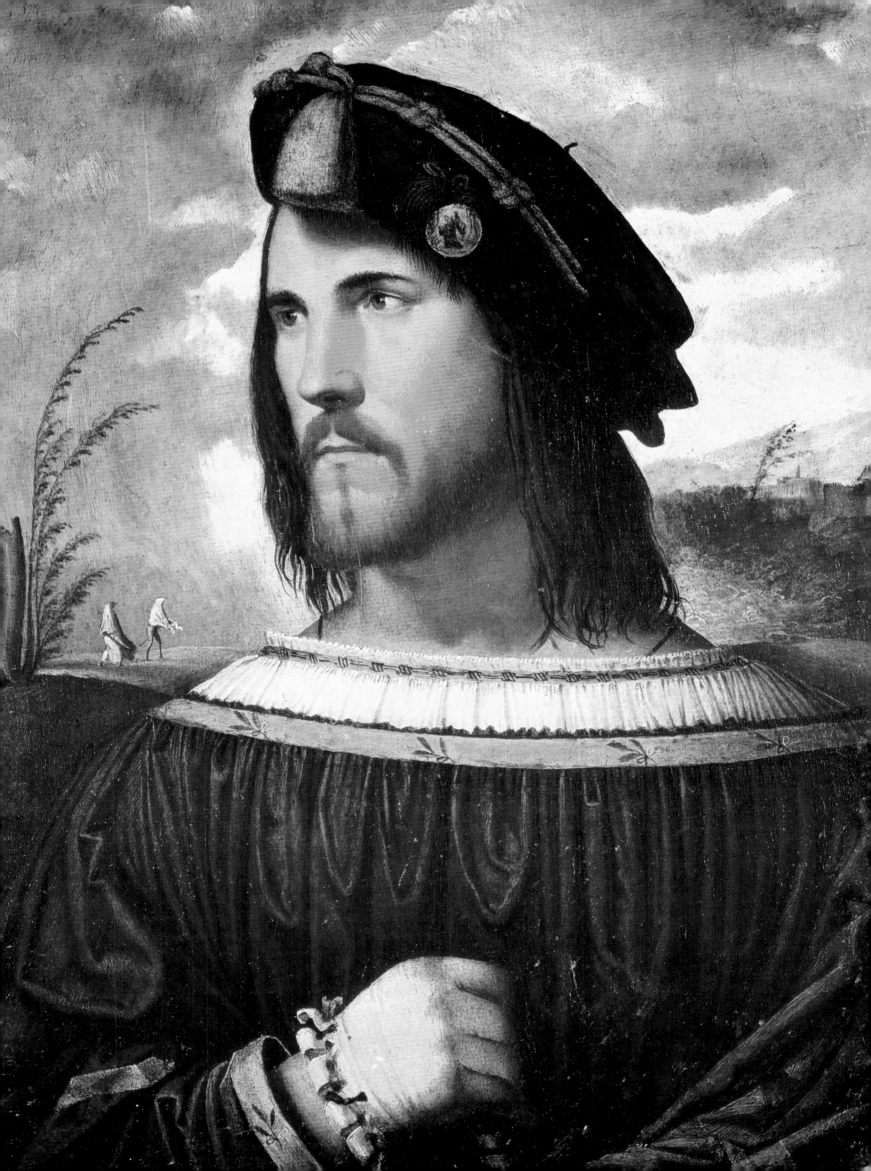

During Leonardo's 18-year absence the Medici rulers had been banished from the city and Florence had become a republic. Although he never enjoyed the same security from which he benefitted as court painter in Milan, Leonardo was not neglected by the state. Furthermore, Leonardo's father was now a procurator of the Servite monastery of Annunziata where the monks had commissioned Filippino Lippi to complete two paintings for the high altar of the church. Possibly because his father was a procurator, the commission was transferred to Leonardo. By September he was hard at work, but not on the altarpiece, although he did complete a cartoon (now lost) of the Virgin and Child with St Anne and the *Madonna of the Yarnwinder* for the Secretary of State to the French King Louis XII, Florimond Robertet.

By the end of May 1502 Leonardo was in the employ of Cesare Borgia as architect and chief engineer. Cesare Borgia shared Ludovico Sforza's desire to rule all of Italy and Leonardo travelled with him on his journeys through Emilia-Romagna and the Marches and produced maps and surveys of river systems as well as plans for diverting the Arno river in order to cut off the city of Pisa's access to the sea.

In the summer of 1502 Leonardo accompanied Cesare on his conquering expedition through Italy operating as the chief inspector of military buildings. Manuscript 'L' in the Bibliothèque Nationale in Paris is Leonardo's diary of these journeys and records stops in the region between Imola, Cesena, Rimini, Urbino, and Pesaro. But apart from some sketches outlining improvements for the docks at Porto Cesenatico, we do not have any further insight into Leonardo's official activities.

Leonardo did, however, draw up the areas of Borgia's military operations: a map of parts of Tuscany and Romagna was made for Borgia as was the magnificent, colored *Plan of Imola*, a circular map of the city that is not only beautiful but also immensely accurate. Every detail is pinpointed and color-coded: houses are tinted pink, public squares a dark yellow, the streets in white. Imola with its castle at the lower left is surrounded by a blue-colored moat. The notes to either side of the circular plan, written very neatly but nevertheless in Leonardo's 'mirror writing' (from right to left with the letters in reverse) refer to the geography, distance, and bearings of Bologna and other cities of military importance or interest to Borgia.

RIGHT: Leonardo's map of Milan from the 1490s. Below the circular plan of the city is a view in perspective. The cathedral is near the centre and to the left is the Castello Sforzesco.

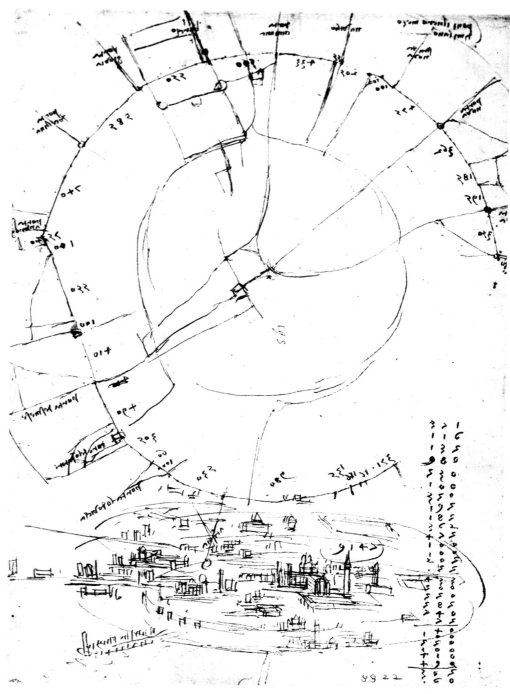

Earlier in the 1490s Leonardo had produced maps: the *Map of Milan* is also circular in groundplan with the city gates marked on the circumference. Below this Leonardo sketched in perspective a view of the city showing the main buildings – the cathedral in the middle and the Castello Sforzesco at the left.

From Leonardo's remarks in ms L we are able to see that he also visited the area of Piombino, part of Borgia's dominion at the northern end of the Tyrrhenian Sea, for which Leonardo designed a breakwater for the harbor of Piombino. The city was of economic importance for it was in its fortified harbor that iron ore from the island of Elba was unloaded. Furthermore, Piombino was strategically important as it occupied a central position between the bordering territories of the Papal States in the south, Lombardy and Genoa to the north and Florence to the east. Following a protracted seige in 1501, Cesare Borgia succeeded in wresting the city from its ruler and now added 'Signore de Piombino' to his already long list of titles.

In 1502 Leonardo appears to have made a map of Arezzo and the Valley of Chiana, also for Borgia. The striking feature of this map is that it appears to have been drawn from the air, an 'illusion' created by Leonardo's use of imaginary perspective.

By the spring of 1503, Leonardo had given up his post with Borgia and returned to Florence which at this time was engaged in a lengthy war against Pisa. In the new campaign against their old adversary, there emerged in the Florentine camp a plan to divert the course of the river Arno to cut off the Pisans' access to the sea and thus starve them into submission. In July 1503 by order of the Signoria, Leonardo set off for the Florentine camp to inspect the trench-digging for the Arno plan. The entire plan was in action for about a year before it was abandoned in October 1504. Leonardo himself had for a number of years a strong interest in diverting the Arno – not to isolate Pisa, but to make the river navigable from Florence to Pisa, thereby increasing trade in Tuscany. Many maps drawn by Leonardo outline the course of the

27

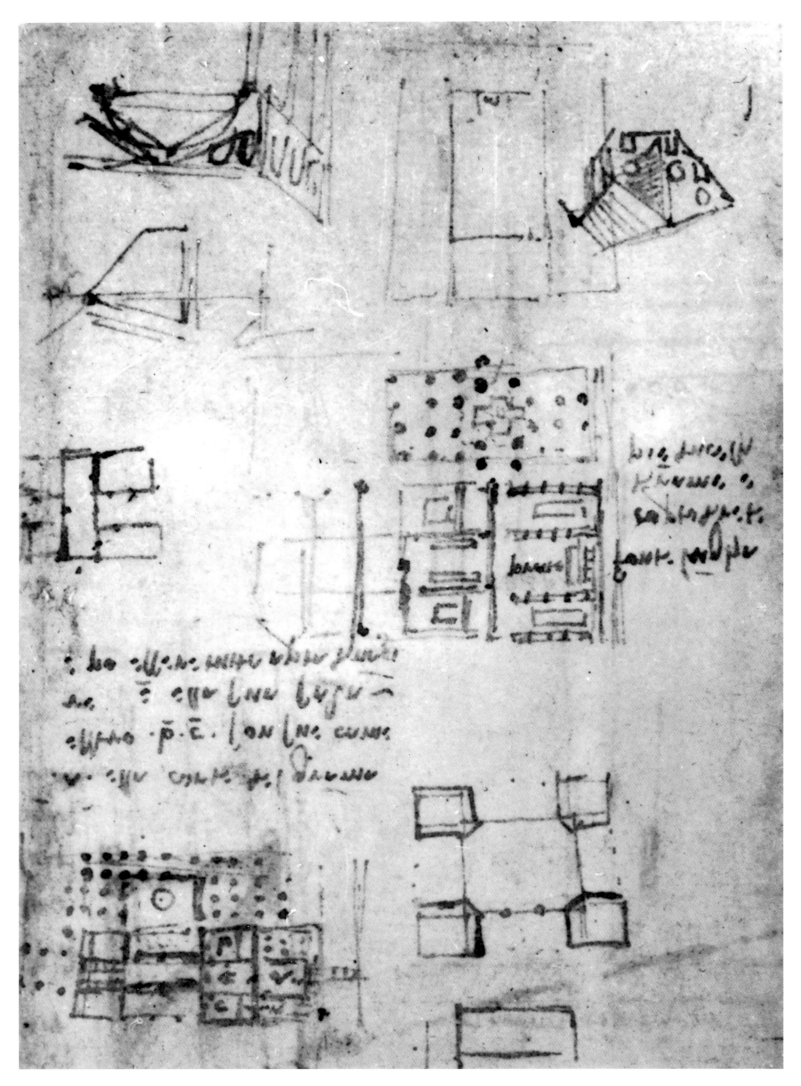

28

LEFT: Some time around 1506-08, Leonardo was at work on designs for a villa outside Milan for Charles d'Amboise, the French governor of the city. Its garden, complete with 'oranges and citrons,' was also to have an automated watering system, a water-powered organ, an aviary, and a theater.

river and some offer schemes for a canal system between Florence and the sea.

In October 1503 Leonardo rejoined the Guild of St Luke in Florence where he was listed not as an engineer but as a 'city painter'. On 18 October the mayor of Florence, Piero Soderini, ordered a large fresco to be painted in the Palazzo Signoria's Grand Council Hall, and both Leonardo and Michelangelo were commissioned to produce designs. While Michelangelo chose for his subject the Battle of Cascina, an episode in the Florentine-Pisan wars when Florentine soldiers were surprised by the enemy, Leonardo chose the theme of the 1440 Florentine triumph over Milanese merceneries at the Battle of Anghiari in the upper valley of the Tiber.

Work for the cartoon for the *Battle of Anghiari* was carried out in the Sala del Papa near Santa Maria Novella. According to Vasari, it was here that Leonardo also painted the *Mona Lisa*, reputedly a portrait of the wife of Francesco Giacondo, a Florentine silk merchant, but which remained unfinished for some years. At the same time Leonardo was also making studies for *Leda and the Swan* which were admired and copied by the young Raphael who had arrived in Florence in 1504.

Although Leonardo started work on the painting proper of the *Battle of Anghiari*, very little remains except for a detailed record of the project and later artists' copies of the central portion of the original composition. The materials Leonardo used - oil paint on a type of stucco base – proved unsuccessful and the painting was never completed and the cartoon subsequently vanished.

The failure of Leonardo's scheme for the *Battle of Anghiari* coupled with the failure of his engineering scheme to divert the Arno (which resulted in the creation of a new area of swampland and the outbreak of malaria in 1504) did not endear him to Mayor Soderini and as the treasury coffers were being rapidly depleted by the war effort, payments to Leonardo promptly ceased.

In the spring of 1506, at the request of Charles D'Amboise, Lord of Charmont-sur-Loire and Governor of the City in the name of Louis XII, Leonardo was once again back in Milan. Having left the *Battle of Anghiari* unfinished, Leonardo promised the Signoria that he would return in three months. But in August the French Chancellor in Milan, Geoffroy Charles, contacted Florence with the news that Charles d'Amboise wished to extend Leonardo's stay. It has been assumed that Leonardo's original reason for returning to Milan was to sort out the contract for the *Madonna of the Rocks*, which after 13 years had still not been delivered. It soon became apparent, however, that Leonardo had found himself patronage from a source far more powerful and wealthy than that of the Sforza's: on a visit to Milan in July 1507, the French

king Louis XII was calling Leonardo 'our dear and good friend . . . our painter and engineer in ordinary.' Furthermore the king was paying Leonardo a salary.

Leonardo's works from the early part of the sixteenth century are not easy to identify or date as contemporary reports do not quite fit with extant works. One work, however, which was described in letters from Fra Pietro da Novellara to Isabelle d'Este, was a cartoon of the Virgin, Child, St Anne and a Lamb, many features of which fit with the painting now in the Louvre.

Around the same time Leonardo began re-working the drawings that he had produced earlier in Florence – variations on the *Leda and the Swan*. The earliest drawings date from around 1504, about the same time as he was working on the *Battle of Anghiari*. These drawings along with those drawn around 1506, developed a scheme of Leda kneeling on one knee with one arm around the swan. (The story of Leda and the swan tells how Jupiter disguised as a swan, fathered by Leda four children: Castor, Pollux, Clytemnestra and Helen, who were hatched from eggs.) Some time around 1507 Leonardo transformed the kneeling Leda into a standing figure.

Back in Milan Leonardo once again began work on a large-scale monument, this time for the Milanese nobleman Gian Giacomo Trivulzio, who had made a financial provision for a monumental tomb to be erected in the church of San Nazarro. This commission, it would seem, offered Leonardo some compensation for the destruction of his masterpiece-never-to-be, the equestrian statue of Francesco Sforza. But like the Sforza monument, the Trivulzio monument, although carefully planned and calculated was never completed.

The only surviving painting by Leonardo from the period after he left Florence in 1508 (following a short stay in the city to sort out legal matters with his brothers over an uncle's will) is the *St John the Baptist* (page 90). While the effects of time have no doubt darkened this painting, it has merely exaggerated an already present effect, for it is possibly the finest example of Leonardo's chiaroscuro technique, bringing the figure of the saint brightly lit out of the dark background. This chiaroscuro effect is present to a greater or lesser degree in all of Leonardo's paintings; likewise, the gesture of the raised finger, found so often in his works from the *Adoration of the Magi* onward.

Between 1506 and 1508 Leonardo was also at work planning a villa outside Milan for the French governor of the city, Charles d'Amboise. In addition to a theater and a sprinkler system that could be turned on to give guests a brief shower from outlets hidden alongside the pavements, the garden also had an orangery. In a manuscript from around 1508, Leonardo described how citrus trees

could be grown without the usual recourse to lighting fires to heat the trees in winter, and rather than growing trees in large terracotta pots (which allowed them to be moved indoors in winter), Leonardo suggested that the trees could be grown permanently in a covered area watered by a natural spring. In summer the spring would irrigate the trees and in winter, by means of a hydraulic mill, Leonardo would produce a current of warm air to protect the covered-over trees and prevent them from freezing.

For Charles's villa, Leonardo also made provision for a series of rivulets running through the garden, a table with running water to cool wine and for fish to be visible when swimming in a central stream. Recognizing the need for the cleanliness of the water, he also decreed that only plants such as watercress be left to grow in the shingle banks of the stream as it served as food for the fish. In the same manner, he also cautioned against introducing tench, eel, and perch to the river system as they preyed on other fish.

For Leonardo the concept of a 'total garden' also involved pleasant music: in addition to the songs of exotic birds contained in the gardens by a copper net overhead which was invisible to the naked eye, a sort of organ was devised that was powered by the stream's current. Thus Leonardo's conception of a garden was a combination of elements to please the senses: it diverted the eyes by providing views with architectural and sculptural elements, the ear with birdsongs, hydraulically produced music and splashing fountains and the nose with scented flowers and trees.

The sheer number of drawings of botanical studies and, particularly, of landscapes, testifies to the passionate interest with which Leonardo observed nature. In addition to recording the slight variations within families of trees, and the effect of light and shadow on copses, Leonardo also laid the basis for a theory of landscape in his *Trattato della Pittura*. For Leonardo, the purpose of a landscape as a work of art was not merely a decoration, but had to correspond to something actual and true.

In his landscape drawings and in the magical results seen in the backgrounds of the *Mona Lisa* and the *Virgin and St Anne* Leonardo excelled in modelling by gradations of light and dark and was a promoter of the chiaroscuro and sfumato techniques. His interest in reflections, contrasts and neutralizations of color and his observations of atmospheric effects in many ways make Leonardo a forerunner of the Impressionists. In his modelling of mountainous landscapes, Leonardo's skills as an artist, scientist and geologist are fused together.

This period in Milan saw an incredible increase in Leonardo's output of botanical studies. The majority of these extant studies are related to the years 1508 and after – around the time he was working on the theme of *Leda* (pages 84-88). Leonardo's best-known botanical drawing, as well as being one of the most spectacular, is the red chalk, pen and ink study of the spiralling plant *Ornithogalim umbrellatum* or the *Star of Bethlehem* (page 123), one of the plants that also appears at the foot of *Leda* in the Chatsworth version. It has been suggested by botanists that the Star of Bethlehem does not have such a pronounced spiral leaf formation, and that its appearance here is probably due to Leonardo's method of observation which resulted in works which placed emphasis on the underlying structure of things and on the patterns that those structures produced.

Leonardo was also fully aware of the iconography of plants and flowers in paintings, but ensured that any plant life that did appear, did so in its proper 'ecological' setting. Thus at the same time that the plants in Leonardo's works carry symbolic meaning, they are also true to nature.

The spiralling form that is apparent in the *Star of Bethlehem* and the energies embodied in the spiral form was an area of interest to which Leonardo often returned: we can see the spiral forms in his studies of water and in the *Deluge Drawings* and even in the form of Leda's hair dressing.

In a similar way, many of Leonardo's botanical studies are related to architectural forms such as arches and vaults. The study of the grass *Coix Lachryma-Jobi* is reminiscent of Leonardo's definition of an arch:

What is an arch? An arch is nothing else than a force originated by two weaknesses, for the arch of a building is composed of two segments of a circle, each of which being very weak in itself tends to fall, but as each opposes this tendency in the other, the two weaknesses combine to form one strength.

Furthermore, we see a similar shape in his studies for churches and for the triburio for Milan cathedral, while at the same time the drawing also explores the theme of reproduction that can be seen in an earlier series of flowering and seeding plants as well as in the studies of the human reproductive system and embryos.

The first date that occurs in Leonardo's notebooks on the subject of anatomy is 'the second day of April 1489,' when it appears that he was planning a treatise entitled *Of the Human Figure*. While his anatomical studies gained impetus from the dissection of an old man whom he called the 'Centenarian' in Florence during the winter of 1507-08, the majority of Leonardo's anatomical drawings, including the famous studies of hearts and embryos, were carried out during the second period in Milan between 1506 and 1513.

In his study of the *Principal Organs and Vascular and Urino-genital Systems of a Woman*, c.1507, Leonardo produced one of his greatest attempts at synthesizing his investigations into the 'irrigation' system of the human body. In his drawing some of the forms appear in section, some are transparent, while others are depicted three-dimensionally. Some of the organs – the liver, spleen, kidneys and bronchial tubes – demonstrate Leonardo's knowledge gained from dissection, while other organs are conceptualized: the heart lacks an aorta and the womb is treated as a sphere with horn-like tubes. What Leonardo has done is fuse together ancient inherited beliefs with the results of his empirical studies.

In the accompanying notes Leonardo wrote of his intention for a series of works that began with the forma-

tion of the child in the womb, a discussion of reproduction and blood vessels as well as the cycles of life and death in the human body.

In the last decade of his life Leonardo was to concentrate his anatomical studies in two fundamental areas: the heart and embryology. He was the first to draw the uterine artery and the vascular system of the cervix and vagina as well as the single-chambered uterus at a time when it was generally believed that it was made up of several compartments as this being the usual explanation given for the mystery of twin births and multiple litters in animals. Furthermore, Leonardo was the first to describe correctly the fetus 'in utero,' tethered by the umbilical cord, although he was wrong when he suggested that the cord was equal in length to the body at

31

each stage of the child's development and that the child did not respire since it was in 'water.' Meanwhile the circulatory system was described in detail over fifty drawings of the heart. For Leonardo, the circulation of blood and the flow of sap in plants and trees were analogous processes.

In the meantime the duchy of Milan was preparing itself against possible hostilities on its eastern borders. When Pope Alexander VI died in 1503 and was succeeded by Julius II (after a short interim Piccolomini Papacy), Cesare Borgia found himself cut off from the Papal treasury and in opposition to Julius, an old adversary of the Borgias. As Cesare's Romagna dukedom slowly fell apart, Venice was on hand to pick up the pieces. But since the lands now claimed by Venice technically belonged to the Papacy, Pope Julius prepared to smite Venice by entering into an alliance with the Emperor Maximilian and King Louis XII. As the pressure mounted, the Venetians ceded some of the lands formerly held by the Borgias but still refused to give up claims on other important areas. Despite being backed by Swiss and Romagna mercenaries, Venice was swiftly relieved of Trieste, Gorizia, Pordenone, Fiume and some territories in Hungary. Julius and Maximilian mustered anti-Venetian sympathies which resulted in the League of Cambrai in December 1508 which was to ally all the major western powers against Venice.

But in a reversal of policy whereby he now saw Louis XII as the great enemy, Julius resolved to rid Italy of the French through a coalition – the so-called Holy League of 1511, which allied the Pope, Venice, and Spain with additional support from the Swiss and English. In 1512 Massimilio Sforza, son of Ludivico, entered Milan with the Pope, the Emperor and the Venetians and finally drove out the French.

Leonardo thus found himself in a tricky position: he would obviously not be popular with Maximilian since he had fled Milan and Ludovico at the first sign of trouble. Fortunately for Leonardo, in September 1512 a bloodless revolution in Florence returned Lorenzo de Medici to power and the following March Giovanni de Medici was hailed in Rome as Pope Leo X. On 24 September 1513 Leonardo was on his way to Rome.

Once in Rome Leonardo lodged in the Belvedere, the summer palace at the top of the Vatican hills. Also in Rome were Donato Bramante (1444-1514), Raphael (1483-1520), and Michelangelo (1475-1564) all artists who seemed to be preferred by the Pope since commissions for Leonardo were few. He was, however, given a dispensation allowing him to continue his studies in anatomy which involved dissecting cadavers, a practice normally forbidden by Papal decree, but possibly in this

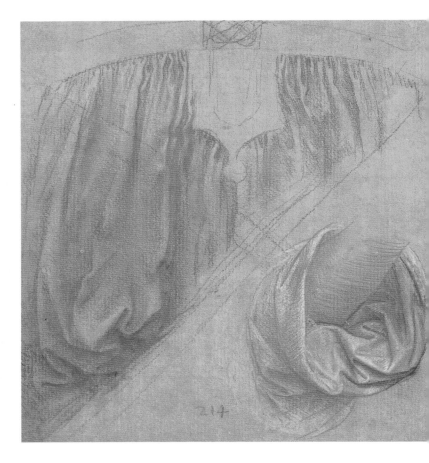

case allowed since the Church believed Leonardo to be searching for the seat of the soul. Nevertheless in his letters to Lorenzo de Medici, Leonardo realized his studies were being misinterpreted: it appears rumors were being spread by one of Leonardo's servants, one Maestro Giorgio, that Leonardo was a sorceror, rumors which ultimately convinced the Pope to ban all further dissections.

Of the commissions he did receive, one which interested Leonardo greatly was the project for draining the Pontine Marshes around Rome. By transforming the Afonte river into a controlled canal system, the marshes could be drained and the land reclaimed for urgently required building.

When Pope Leo finally awarded Leonardo with a commission for a minor painting, he noted that he never expected the work to be finished. According to Vasari, when the Pope learnt that Leonardo was experimenting with varnishes, the Pope is said to have commented that Leonardo would never complete the painting since he was thinking about the end of the project before he had even started painting it.

While Michelangelo was viewed as being a master of both painting and sculpture, Leonardo was seen as an able engineer, and in Rome, now the center of artistic production in Italy, the powers and the patrons in the city were interested less in intellectual matters and more in immortalising themselves in displays of opulence and beauty.

It is very difficult to determine exactly what paintings Leonardo was working on after 1510, apart from continuing to re-work the *Mona Lisa*, and presumably, the *Leda*. Some red chalk drawings certainly date from 1510 or after and may be studies for a 'Christ à demi-corps'

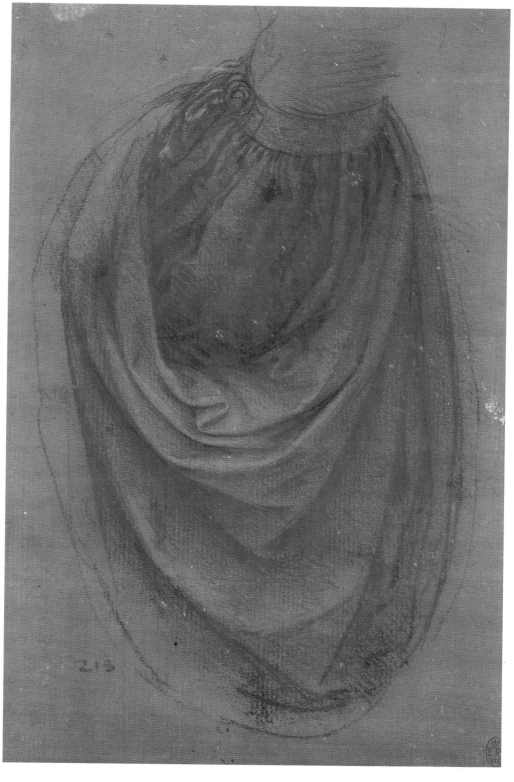

recorded as being at Fontainebleau in 1642. Several versions of a *Salvator Mundi*, a hieratic figure of Christ with a globe in one hand and the other hand raised, must be copies of the painting for which the drawings are preliminary studies. More convincing as a work at least partly by Leonardo is the *Saint John-Bacchus* (page 91) in the Louvre. This work is largely by a pupil of Leonardo's but was based quite closely on a very fine red chalk drawing by Leonardo that was formerly in a mountain monastery in Varese. The drawing is of a seated St John figure and the transformation to a Bacchus – the reasons for which we can only speculate – was achieved by the addition of a crown of vine-leaves and a leopard skin.

Before his stay in Rome, between 1511 and 1513 Leonardo lived and worked at the villa of his lifelong friend Francesco Melzi at Vaprio d'Adda. Leonardo was already familiar with the area from his earlier stay in 1508 and from his studies for the canalization of the river Adda to provide a navigable waterway between Milan and Lake Como. Furthermore, the Villa Melzi was quite accessible from Milan being only twenty miles from the city. As a guest of the Melzi family, Leonardo was to be involved in the projected enlargement of the villa. Leonardo's drawings of the villa show a ground plan with parts of the interior and exterior. Notes indicate that the garden was to be reached from the ground floor of the house or via the cellar. The gardens with terraced slopes facing the river Adda would provide a pleasant view, while the villa itself was to have corner rooms topped by cupolas. The terraces and the stairs were

eventually built, but the wings, pavilion and the gardens were never constructed. We can only imagine how the scheme might have looked and sounded with its waterfalls and statues.

The year 1515 was to prove another turning point for Leonardo as it would for most of Italy. The first day of the year brought the news of the death of his former patron, Louis XII of France. Succeeding him Francis I set out to regain the Duchy of Milan for France, where the son of Massimiliano Sforza, supported by Swiss infantrymen, had ruled since 1512.

Allied with the Venetians, Francis I quickly took control of Genoa and was victorious in battle in Lombardy against the anti-French League forces which included the Emperor Maximillian, King Ferdinand of Spain, the Swiss Cantons, Massimiliano Sforza and, from July 1515, the troops of Pope Leo X as well. In September, against cavalry, artillery, and some 20,000 Swiss pikemen, Francis won the Battle of Melegnamo (Marignano).

By December 1515 Francis and Pope Leo were secretly having discussions in Bologna and according to statements in the Vatican archives which show he received 33

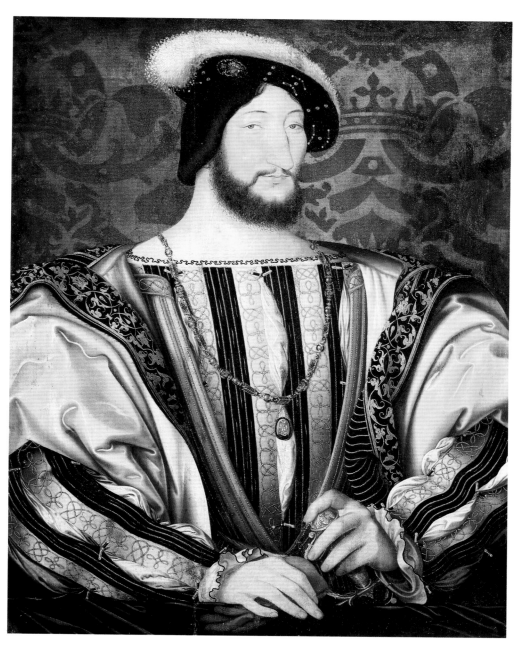

ducats for expenses, Leonardo was in the Pope's retinue. It was in Bologna that he was probably first introduced to the French king – Leonardo was already familiar with him and the earlier French court at Milan and through his work for Charles d'Amboise.

Francis offered Leonardo a pension and a small château at Cloux near Amboise in the Loire valley. With Giuliano de Medici's death in 1516, Leonardo had lost his patron and, faced with disdain the prospect of working for Pope Leo, he entered France with the title 'Foremost Painter and Engineer and Architect to the King of France and Technician to the State of France.' Leonardo was once more a celebrity, adored by the French court whose king visited him in his studio for private discussions.

But at the age of 65, no longer able to paint because of crippling rheumatism and the effects of a stroke, Leonardo continued to design pageants, canal systems and even royal residences.

In September 1517 for the celebrations held by Marguerite d'Angoulême at Argenton, Leonardo devised a mechanical lion, which, when struck on the chest, opened its mouth to reveal a display of fleurs-de-lys, the emblem of France. In May 1518 he staged a mock battle at Amboise to celebrate the marriage of Lorenzo de Medici (Leo X's nephew) to Madeleine de la Tour d'Auvergne (the niece of Francis I).

Between 1516 and 1518 Leonardo also drew up plans for the Queen Mother's palace at Romorantin. Although never carried out, the plans are interesting in that they prefigure in many ways French architecture of the seventeenth century. It is also believed that Leonardo set out to make practical improvements to Francis's castle at Amboise. While there are no notes or sketches to provide evidence of any designs by Leonardo, there is an odd spiral staircase at Blois which winds from left to right. It has been suggested that this could have been designed by a left-handed architect, or by one who had lost the use of his right hand, as Leonardo had after a stroke.

Now in declining health and after a hard winter, on 23 April 1519 Leonardo dictated his last will and testament to a royal notary at Amboise.

Leonardo da Vinci died on the 2 May 1519 and was buried the following August in the monastery of Saint Florentine in Amboise. But this would not be his final resting place: his mortal remains were to be scattered during the Wars of Religion.

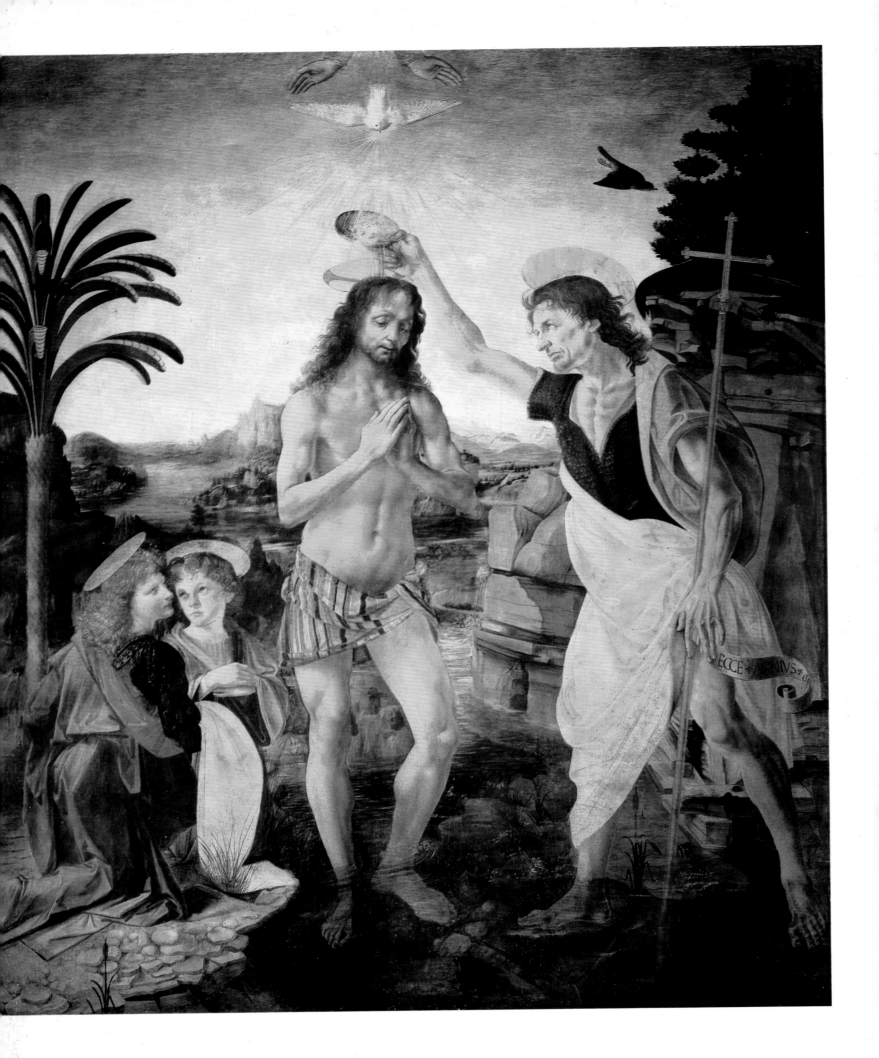

ABOVE: Andrea del Verrocchio (c. 1435-88) *Baptism of Christ*,
c. 1473-78, oil on wood panel, 69⅝ × 59½ inches (177 × 151 cm)
Galleria degli Uffizi, Florence.

RIGHT: One of Leonardo's earliest painted works is the head of the
angel from Verrocchio's *Baptism of Christ*.

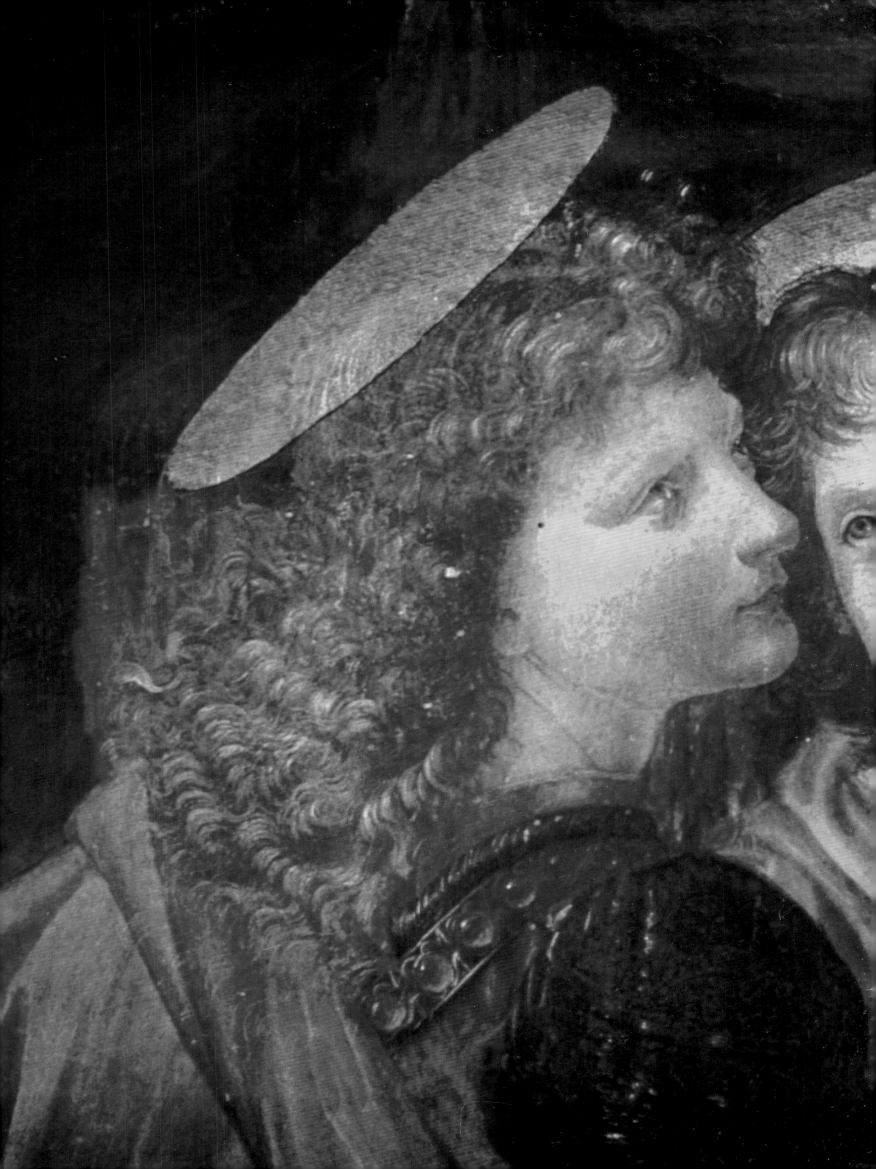

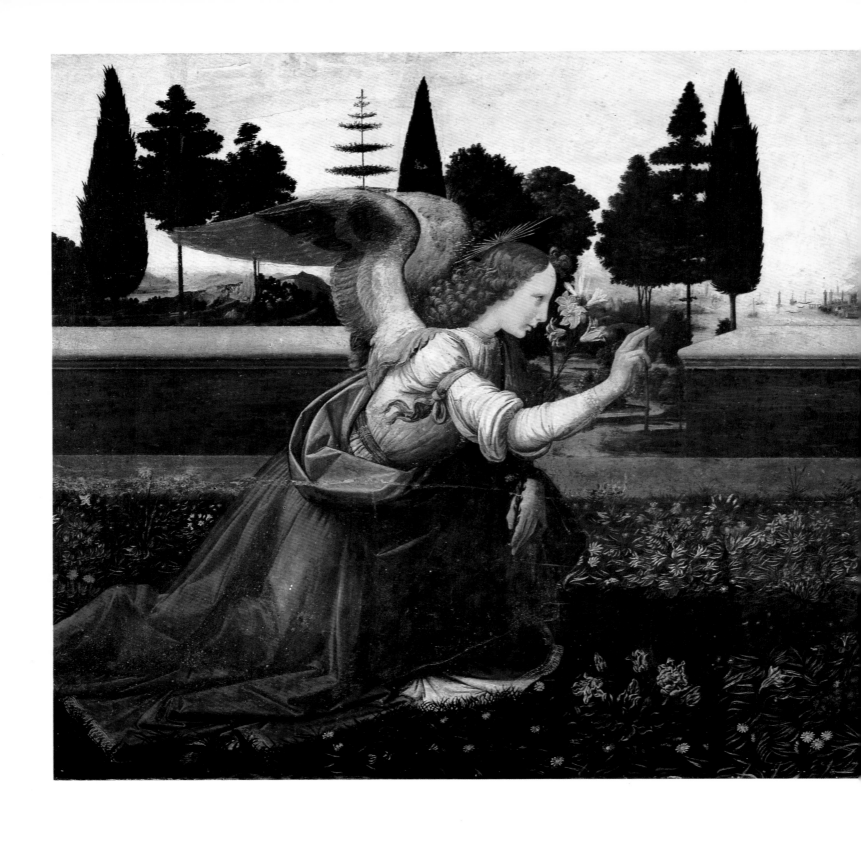

Annunciation, c. 1473, oil on wood panel, 38⅜ × 85½ inches
(98 × 217 cm), Galleria degli Uffizi, Florence.

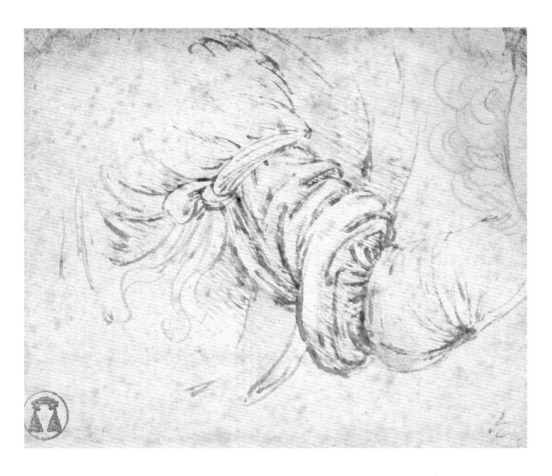

LEFT: *Study of a Sleeve*, c. 1473, pencil and brown ink, 3¼ × 3⅝ inches (8.2 × 9.3 cm), Courtesy of the Governing Body, Christ Church, Oxford. This is almost certainly a study for the right sleeve of the angel in the Annunciation (pages 38-9).

BELOW: *Study of the Drapery of a Figure Kneeling to the Right*, c. 1473, Cabinet des Dessins, Musée du Louvre, Paris.

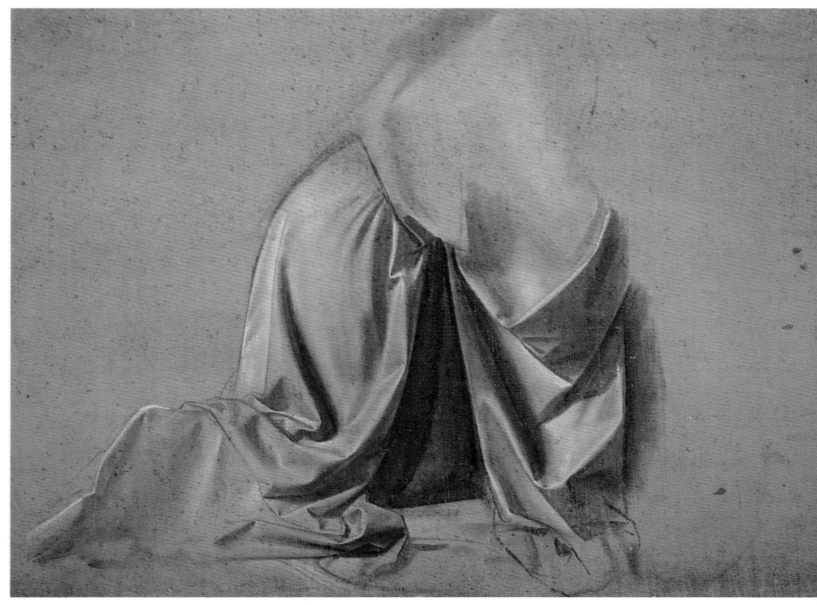

BELOW: *Study of the Drapery of the Legs of a Seated Figure*, c. 1473, brush on linen, heightened with white, 10⅜ × 9 inches (26.3 × 22.9 cm), Musée du Louvre, Paris. This drawing is similar to the legs of the Virgin in the Annunciation (pages 38-9) but is not a direct study for the painting.

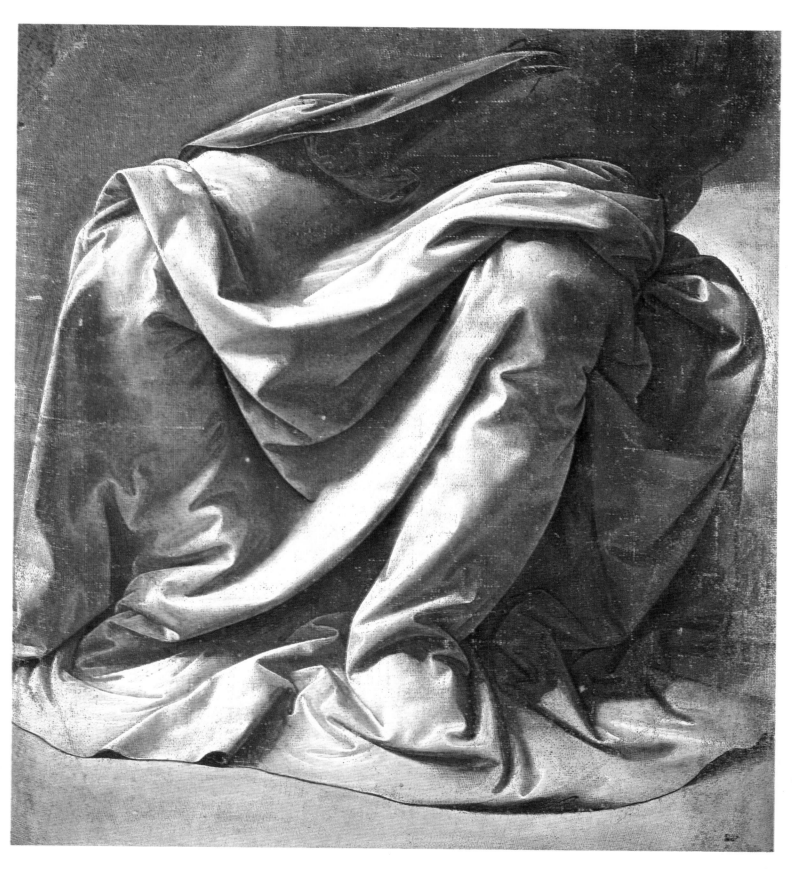

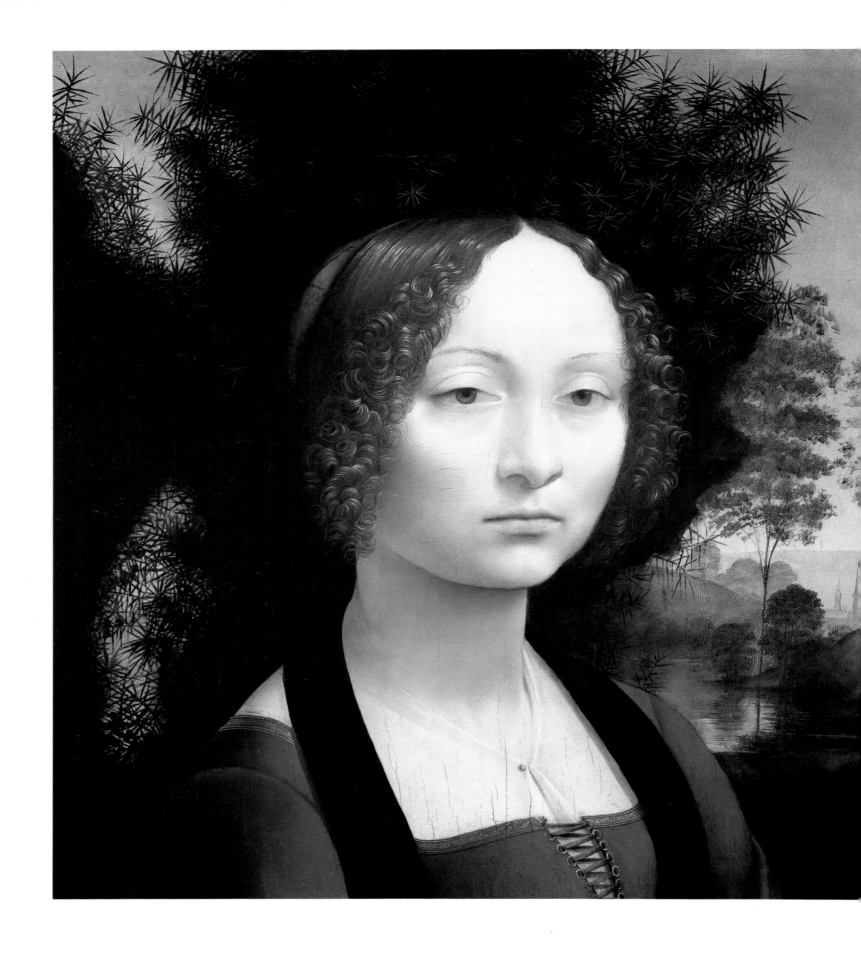

ABOVE: *Portrait of Ginevra de' Benci*, c. 1476, oil on wood panel, 15¼ × 14½ inches (38.8 × 36.7 cm), National Gallery of Art, Washington (Ailsa Mellon Bruce Fund).

RIGHT: *Study of a Woman's Hands*, c. 1476, silverpoint on pink prepared paper, 8½ × 6 inches (21.5 × 15 cm), Windsor Castle, Royal Library, 12558. © 1993 Her Majesty The Queen.

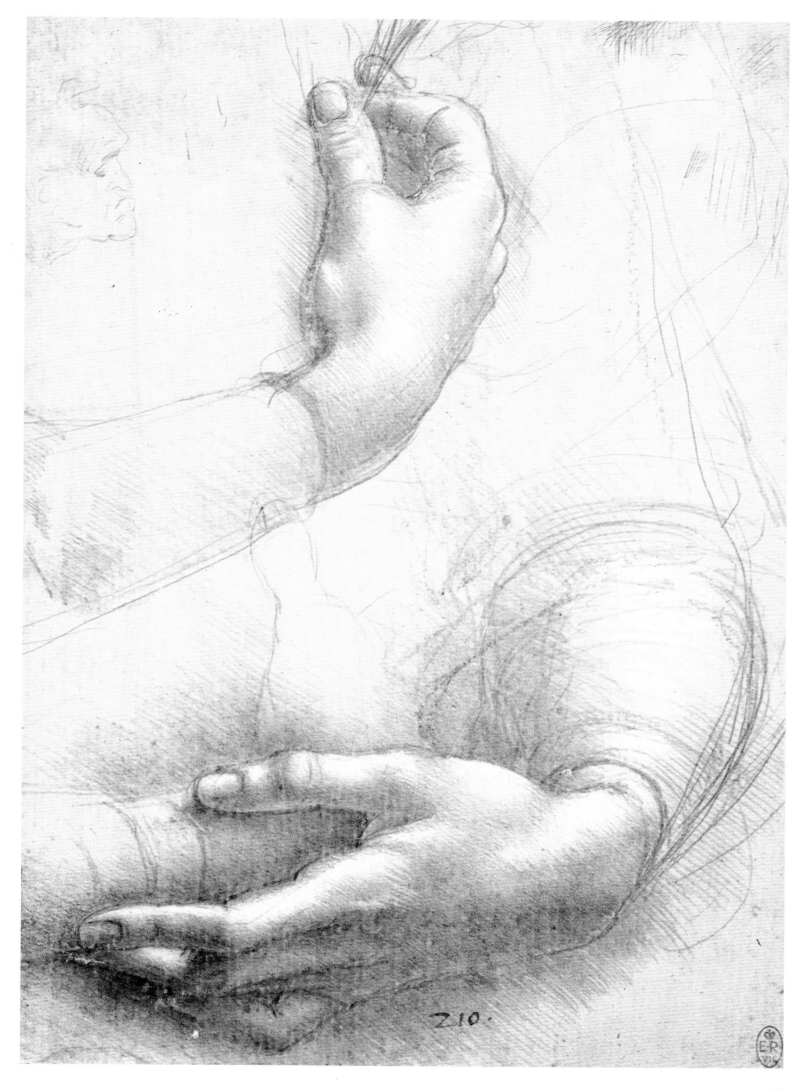

210.

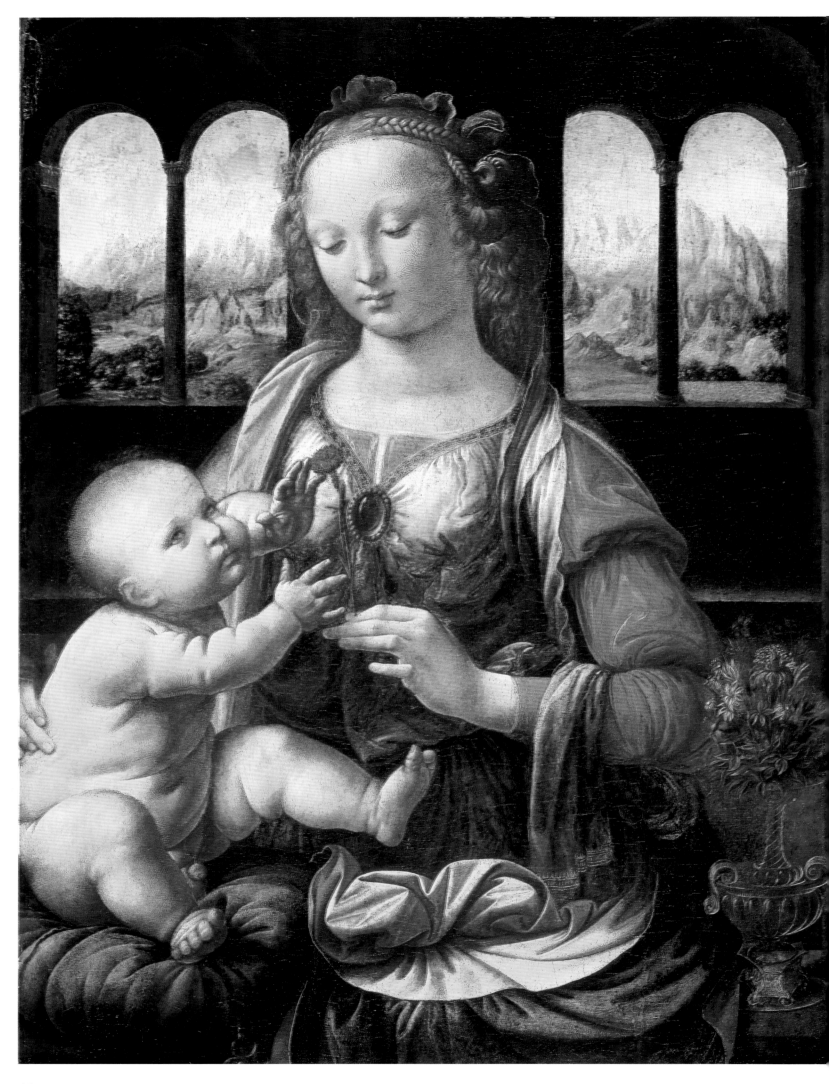

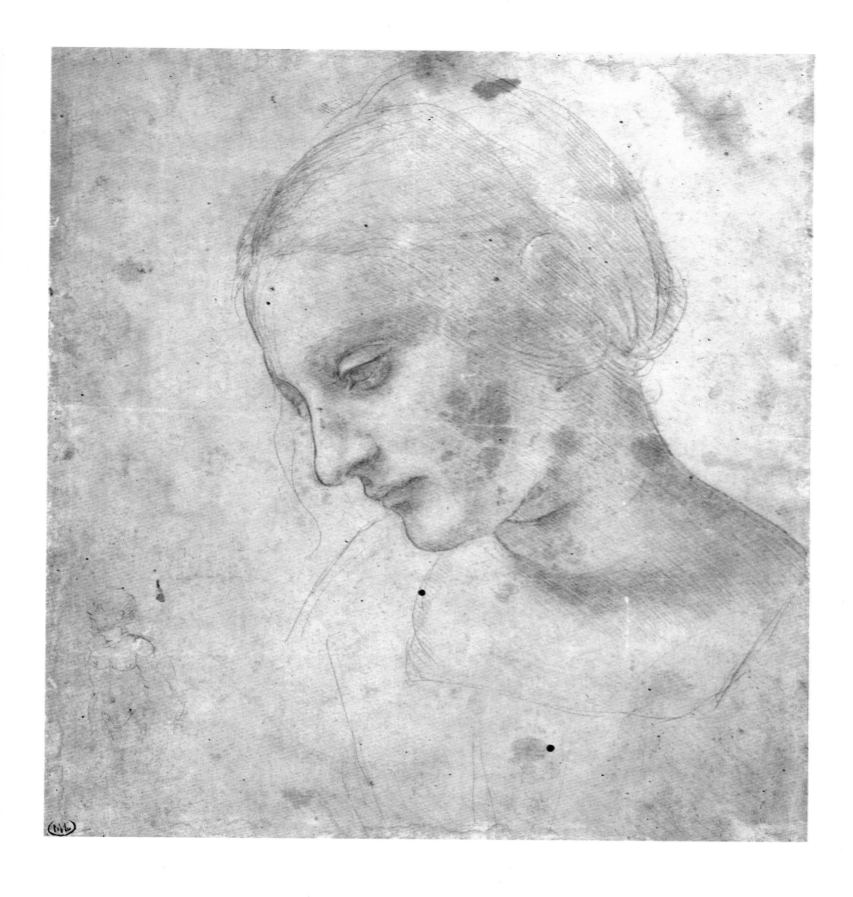

ABOVE: *Head of a Woman Looking Down,* c. 1476, silverpoint on
greenish prepared paper, 7 × 6⅝ inches (18 × 16.8 cm), Cabinet des
Dessins, Musée du Louvre, Paris.

LEFT: *Madonna and Child with a Vase of Flowers,* c. 1475, oil on wood
panel, 24½ × 18¾ inches (62 × 47.5 cm), Alte Pinakothek, Munich.

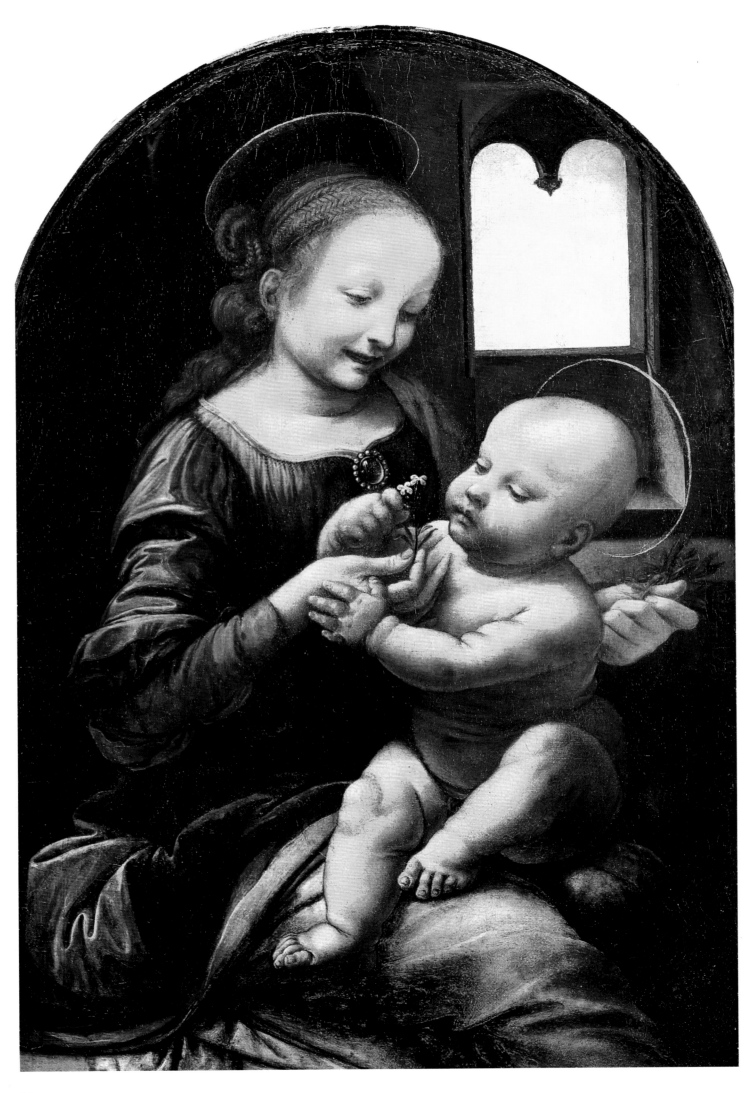

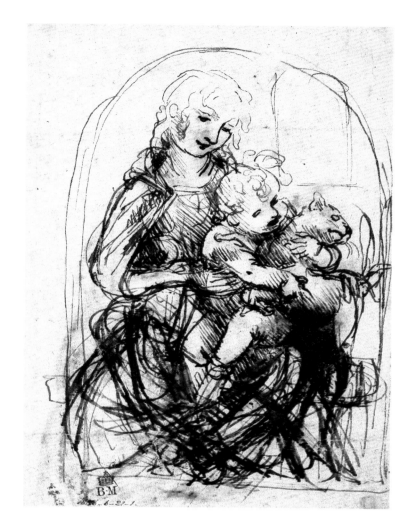

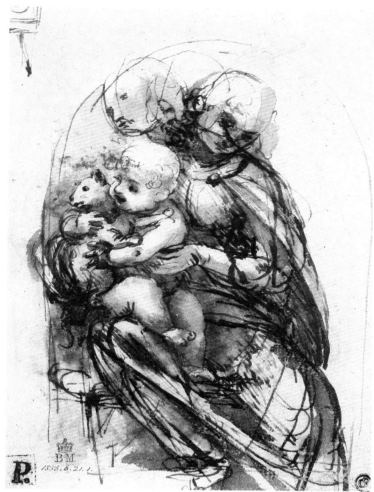

ABOVE: *Madonna and Child with a Cat*, c. 1478, pen and ink, 5³⁄₁₆ × 3¾ inches (13.2 × 9.5 cm), Courtesy of the Trustees of the British Museum, London.

ABOVE RIGHT: *Madonna and Child with a Cat*,, c. 1478, pen, ink and wash, 5³⁄₁₆ × 3¾ inches (13.2 × 9.5 cm), Courtesy of the Trustees of the British Museum, London. The two drawings appear on either side of one sheet of paper. The righthand drawing appears to have been pressed through from the other side with a stylus, then inked and washed in.

LEFT: *Benois Madonna*, c. 1478, oil on wood panel, 18⁷⁄₈ × 12¼ inches (48 × 31 cm), Hermitage Museum, St Petersburg.

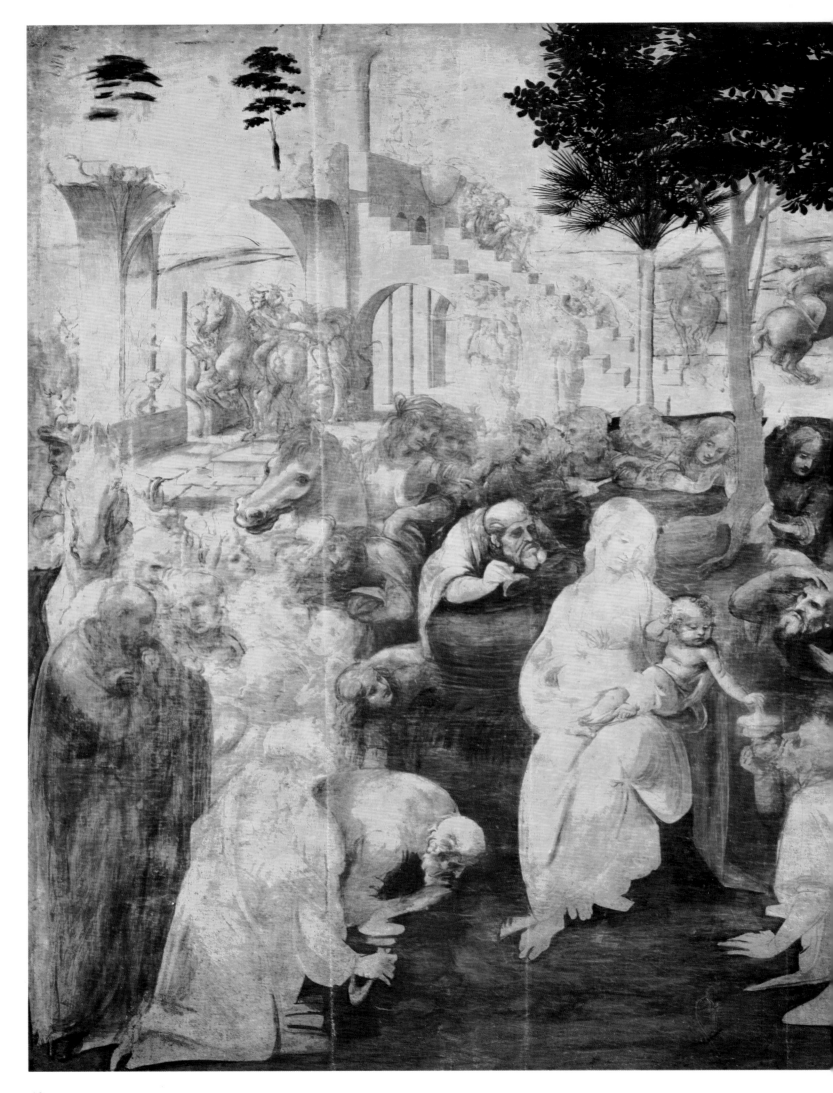

LEFT: *Adoration of the Magi*, 1481, oil on wood panel, 96⅞ × 95⅝ inches (246 × 243 cm), Galleria degli Uffizi, Florence. Leonardo left this painting, commissioned as an altarpiece by the monks of San Donato a Scopeto in Florence, unfinished when he left for Milan in 1481 or 1482.

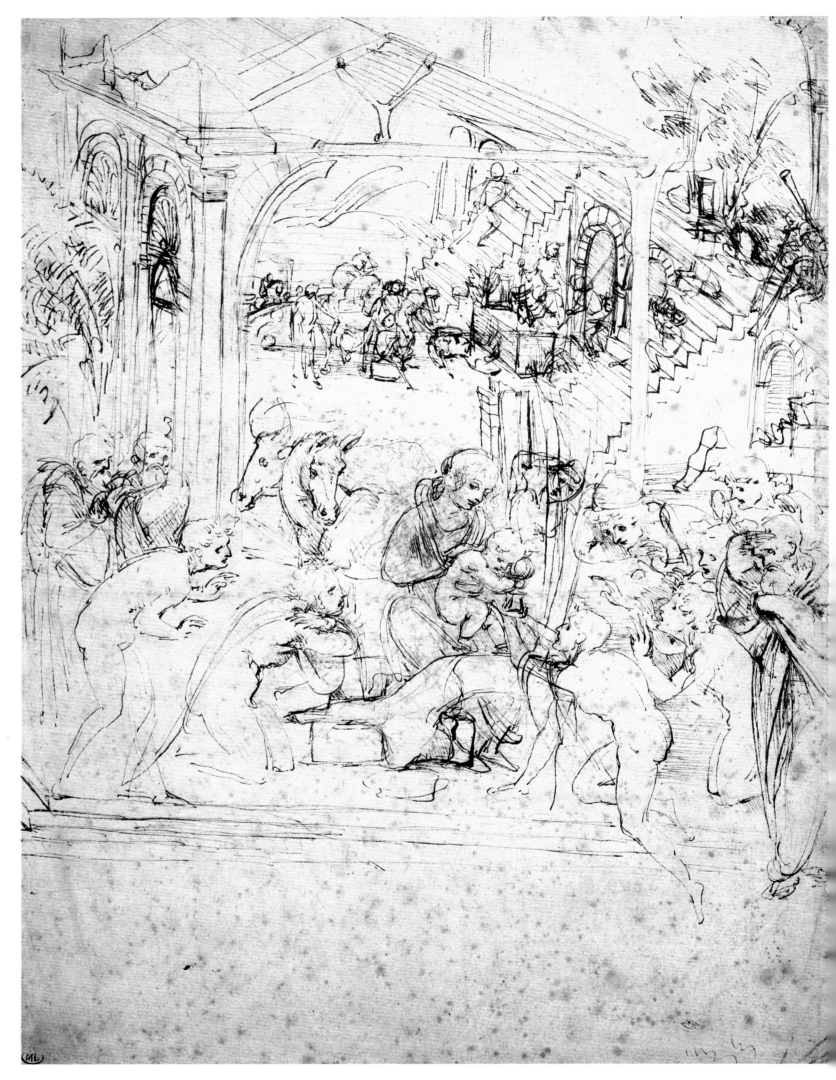

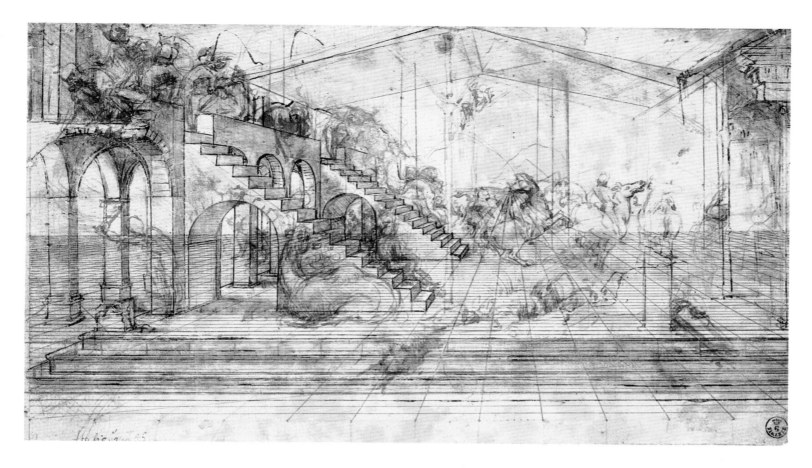

ABOVE: *Perspective Study for the Background of the Adoration of the Magi*, c. 1481, pen and ink over metalpoint with wash, 6½ × 11½ inches (16.5 × 29 cm), Galleria degli Uffizi, Florence.

LEFT: *Compositional Sketch for the Adoration of the Magi*, c. 1481, pen and ink over metalpoint, 11¼ × 8½ inches (28.5 × 21.5 cm), Cabinet des Dessins, Musée du Louvre, Paris.

PAGE 52: *St Jerome*, c. 1481, oil on wood panel, 40½ × 29½ inches (103 × 75 cm), Vatican Museum, Rome. This painting was rediscovered in two parts in the nineteenth century.

PAGE 53: *Madonna of the Rocks*, c. 1483, oil on wood transferred to canvas, 78⅜ × 48 inches (199 × 122 cm), Musée du Louvre, Paris.

PAGE 54: *Lady with an Ermine (Cecilia Gallerani)*, c.1485, oil on wood panel, 21½ × 15⅜ inches (54 × 39 cm), Czartoryski Museum, Kraków.

PAGE 56: Portrait of a Musician, c. 1485 oil on wood panel, 17 × 21¼ inches (43 × 31 cm), Pinacoteca Ambrosiana, Milan. This is possibly a portrait of the court musician Franchino Gaffurio (1451-1522) and the only portrait by Leonardo of a man.

PAGE 56: *La Belle Ferronière*, c. 1495, oil on wood panel, 24¾ × 17¾ inches (63 × 45 cm), Musée du Louvre, Paris. This is reputed to be a portrait of Ludovico Sforza's mistress of the 1490s, Lucrezia Crivelli.

PAGE 57: *Madonna of the Yarnwinder*, c. 1501, oil on wood panel, 18¼ × 14¼ inches (46.4 × 36.2 cm). In the collection of the Duke of Buccleuch and Queensbury, KT, Drumlanrig Castle, Dumfriesshire.

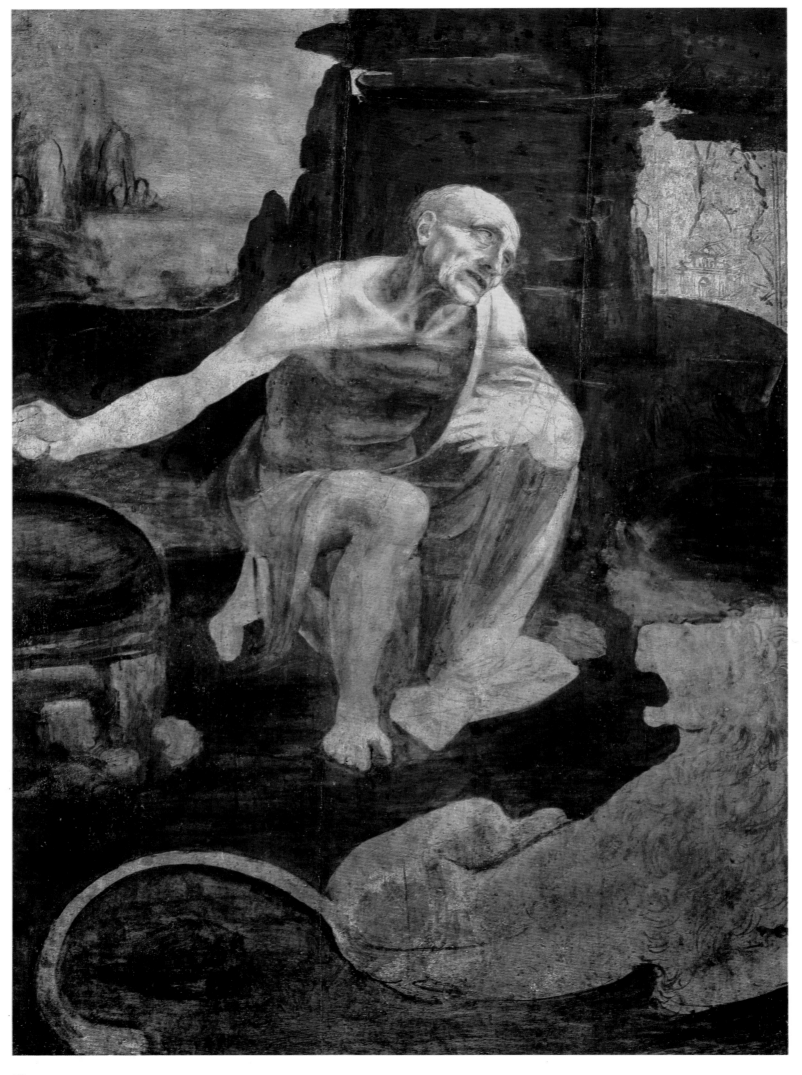

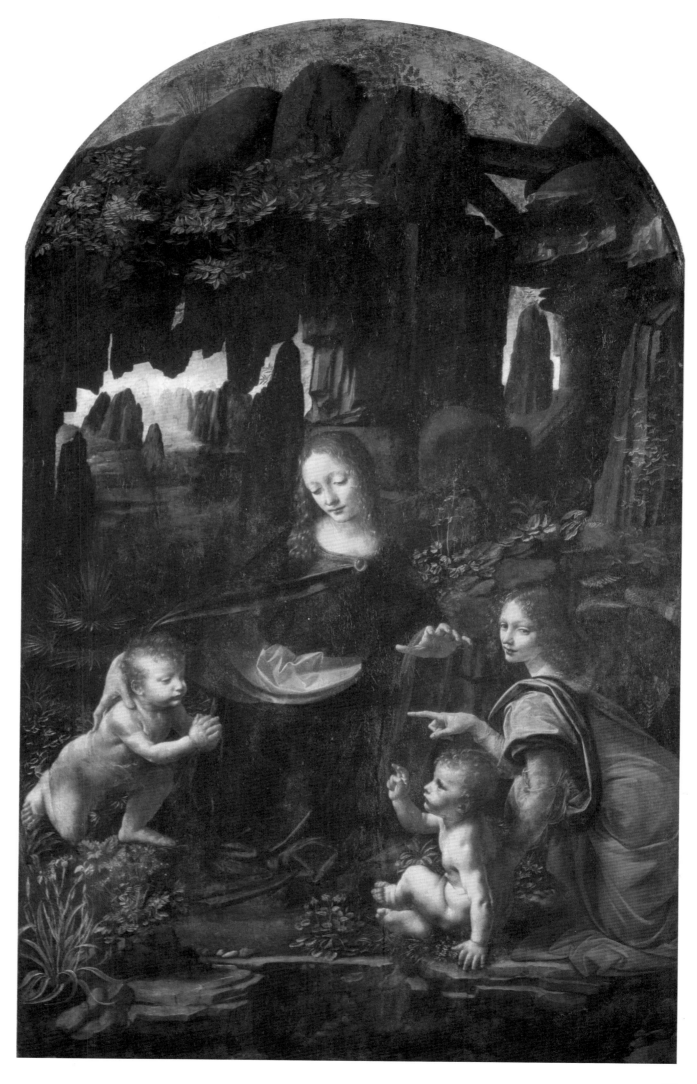

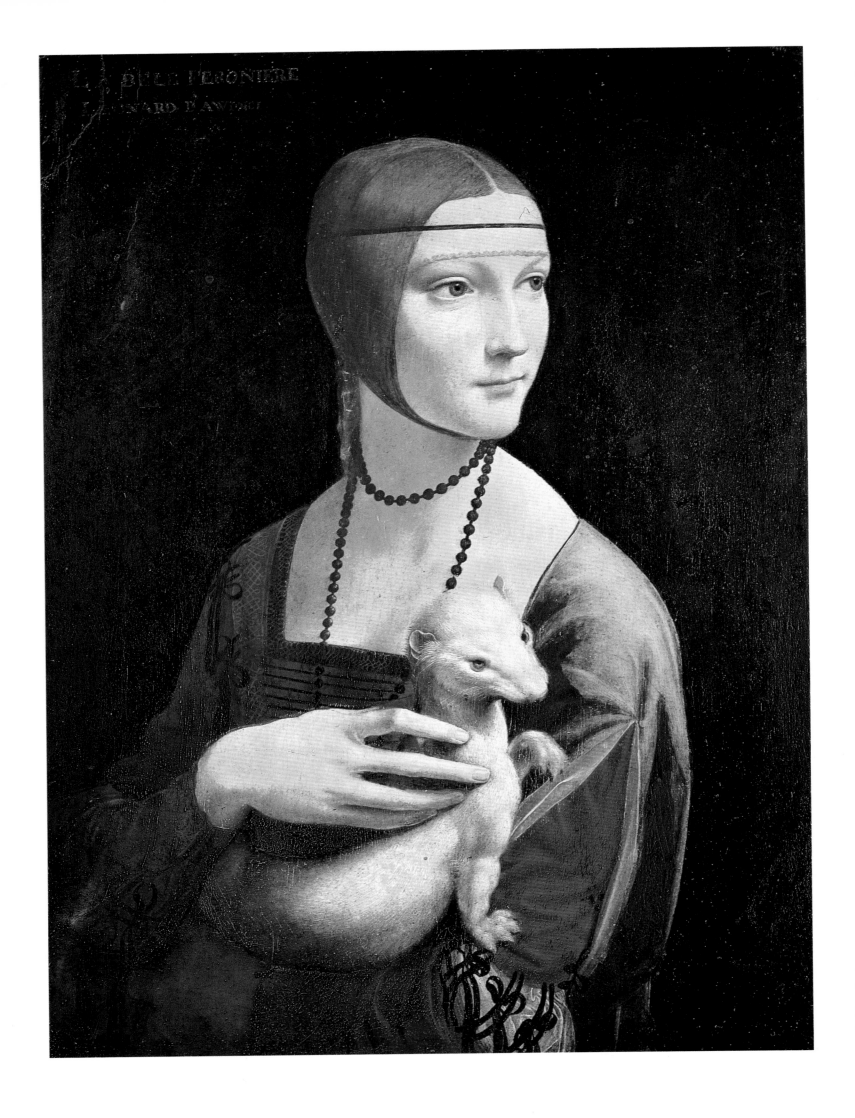

54

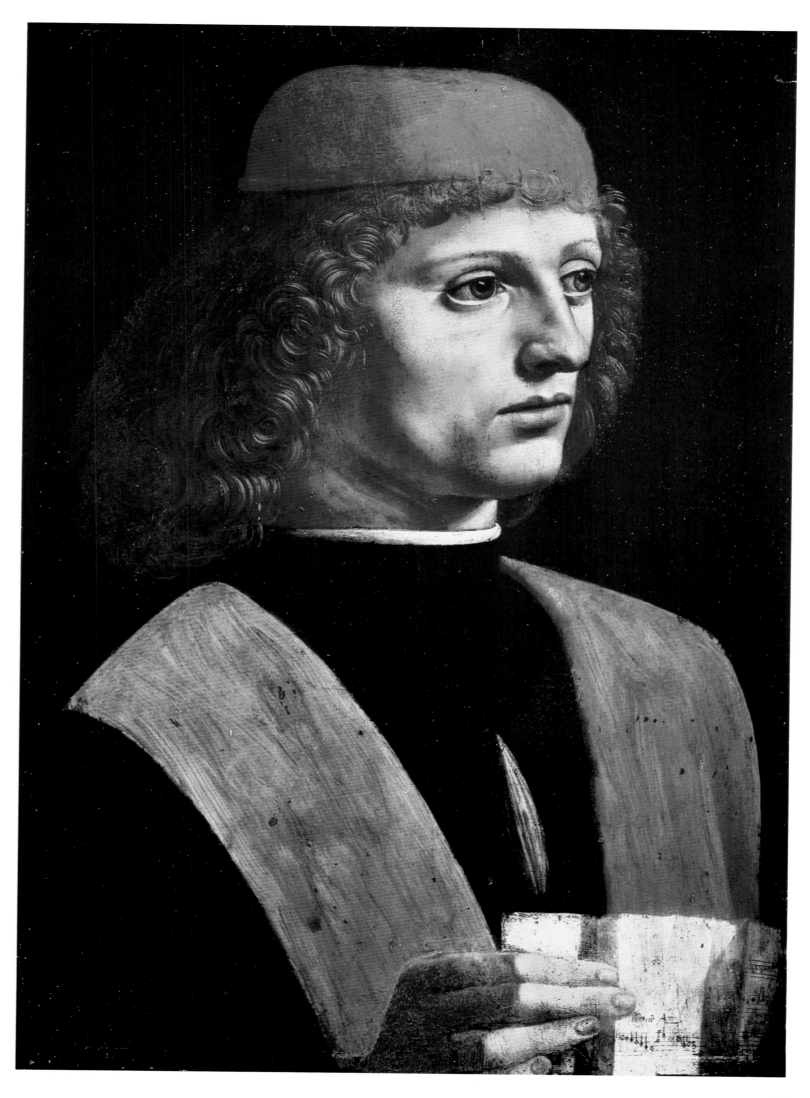

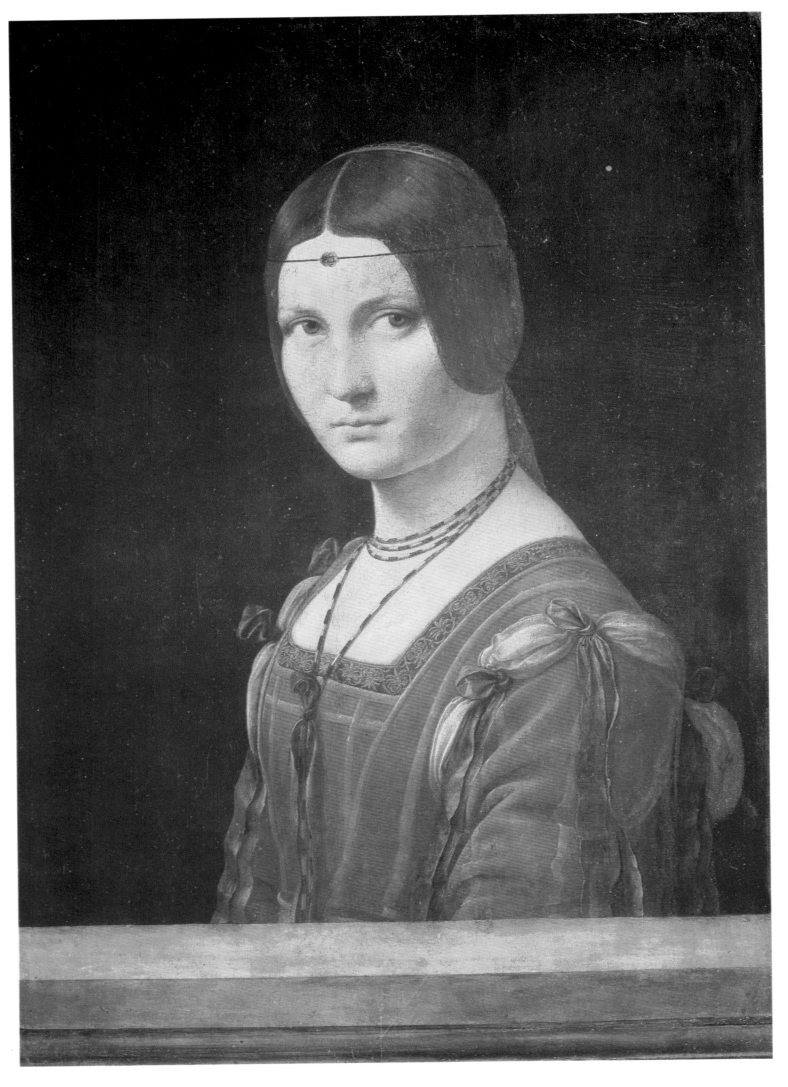

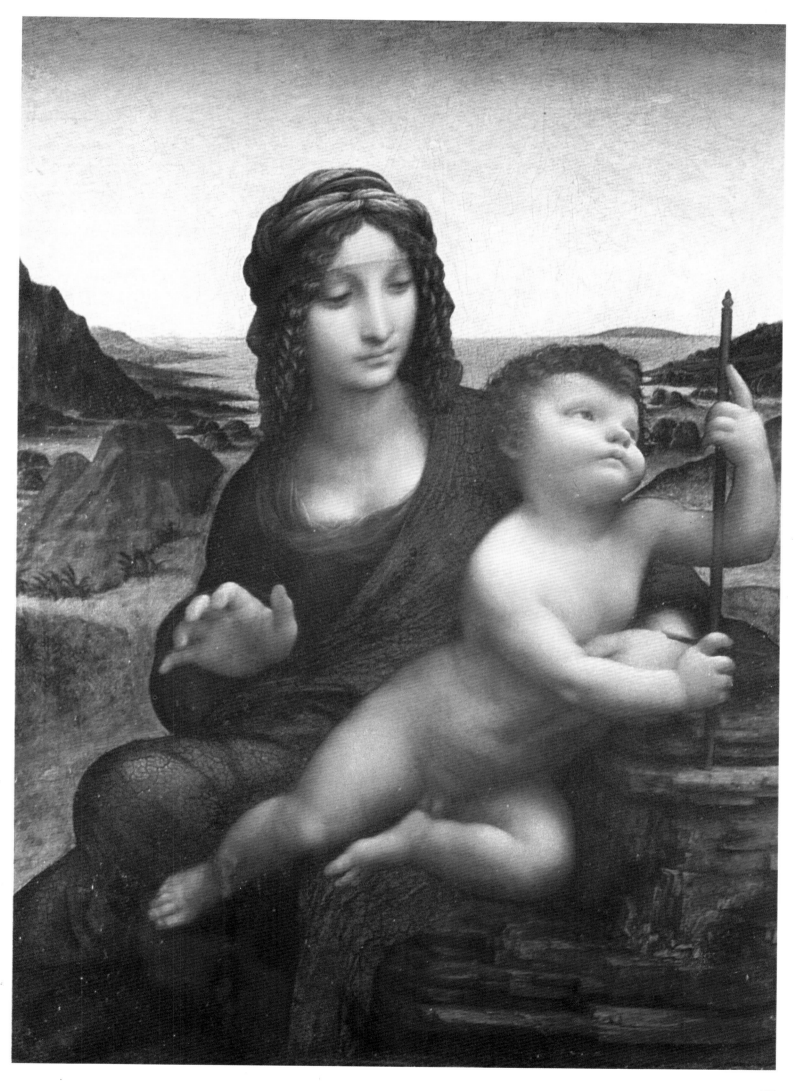

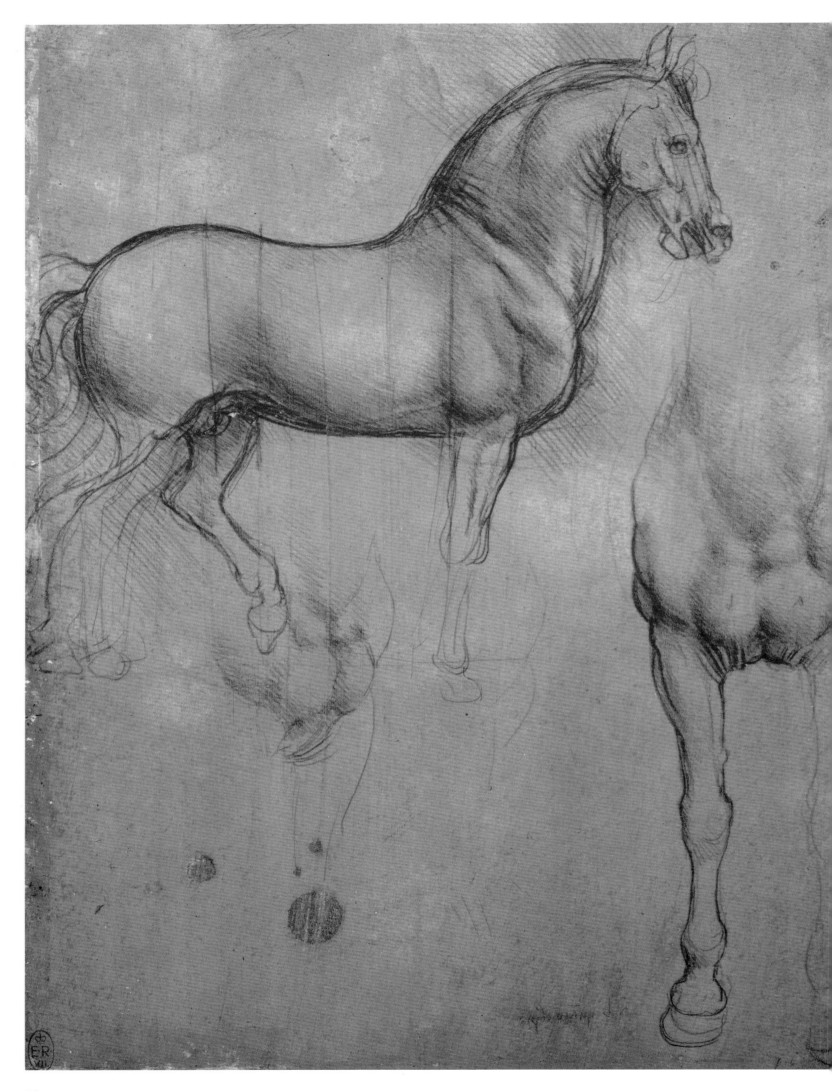

58

LEFT: *A Horse in Profile to the Right and its Forelegs,* c. 1497, silverpoint on blue prepared paper, 8½ × 6¼ inches (21.4 × 16 cm), Windsor Castle, Royal Library 12321. © 1993 Her Majesty The Queen. Leonardo made such studies to further his knowledge of anatomy and as preparatory drawings for the 'Great Horse' monument to Francesco Sforza.

RIGHT: *Study of a Horseman on a Rearing Horse,* c. 1490, silverpoint on blue prepared paper, Windsor Castle, Royal Library 12357. © 1993 Her Majesty The Queen. This is almost certainly a study for the Sforza monument on which Leonardo worked for several years in the 1480s and 1490s.

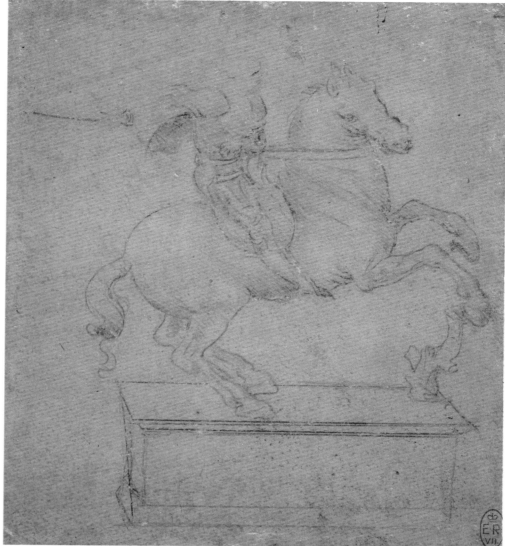

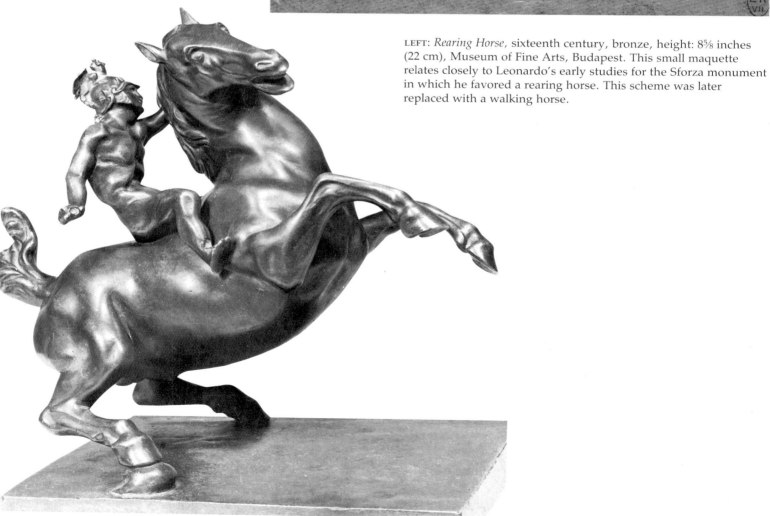

LEFT: *Rearing Horse,* sixteenth century, bronze, height: 8⅝ inches (22 cm), Museum of Fine Arts, Budapest. This small maquette relates closely to Leonardo's early studies for the Sforza monument in which he favored a rearing horse. This scheme was later replaced with a walking horse.

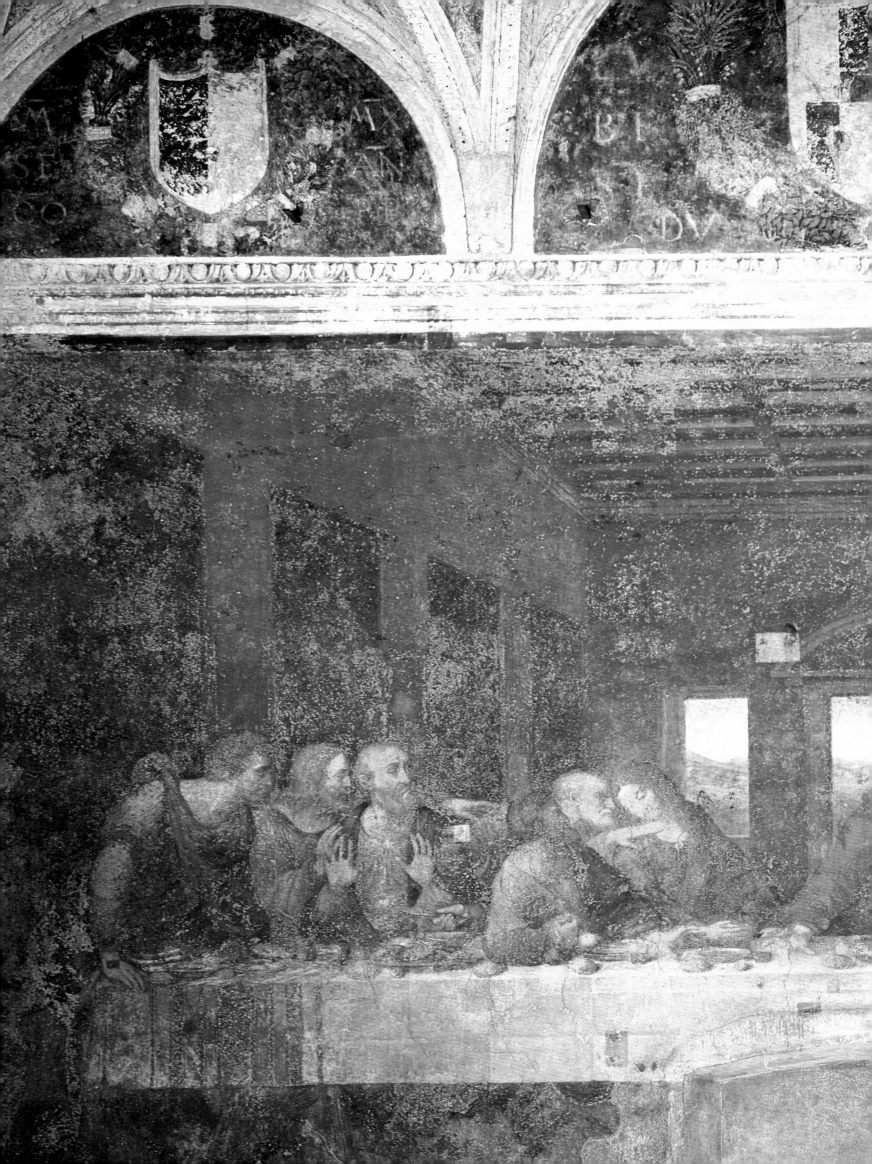

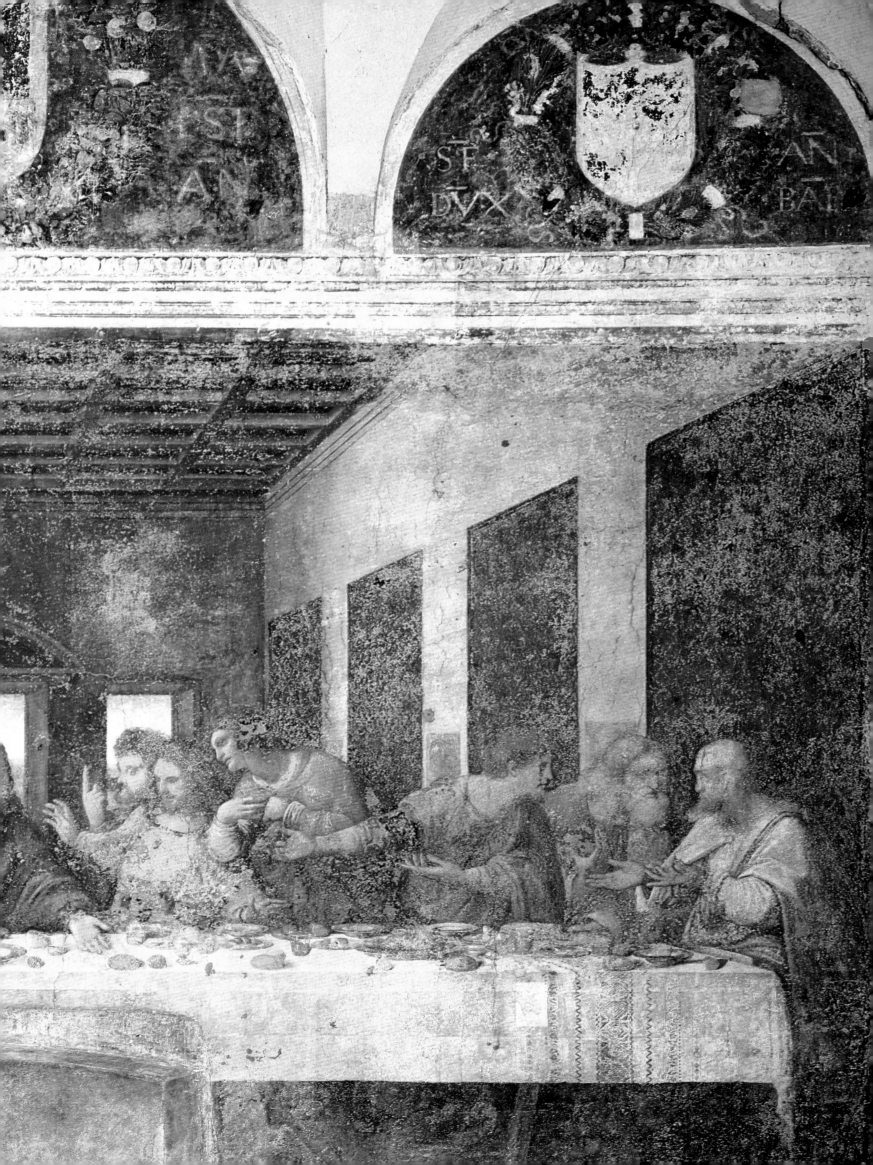

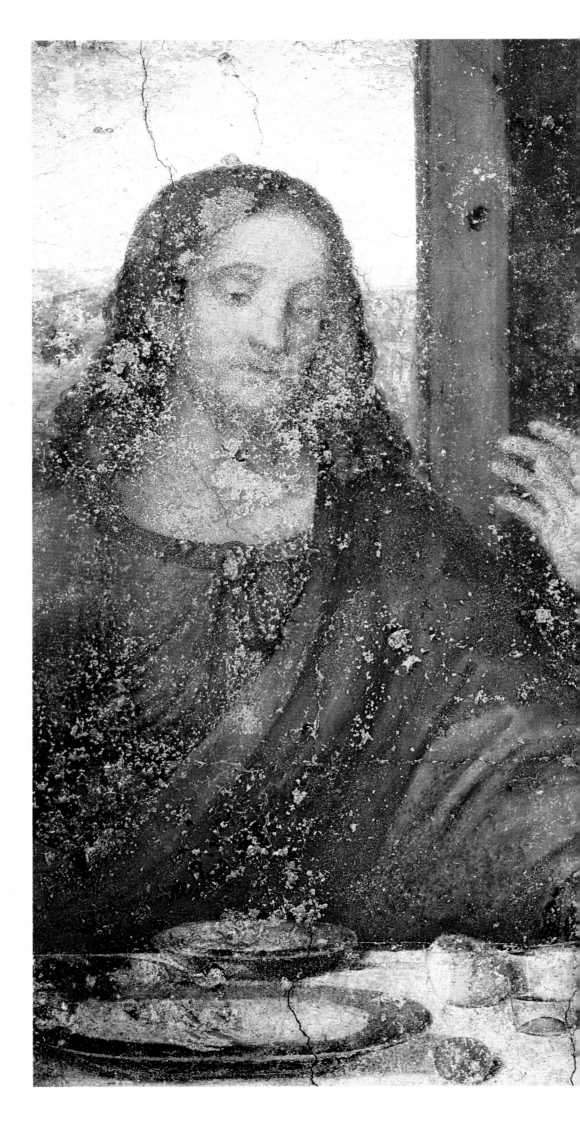

PREVIOUS PAGES: *The Last Supper*, 1495-97, tempera on gesso, pitch, and mastic, 15 feet 1 inch × 28 feet 10½ inches (460 × 880 cm), S Maria delle Grazie, Milan.

RIGHT: Detail from *The Last Supper* showing from left: Christ, Thomas, James the Greater, and Philip.

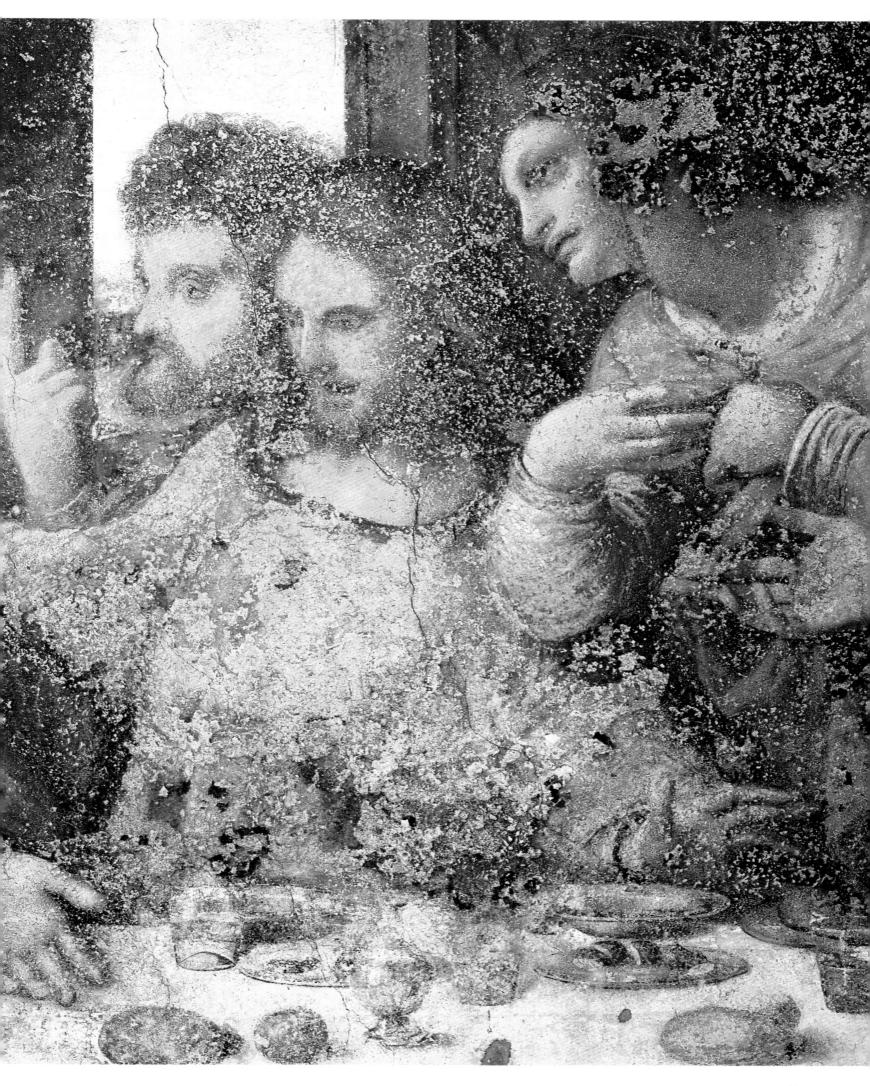

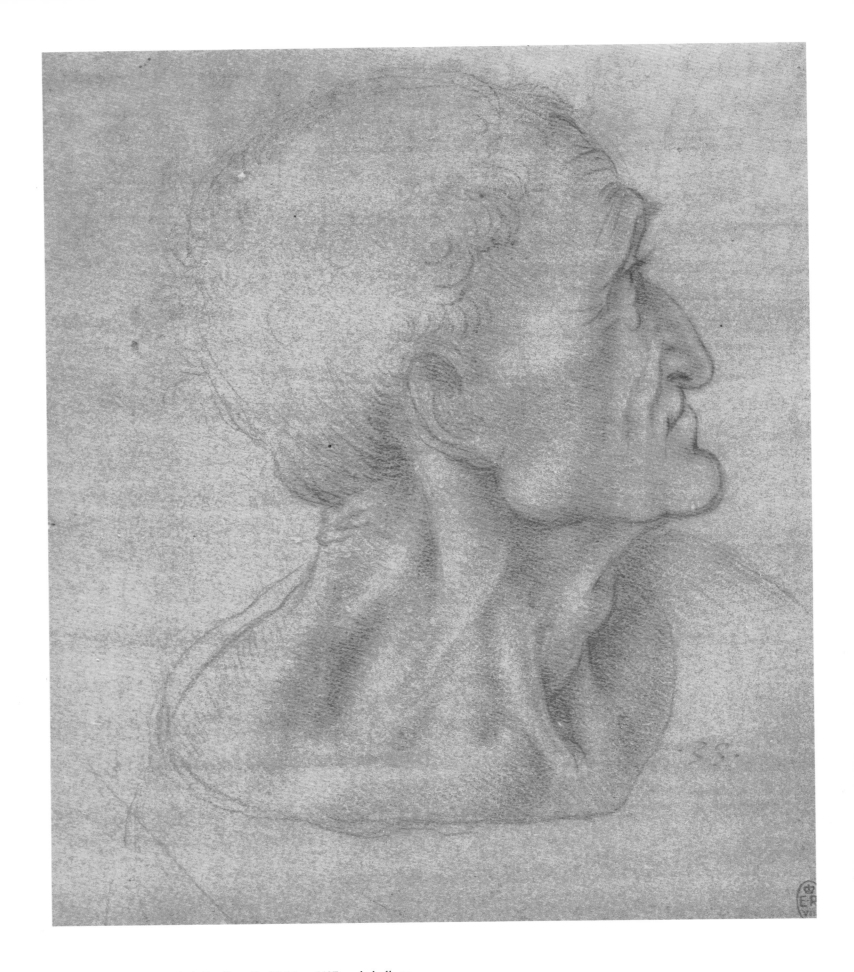

ABOVE: *Head of an Apostle in Profile to the Right*, c. 1497, red chalk on red prepared surface, 7 × 5⅞ inches (18 × 15 cm), Windsor Castle, Royal Library 12547. © 1993 Her Majesty The Queen. This is a study for the shadowy head of Judas in *The Last Supper*.

RIGHT: *Head of an Apostle and Study in Architecture*, c. 1497, red chalk, pen and ink, 10 × 6¾ inches (25.2 × 17.2 cm), Windsor Castle, Royal Library 12552. © 1993 Her Majesty The Queen. This is a study for the head of St James the Greater in *The Last Supper*.

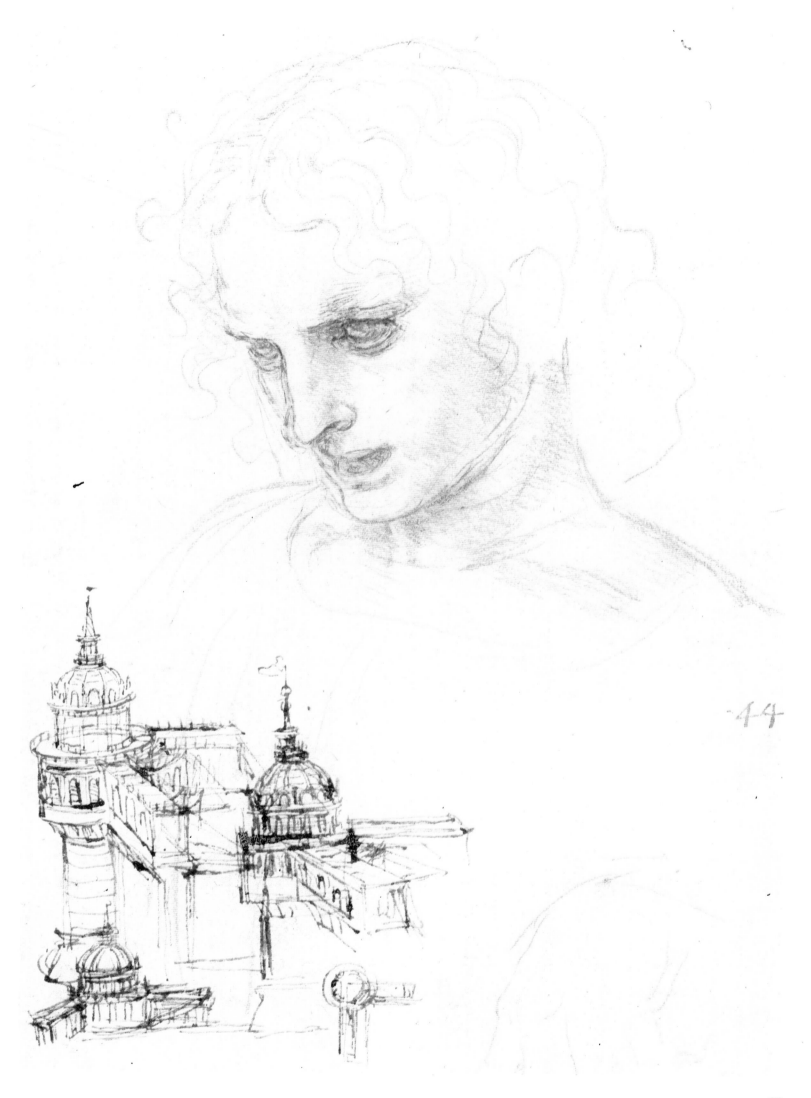

44

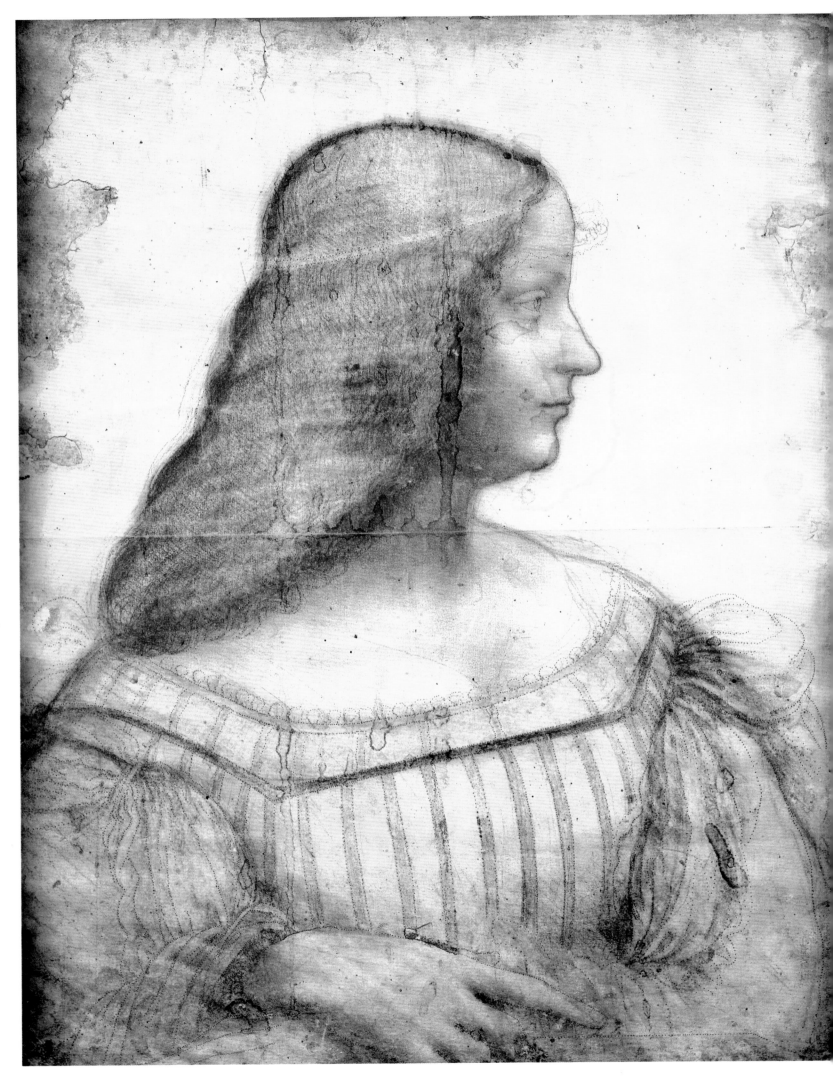

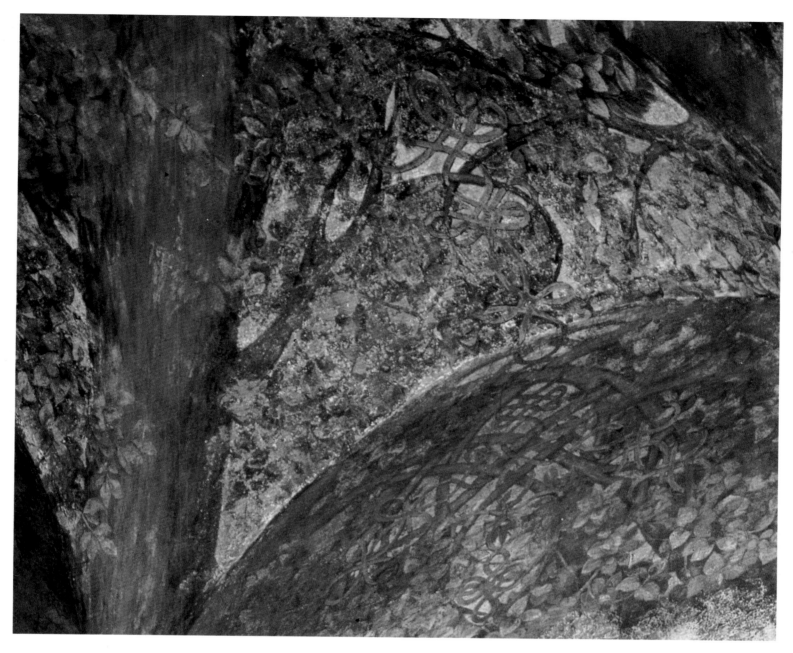

ABOVE: The Sala delle Asse in the Castello Sforzesco in Milan.
These paintings by Leonardo have been heavily restored.
Nonetheless Leonardo's interest in natural forms is evident.
The intertwining of the foliage with a golden thread is also a
representation of a device of Beatrice d'Este, the Duchess of Milan.

LEFT: Leonardo made this drawing of Isabella d'Este during his
brief stay in Mantua in 1500. Cabinet des Dessins, Musée du
Louvre, Paris.

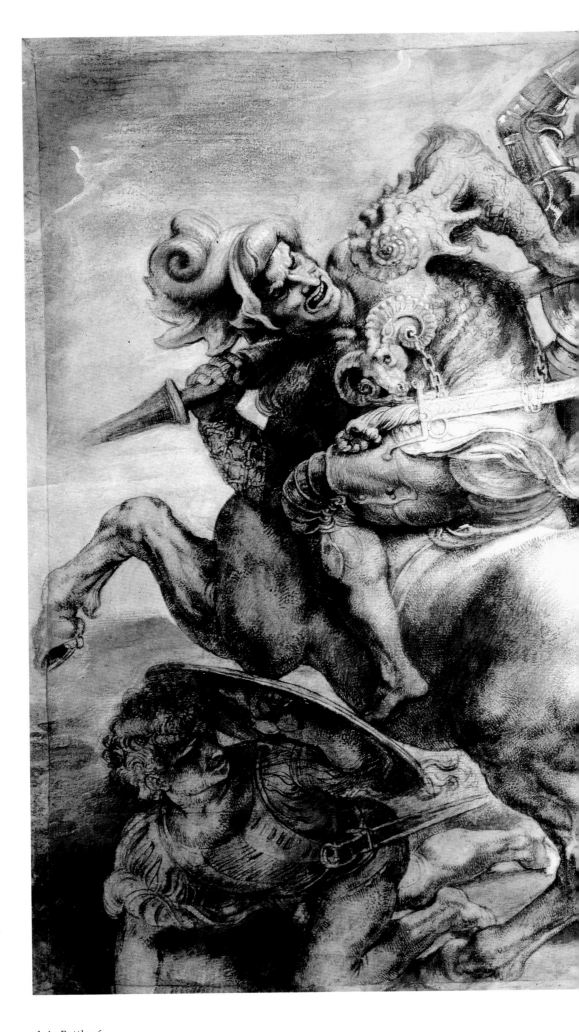

Peter Paul Rubens (1577-1640) copy after Leonardo's *Battle of Anghiari*, c. 1604, black chalk, pen and ink heightened with gray and white, 17¾ × 25 inches (45.2 × 63.7 cm), Cabinet des Dessins, Musée du Louvre, Paris.

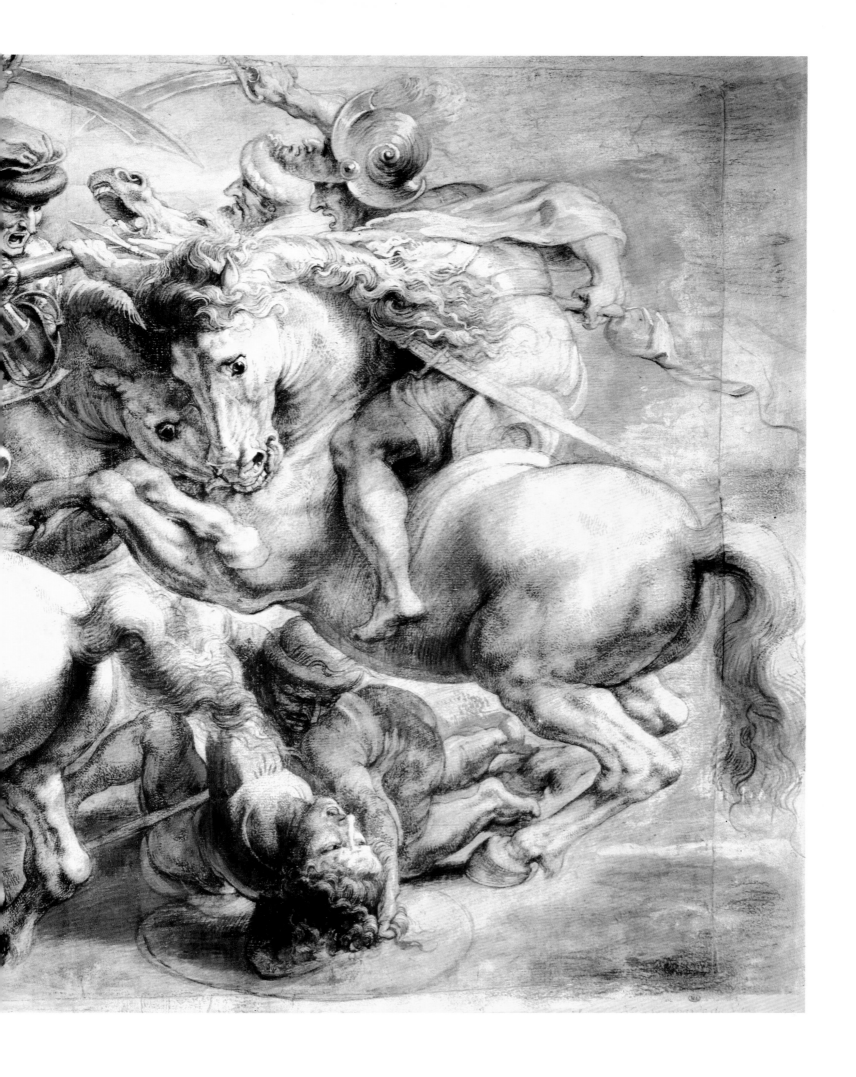

ABOVE: Studies for the central and left groups of the *Battle of Anghiari*, c. 1503-04, pen and ink, 5¾ × 6 inches (14.5 × 15.2 cm) Galleria dell'Accademia, Venice.

RIGHT: Copy of the *Fight for the Standard* from the center of the *Battle of Anghiari*, c. 1550, oil on wood panel, 6 × 8⅜ inches (15.1 × 21.3 cm), Palazzo Vecchio, Florence.

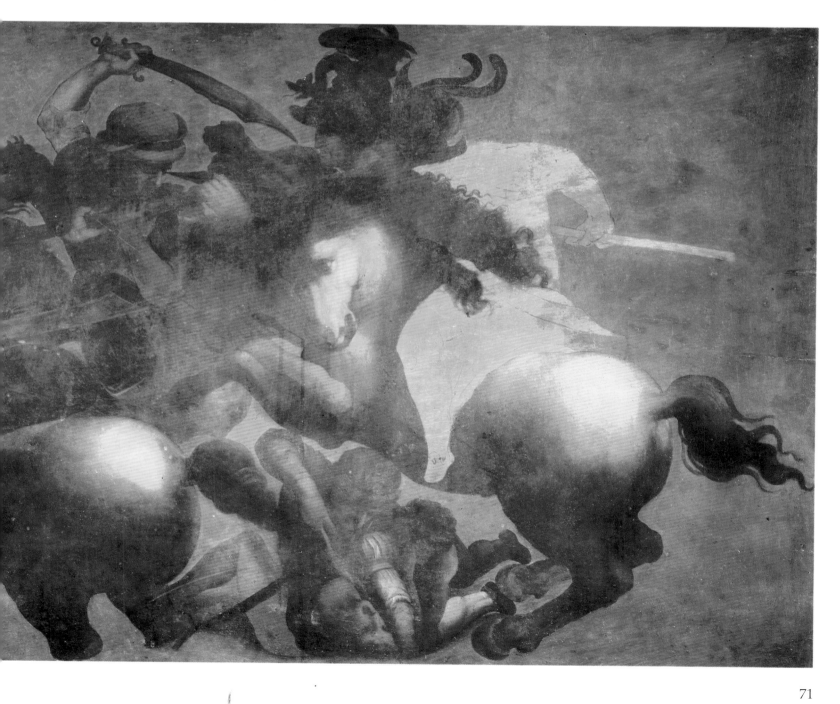

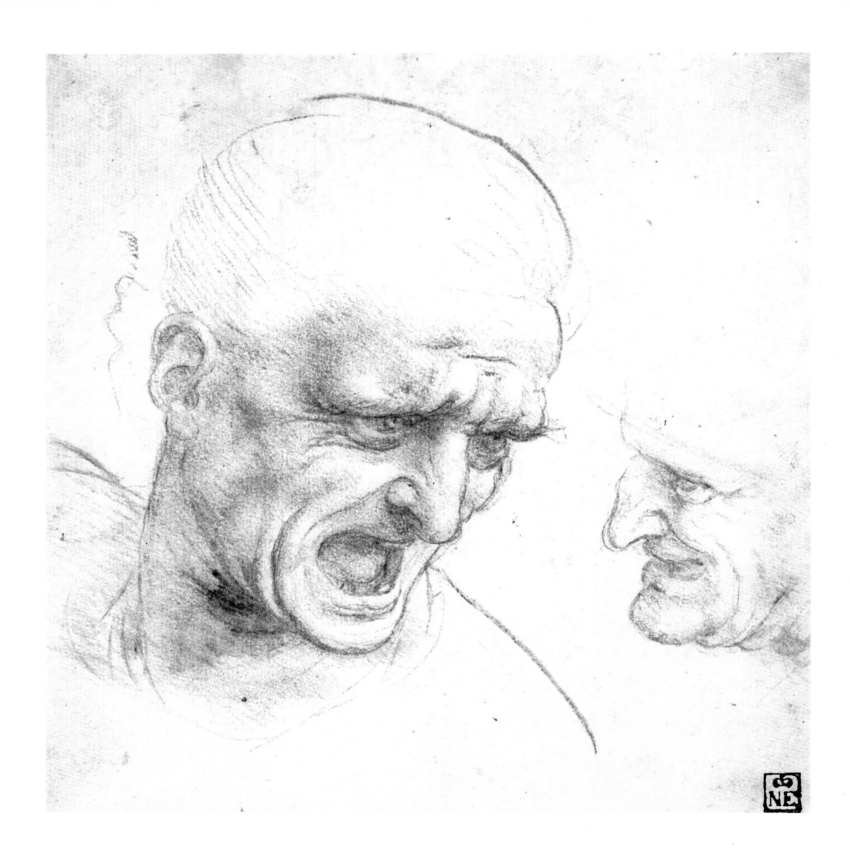

ABOVE: *Head of a Man Shouting*, c. 1505, black and red chalk,
7½ × 7⅜ inches (19.2 × 18.8 cm), Museum of Fine Arts, Budapest.

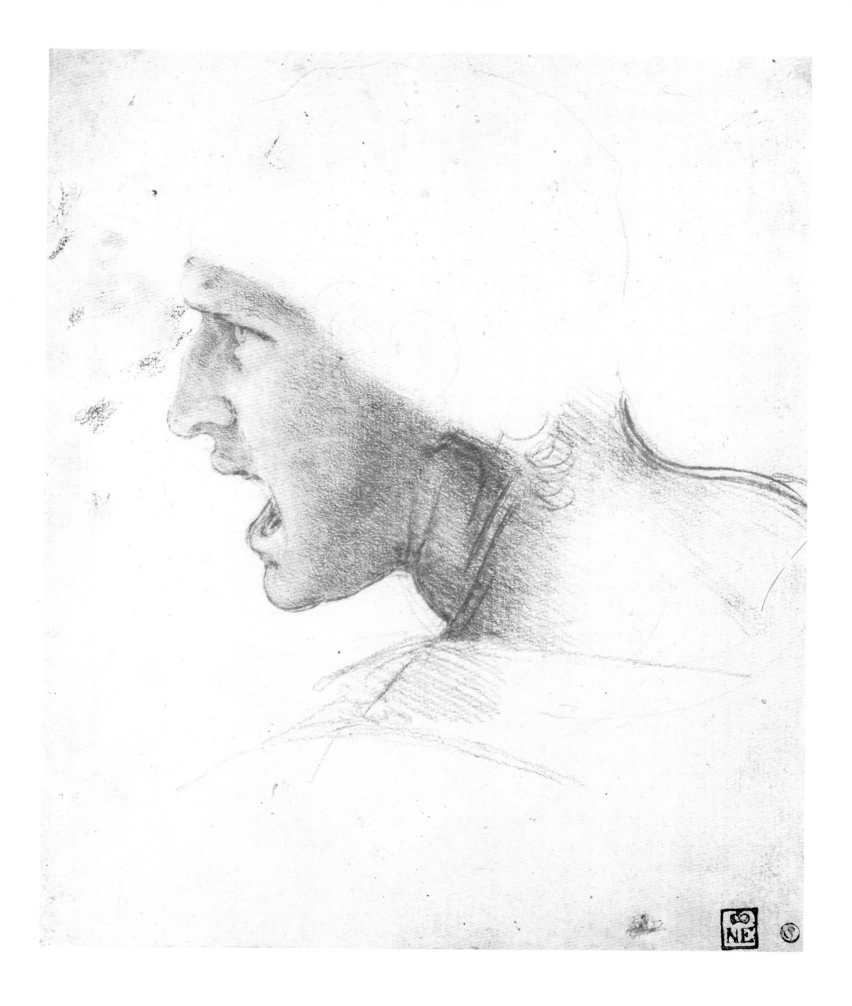

ABOVE: *Head of a Man Shouting*, c. 1505, red chalk, 9 × 7⅓ inches
(22.7 × 18.6 cm). Museum of Fine Arts, Budapest. Both of these
heads are studies for figures in *The Battle of Anghiari*.

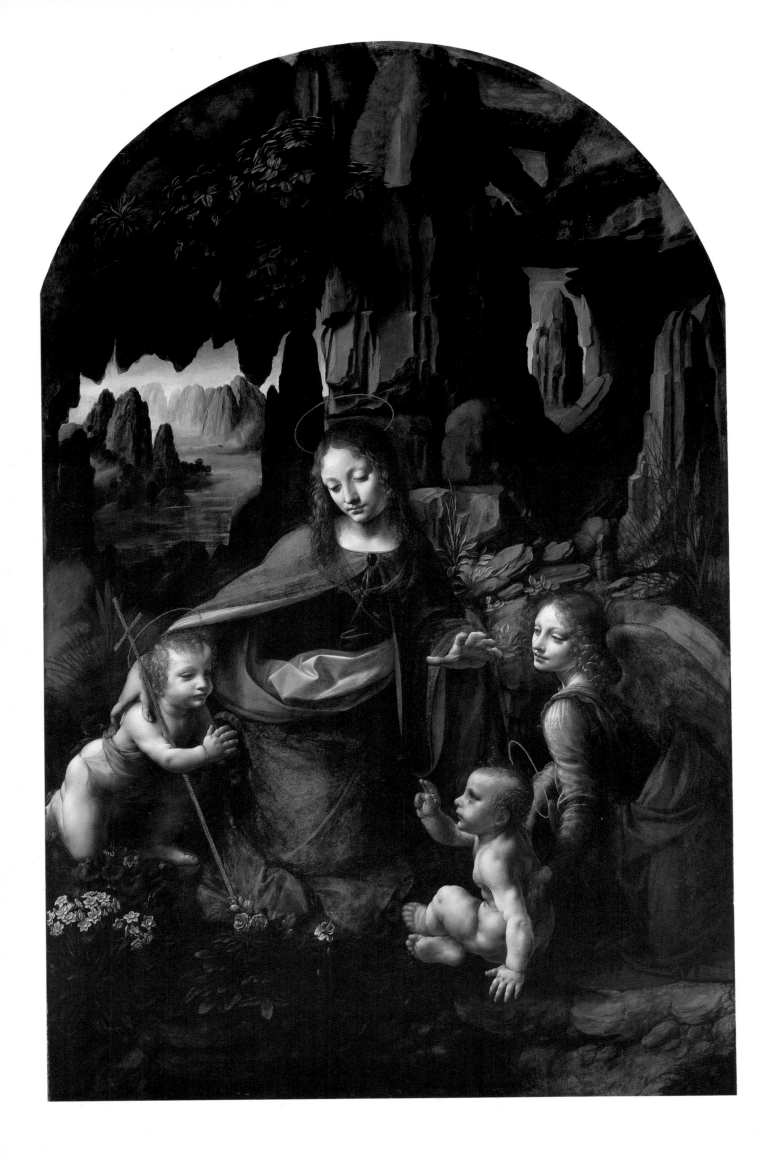

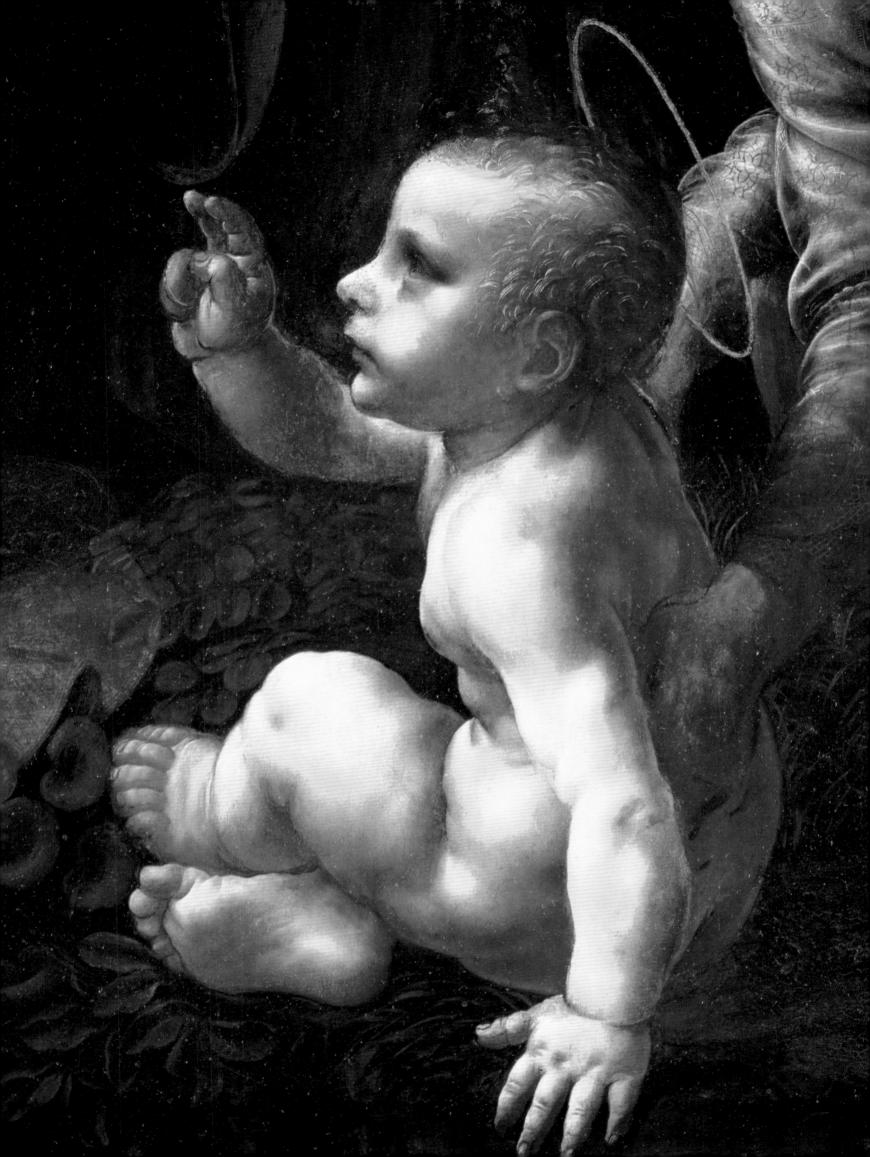

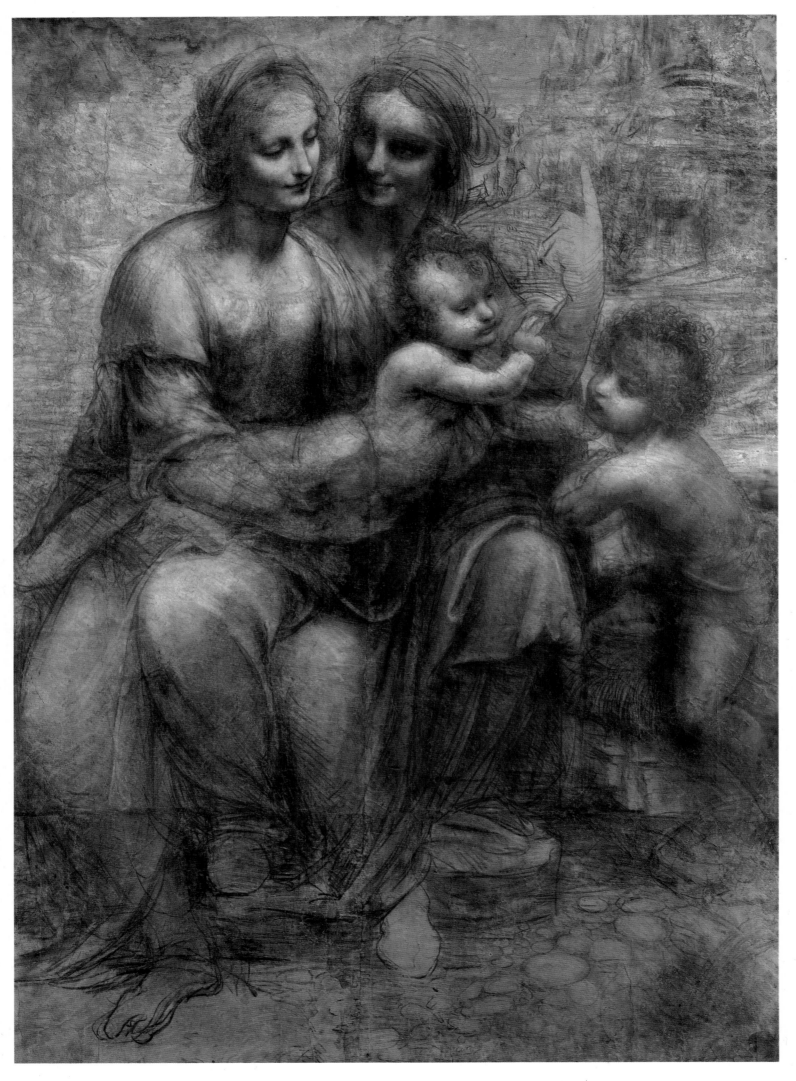

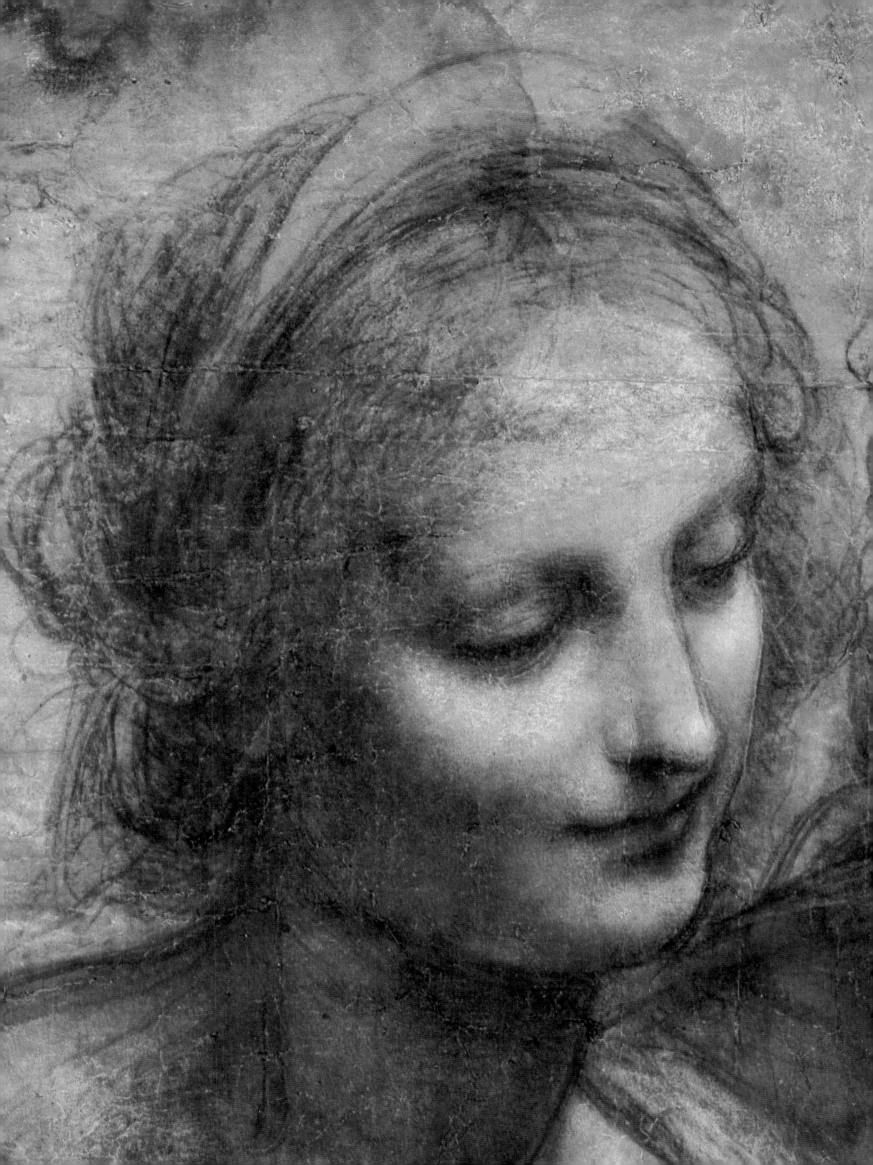

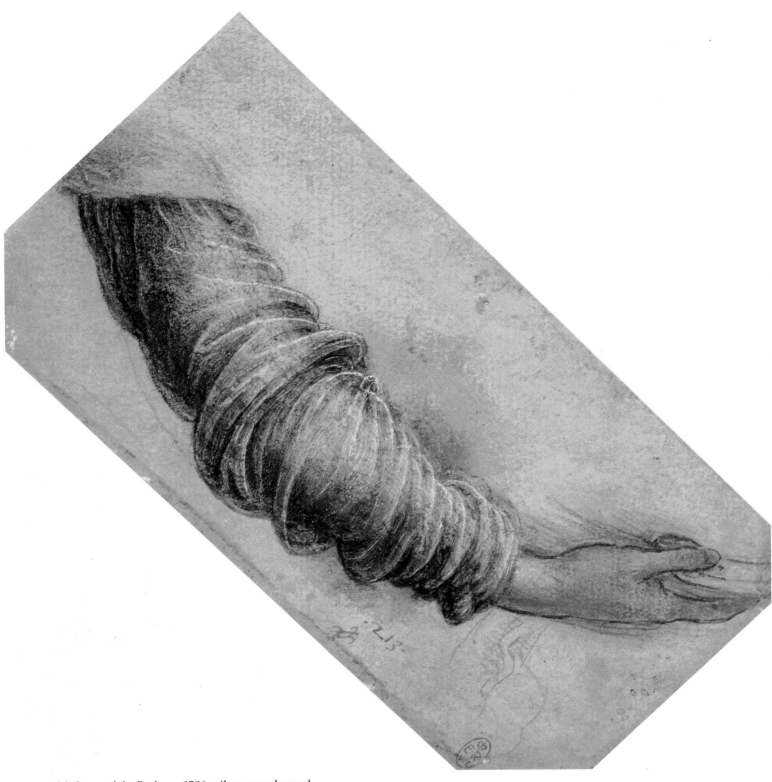

PAGE 74: *Madonna of the Rocks,* c. 1506, oil on wood panel, 74⅝ × 47¼ inches (189.5 × 120 cm), Courtesy of the Trustees of the National Gallery, London.

PAGE 75: Detail of the Christ Child from the *Madonna of the Rocks.*

PAGE 76: *Virgin and Child with St Anne and St John the Baptist,* c. 1505, 54¾ × 39¾ inches (139 × 101 cm), charcoal on brown paper heightened with white, National Gallery, London.

PAGE 77: Detail of the head of the Virgin from *The Virgin and Child with St Anne and St John the Baptist.*

ABOVE: Study for the Virgin's Sleeve and Hand from *The Virgin and Child with St Anne and a Lamb,* c. 1508, black and red chalk, pen and ink with washes of black, 3⅜ × 6¹¹⁄₁₆ inches (8.6 × 17 cm), Windsor Castle, Royal Library 12532. © 1992 Her Majesty The Queen.

RIGHT: *Virgin and Child with St Anne and a Lamb,* c. 1508, oil on wood panel, 66⅛ × 44 inches (168 × 112 cm), Musée du Louvre, Paris.

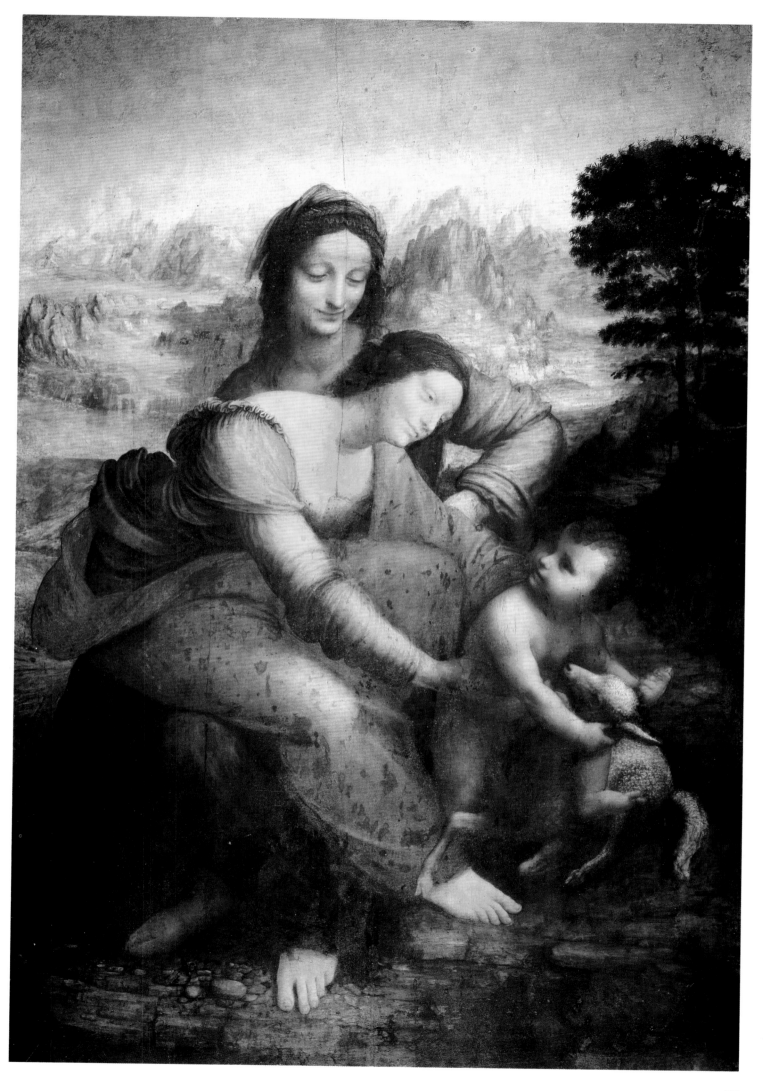

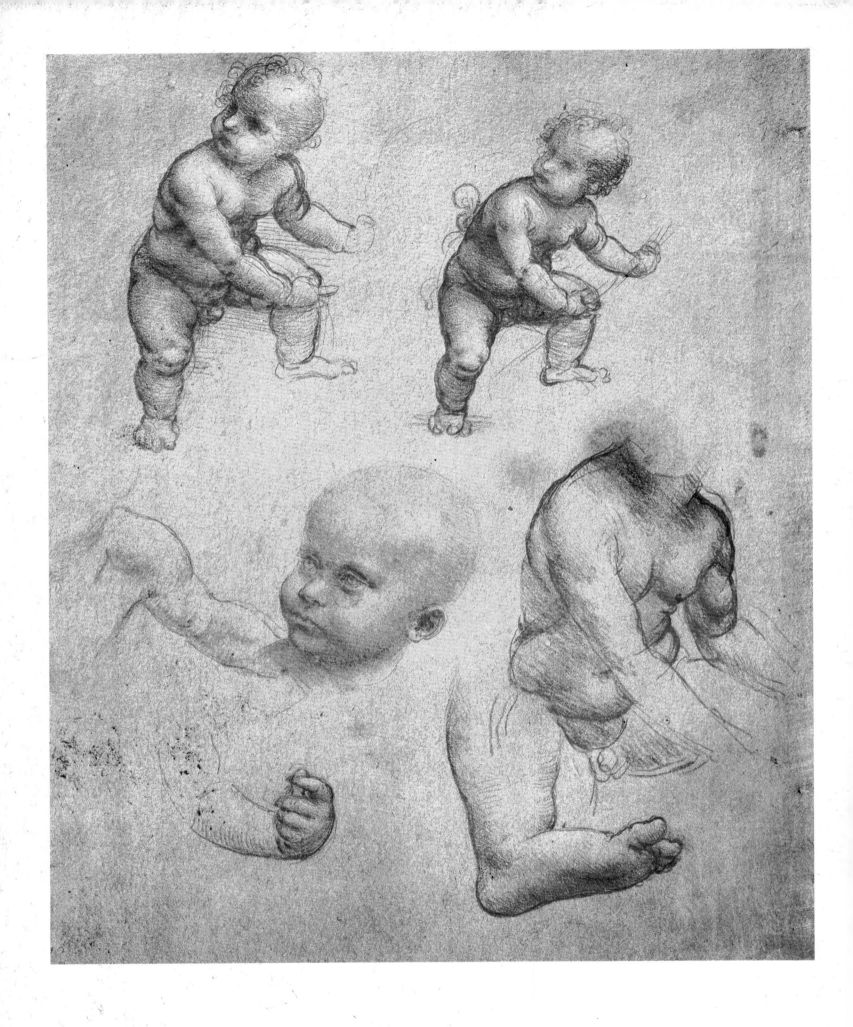

ABOVE: Studies for the Christ Child in the *Virgin and Child with St Anne and a Lamb,* c. 1508, red chalk, 11 × 8⅝ inches (28 × 22 cm), Galleria dell'Accademia, Venice.

RIGHT: Detail of the Christ Child from the *Virgin and Child with St Anne and a Lamb,* (page 79).

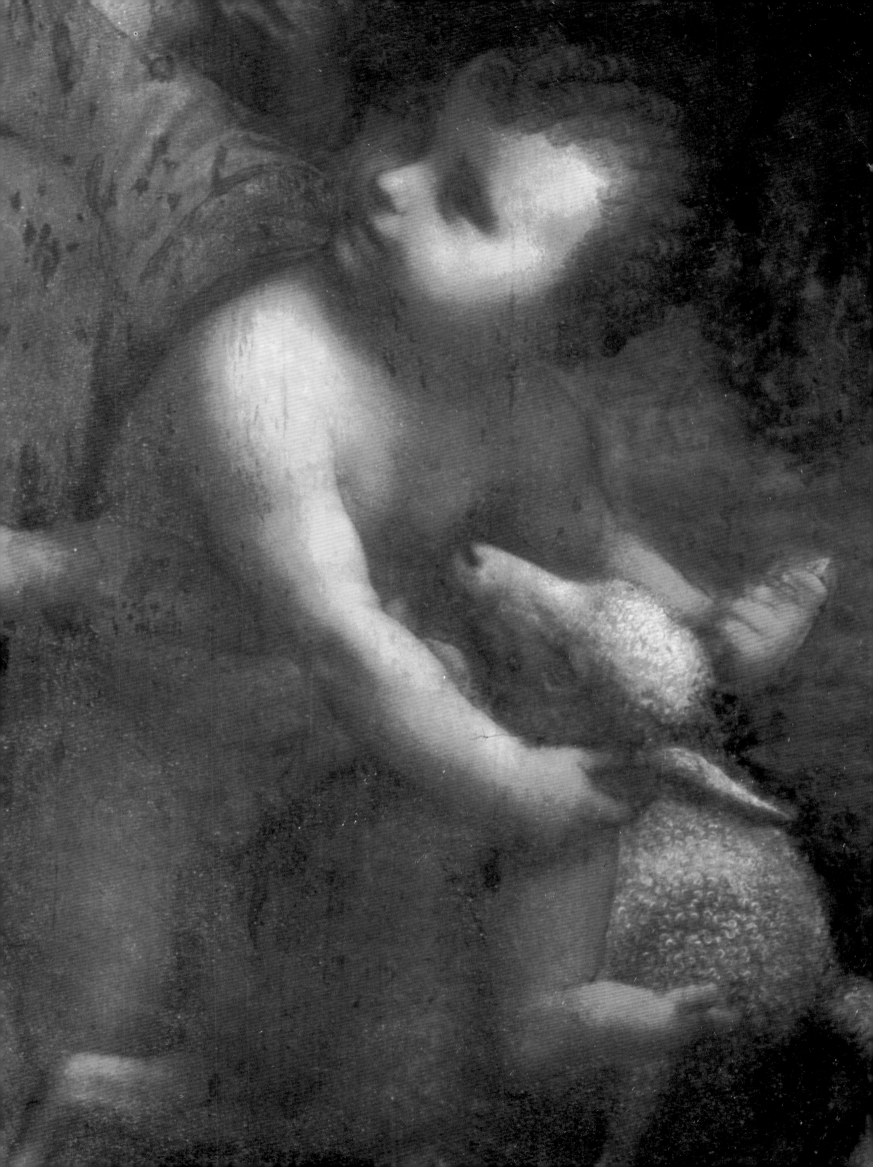

RIGHT: *Mona Lisa*, c. 1505-13, oil on wood panel, 30 × 20⅞ inches (77 × 53 cm), Musée du Louvre, Paris. Although it is now believed that there is no real evidence identifying the subject of this portrait with Mona Lisa, the wife of Florentine silk merchant Francesco del Giacondo, the painting has been known for so long and so widely as the Mona Lisa that it is an affectation to call it anything else.

BELOW: Detail of the hands of the *Mona Lisa*.

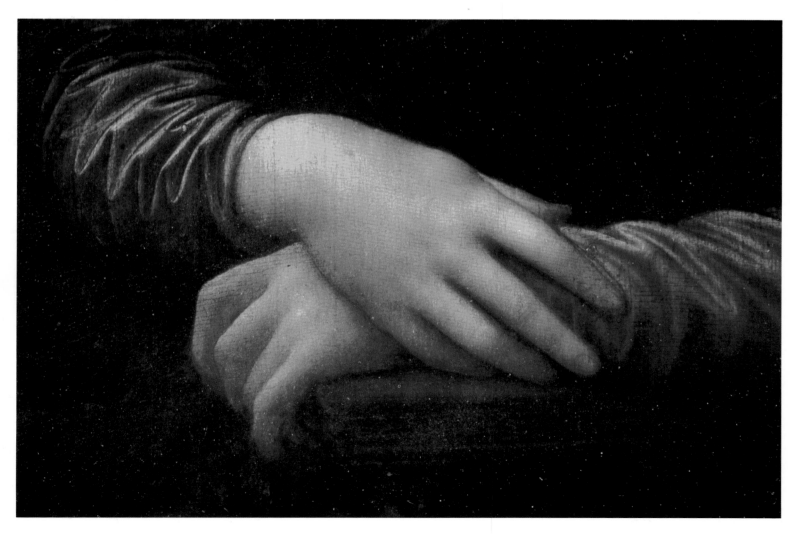

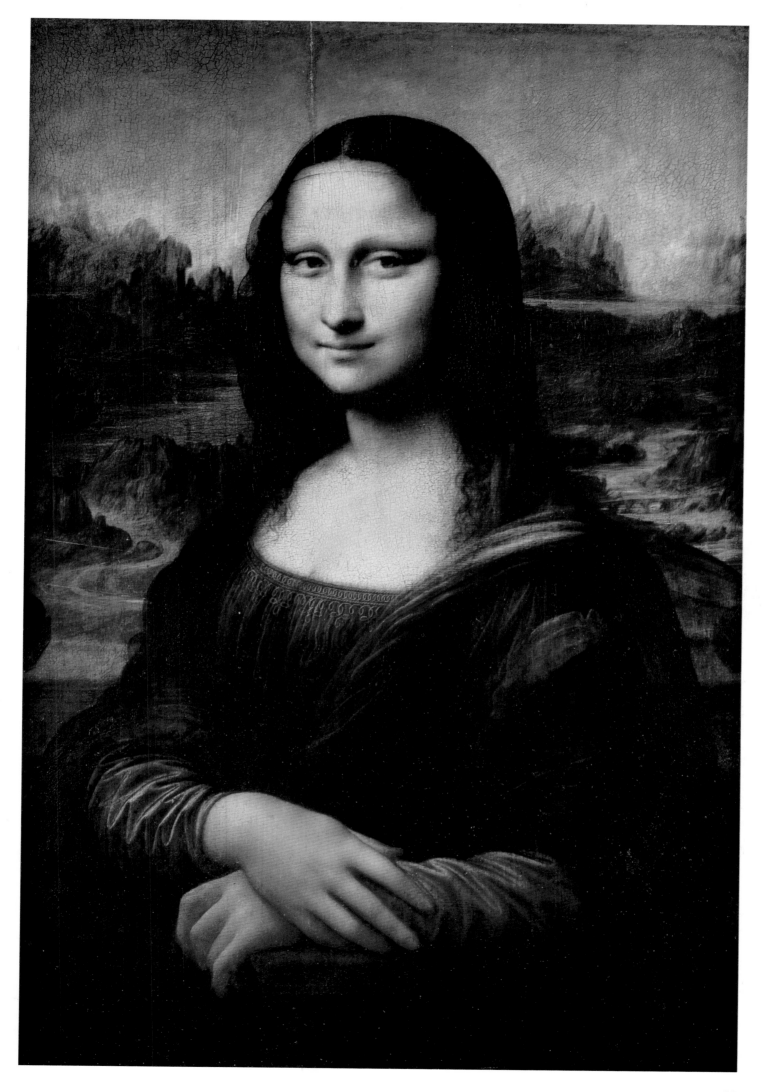

BELOW: Study for the *Kneeling Leda*, c. 1504, pen, bister and wash over black chalk, 6¼ × 5½ inches (16 × 13.9 cm), Devonshire Collection, Chatsworth House, Derbyshire. Reproduced by Permission of the Trustees of the Chatsworth Settlement. Several drawings for a lost painting of Leda survive, of which many show a kneeling figure.

RIGHT: School of Leonardo, *Leda*, oil on wood panel, 38 × 29 inches (96.5 × 73.7 cm), Collection of the Earl of Pembroke, Wilton House Trust, Salisbury, Wiltshire. Since most sixteenth-century copies of Leonardo's now-lost painting of Leda show a standing figure, it is usually assumed that Leonardo settled on this formula for his own painting.

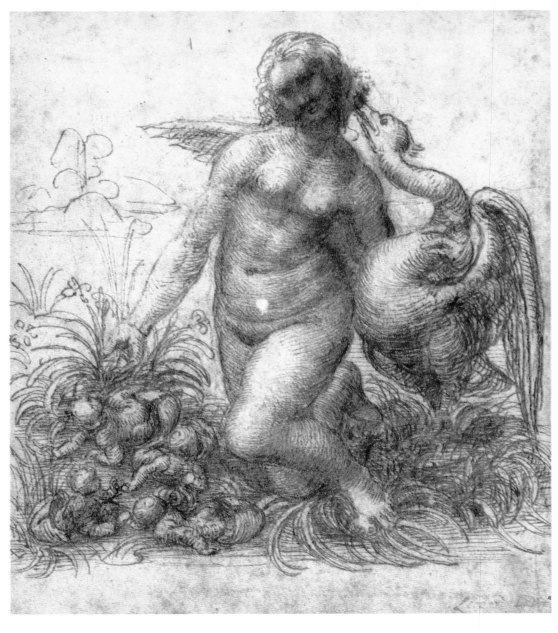

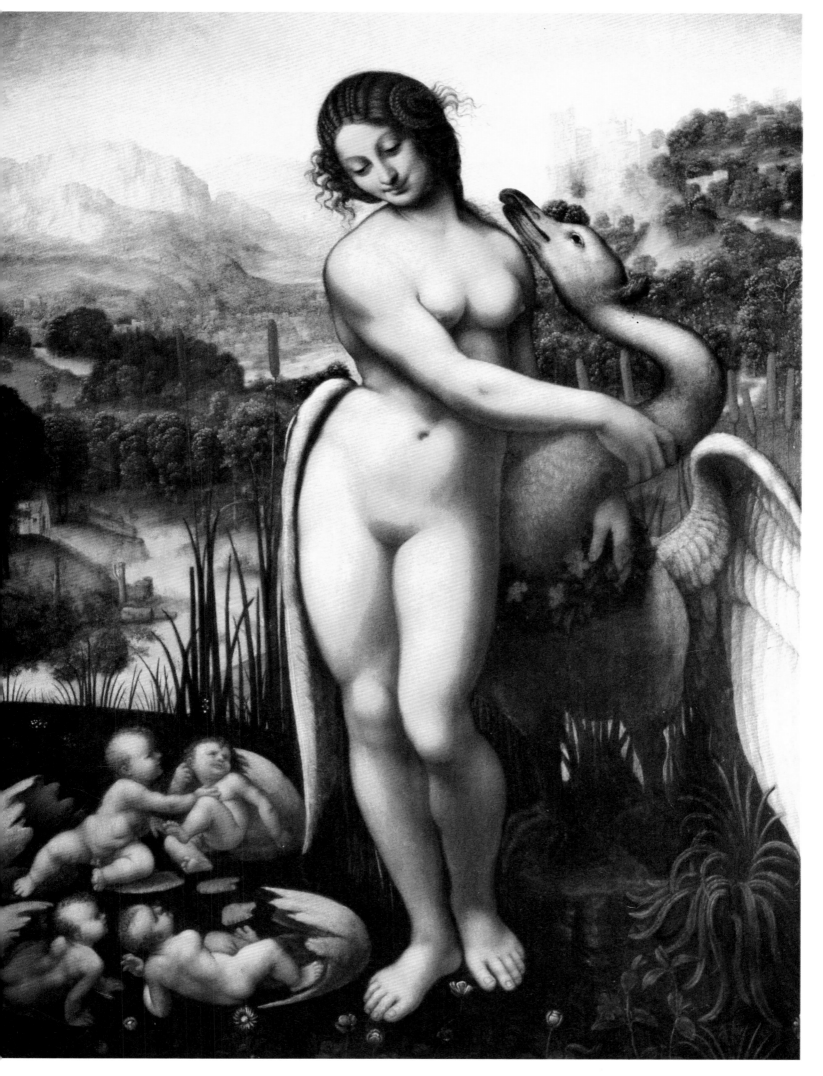

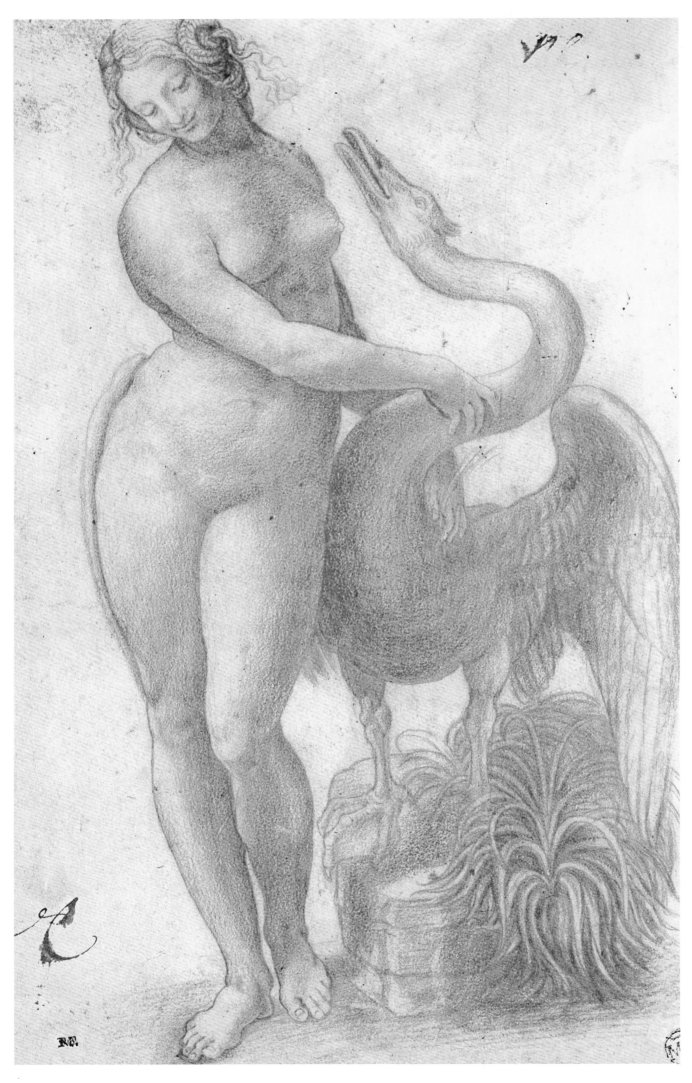

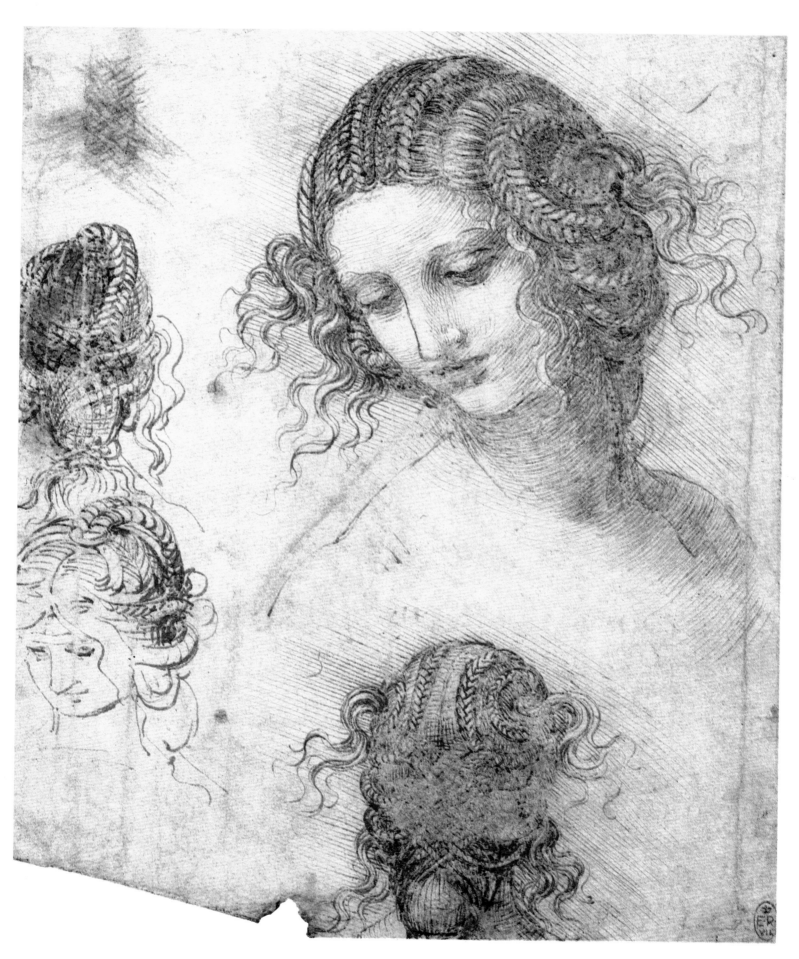

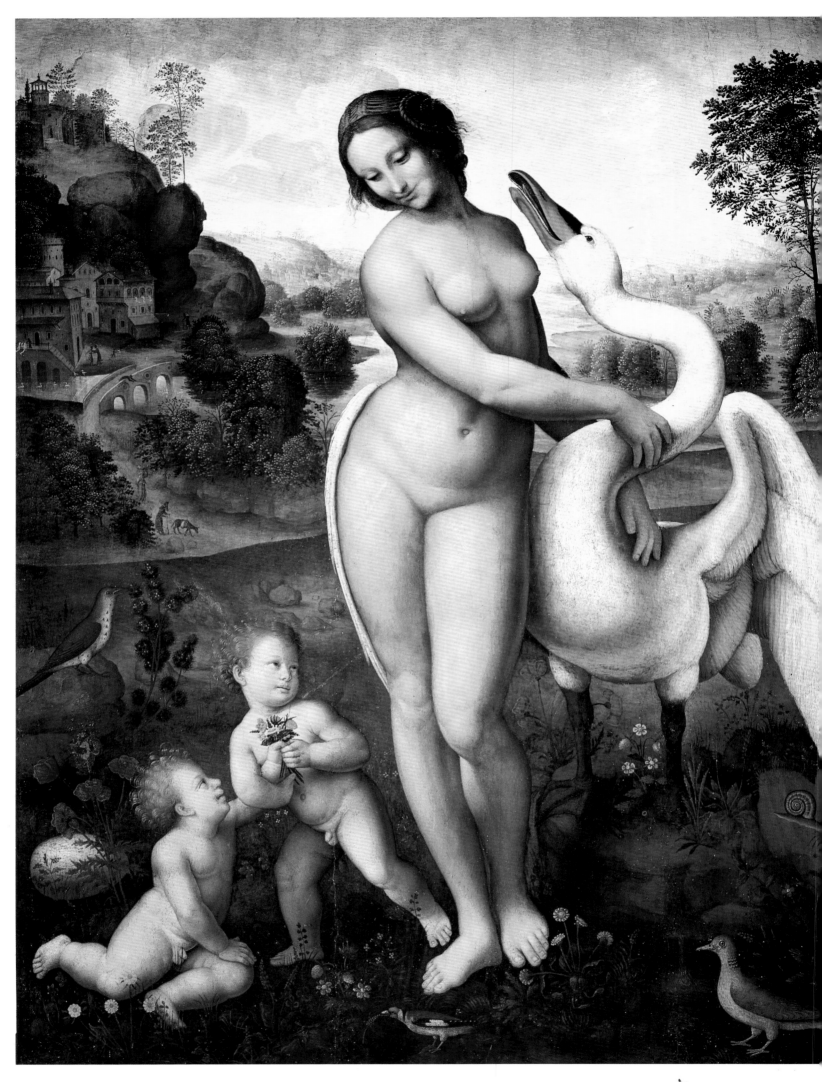

LEFT: School of Leonardo, *Leda*, c. 1510-15, oil on wood panel, 44 × 33⅞ inches (112 × 86 cm), Galleria Borghese, Rome.

BELOW: Andrea del Verrocchio (c. 1435-88) *Lady with Primroses*, c. 1475, marble, height 24 inches (61 cm) Museo del Bargello, Florence. The similarity in conception between this and several of Leonardo's female portraits, especially the *Lady with an Ermine* (page 54) has prompted suggestions that Leonardo may have assisted his master on this work. Otherwise, no sculpture by Leonardo is known to survive.

PAGE 90: *St John*, c. 1509, oil on wood panel, 27½ × 22½ inches (69 × 57 cm), Musée du Louvre, Paris.

PAGE 91: *St John-Bacchus*, c. 1513, oil on wood panel, 69⅝ × 45¼ inches (177 × 115 cm), Musée du Louvre, Paris.

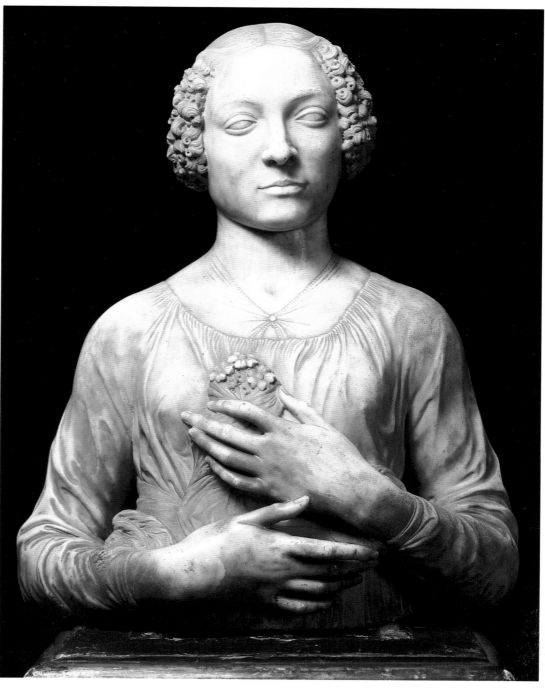

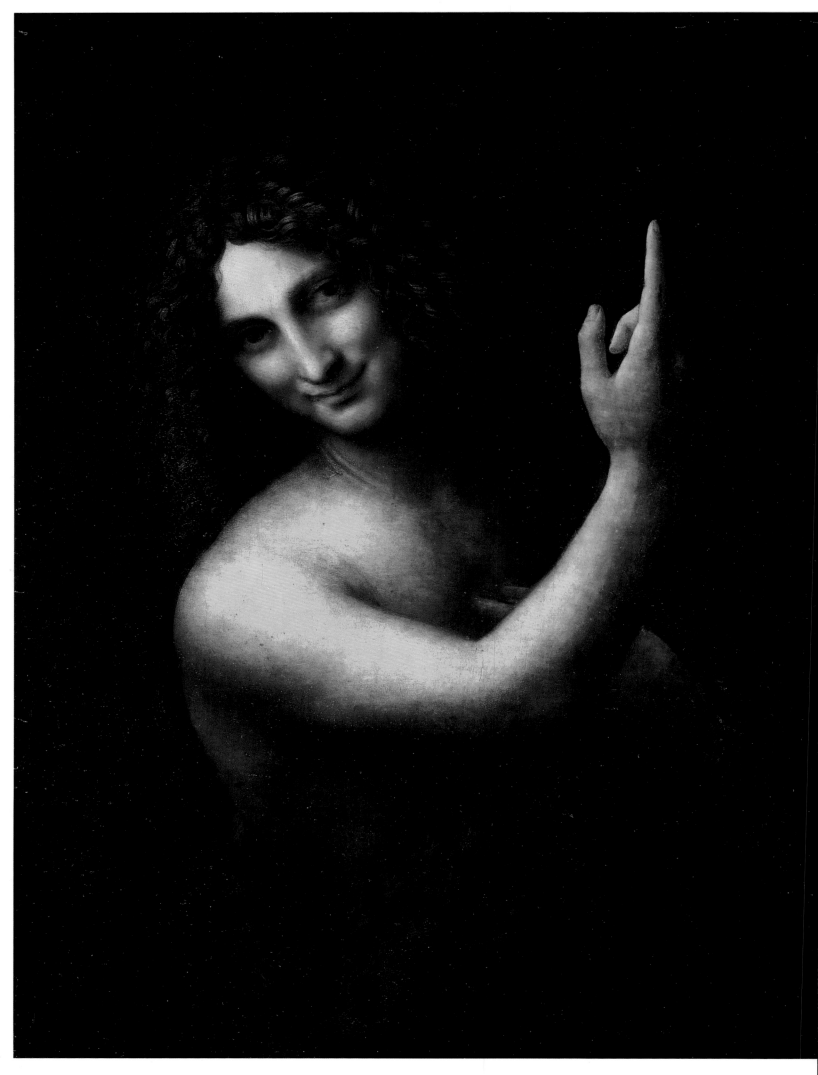

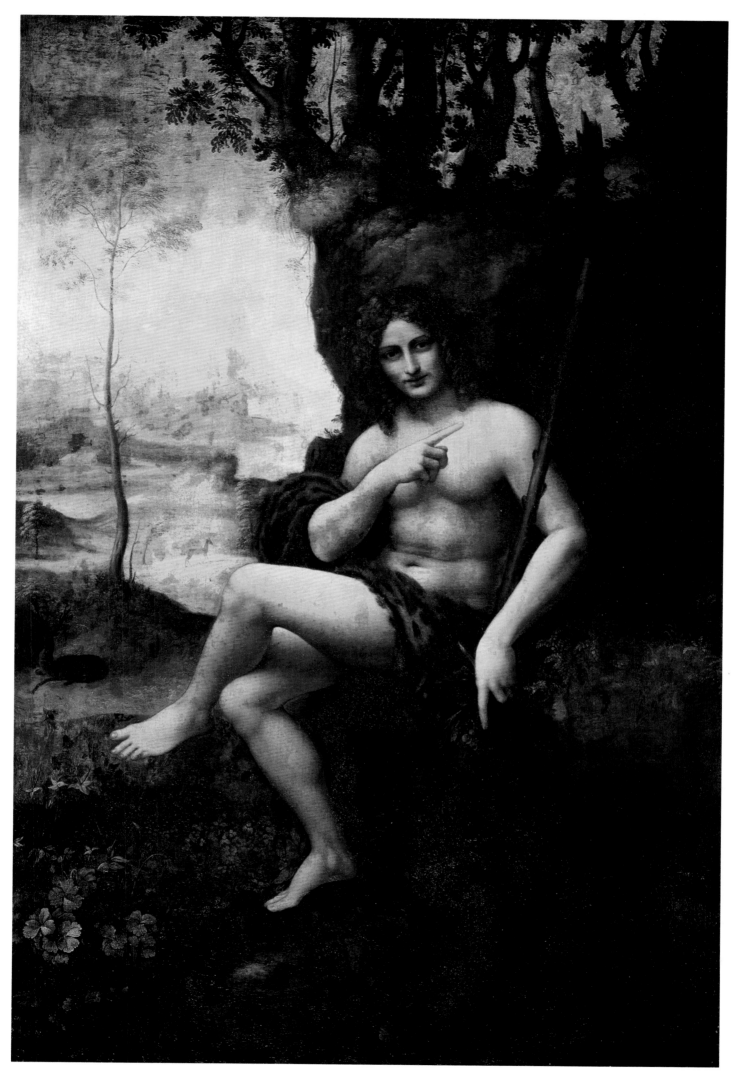

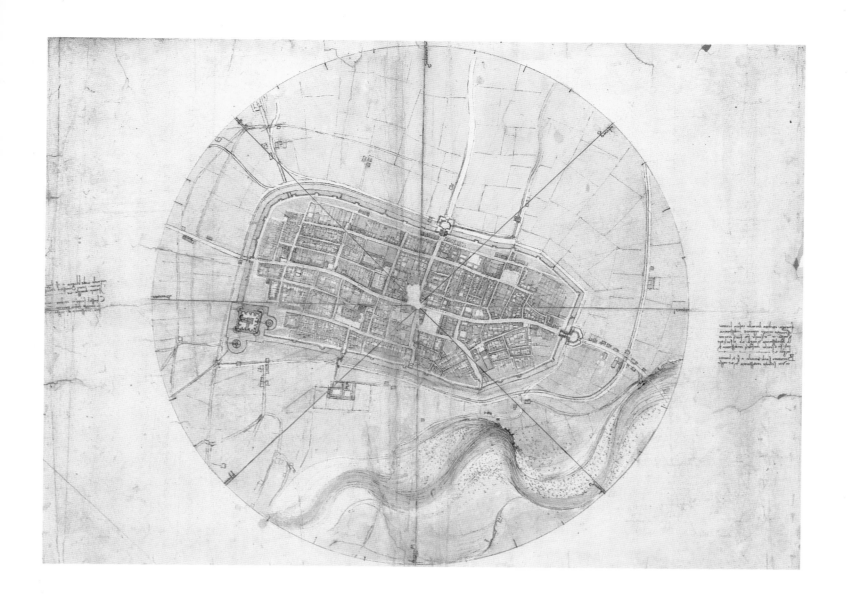

ABOVE: *Plan of Imola*, c. 1503, pen, ink, and watercolor, 17⅓ × 23⅔ inches (44 × 60.2 cm) Windsor Castle, Royal Library 12284. © 1992 Her Majesty The Queen. The castle of Imola appears at the lower left of the plan, surrounded by a moat. At either side of the drawing are notes in Leonardo's mirror writing which refer to the geography, distance, and bearings of towns and cities of military interest to Cesare Borgia, Leonardo's patron.

LEFT: *Human Figure in a Circle, Illustrating Proportion*, 1485-90, pen and ink, 13½ × 9⅝ inches (34.3 × 24.5 cm) Accademia, Venice. This drawing is related to Leonardo's studies of human and animal proportions.

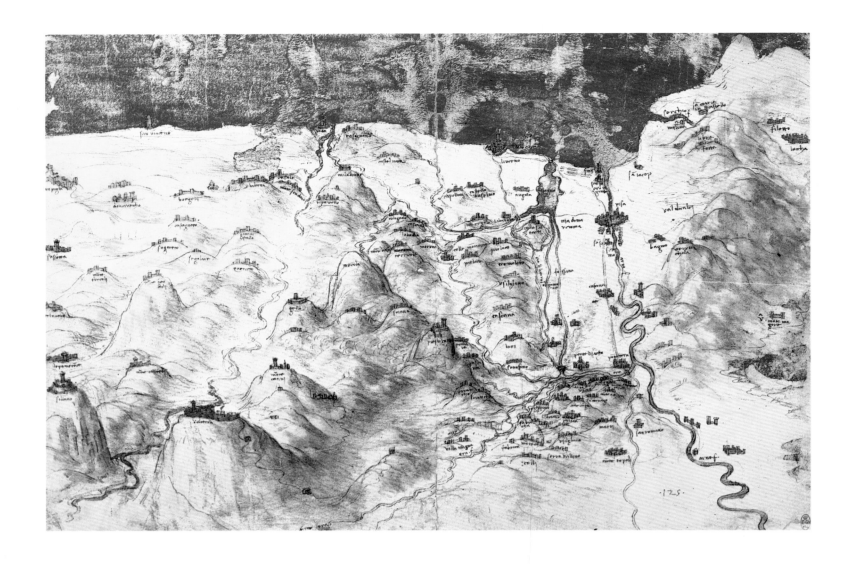

ABOVE: *Bird's-eye View of Part of Tuscany*, c. 1502-02, pen, ink and watercolor, 10⅞ × 15⅞ inches (27.5 × 40.1 cm), Windsor Castle, Royal Library 12683. © 1992 Her Majesty The Queen.

BELOW: Leonardo's *Scheme for Canalizing the River Arno*. Biblioteca Nacional, Madrid.

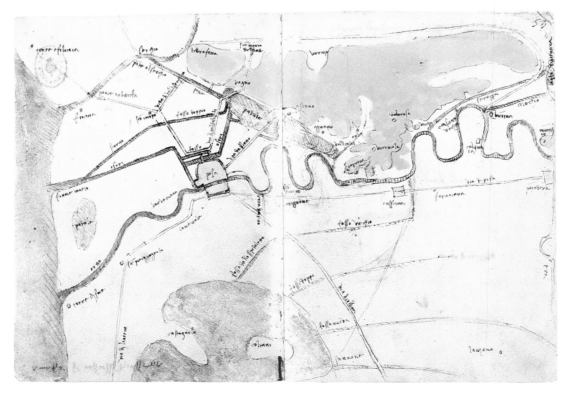

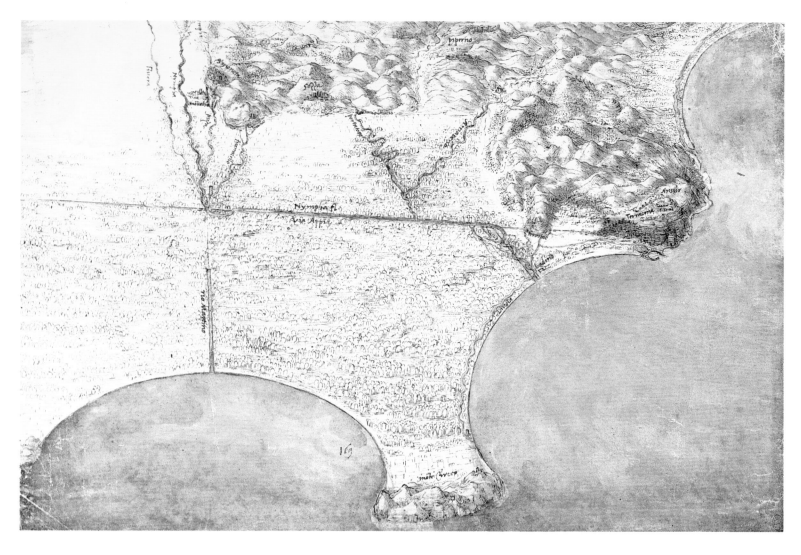

above: *Bird's-eye View of the Coast of Italy,*
North of Terracina, c. 1515, pen, ink, and
watercolor, 10⅞ × 15¾ inches
(27.7 × 40 cm), Windsor Castle, Royal
Library, © 1993 Her Majesty The Queen.

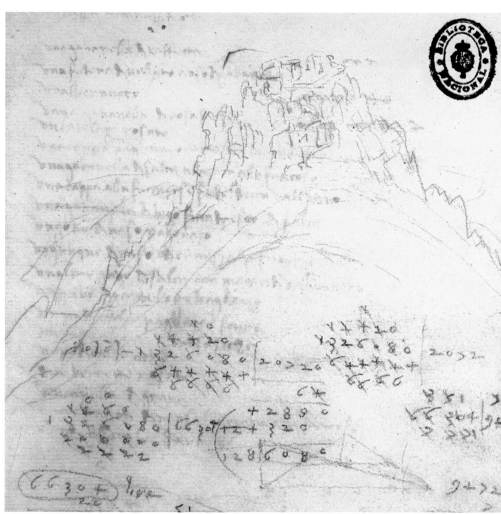

RIGHT: Leonardo calculated in this
drawing how to guarantee that two
tunnels started on opposite sides of a
mountain would meet in the middle.
Biblioteca Nacional, Madrid.

RIGHT: Leonardo designed this breakwater for the harbor of Piombino. It may owe something to the ideas of Francesco di Giorgio, a copy of whose treatise *Architecture, Engineering and Military Art* Leonardo owned. Biblioteca Nacional, Madrid.

BELOW: A further idea for a castle design borrowed from Francesco di Giorgio's treatise. With the increasing use of artillery, castle designs changed from using tall, square towers and high walls to squatter walls and rounded towers which were better able to deflect the enemy fire. Biblioteca Nacional, Madrid.

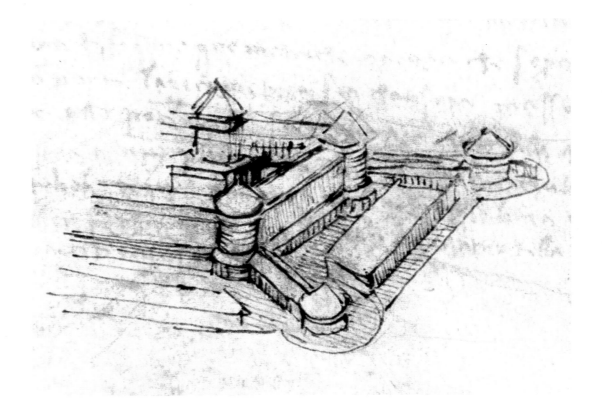

RIGHT: The trajectory of a cannon ball was traditionally believed to be two straight lines joined by a short curve. Although this view was to prevail into the seventeenth century, Leonardo had recognized the true parabolic nature of a cannon ball's path. Biblioteca Nacional, Madrid.

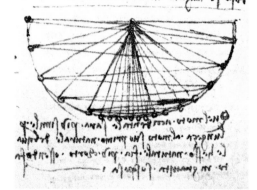

BELOW: *A Scythed Chariot, an Armoured Vehicle, and a Partisan* c. 1485-88, pen, ink and wash, 6⅞ × 9⅝ inches (17.3 × 24.6 cm), Courtesy of the Trustees of the British Museum.

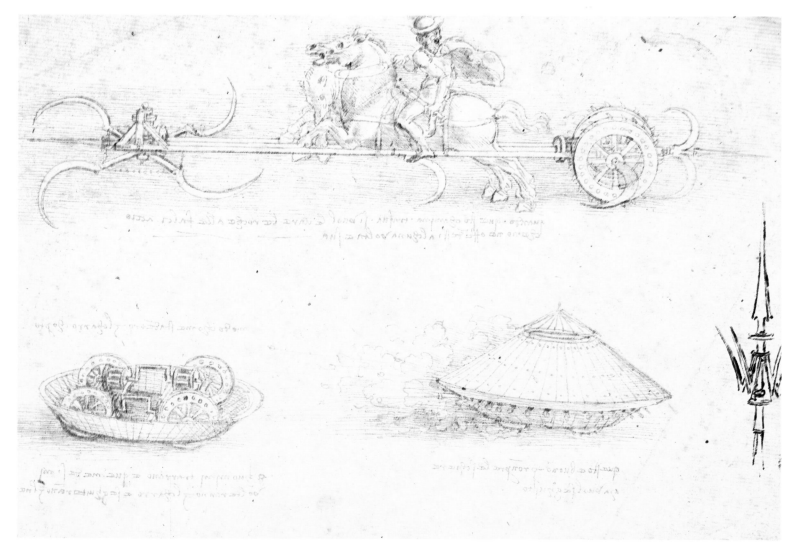

97

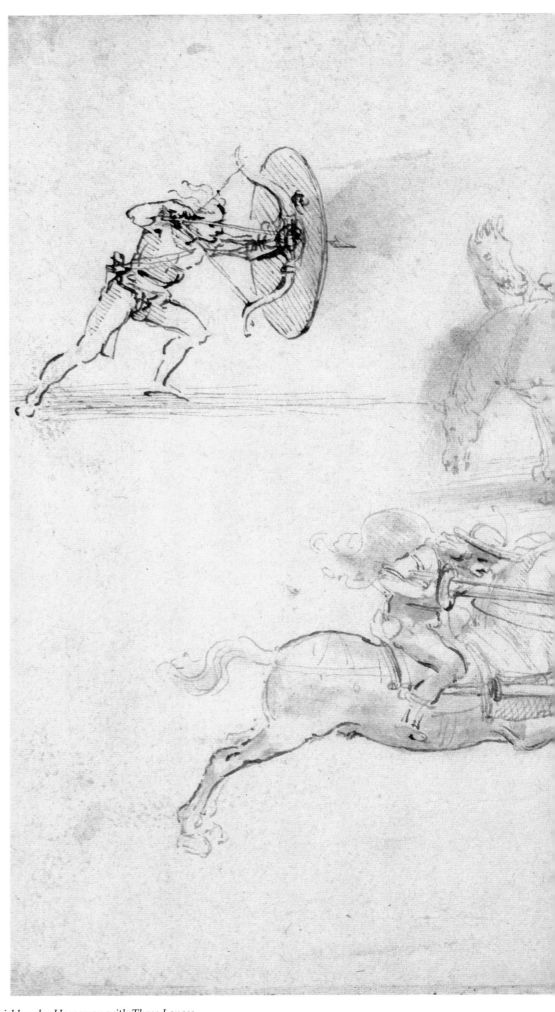

A Chariot Armed with Flails, an Archer with a Shield and a Horseman with Three Lances,
c. 1485-88, pen, ink and wash, 7⅞ × 11 inches (20 × 28 cm), Windsor Castle, Royal
Library 12563. © 1993 Her Majesty The Queen.

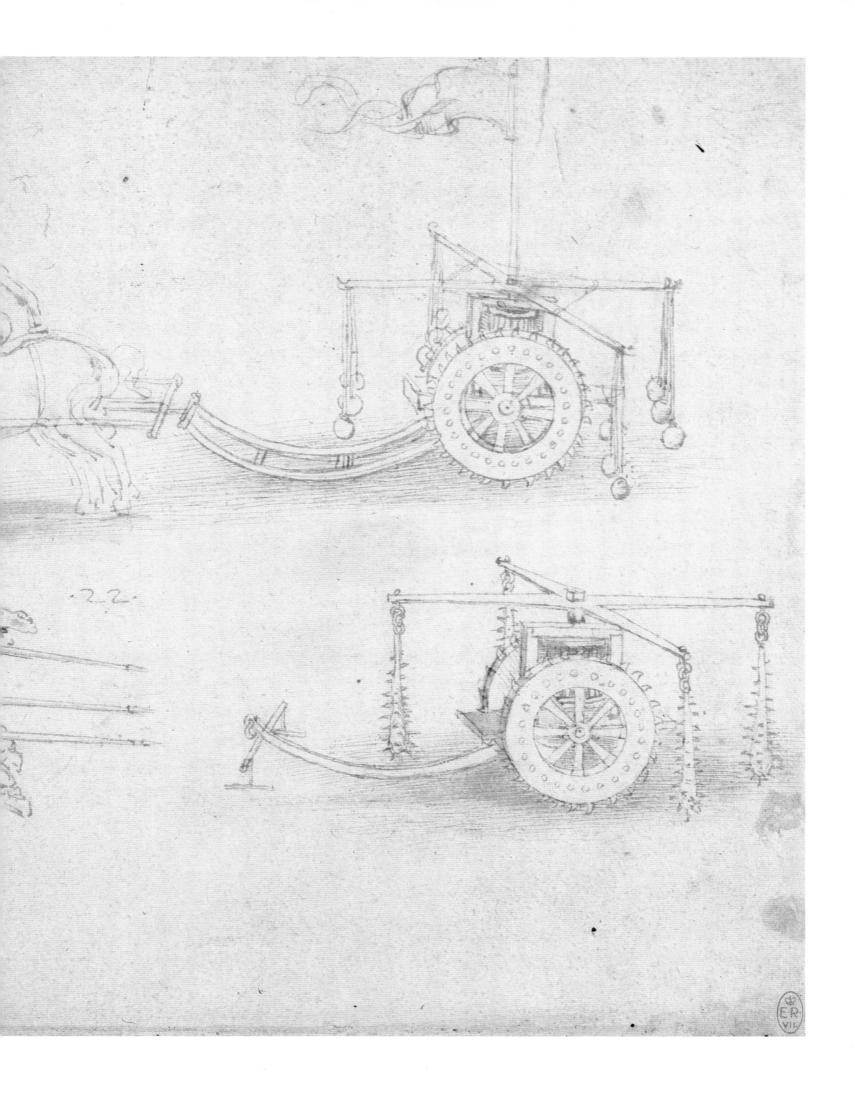

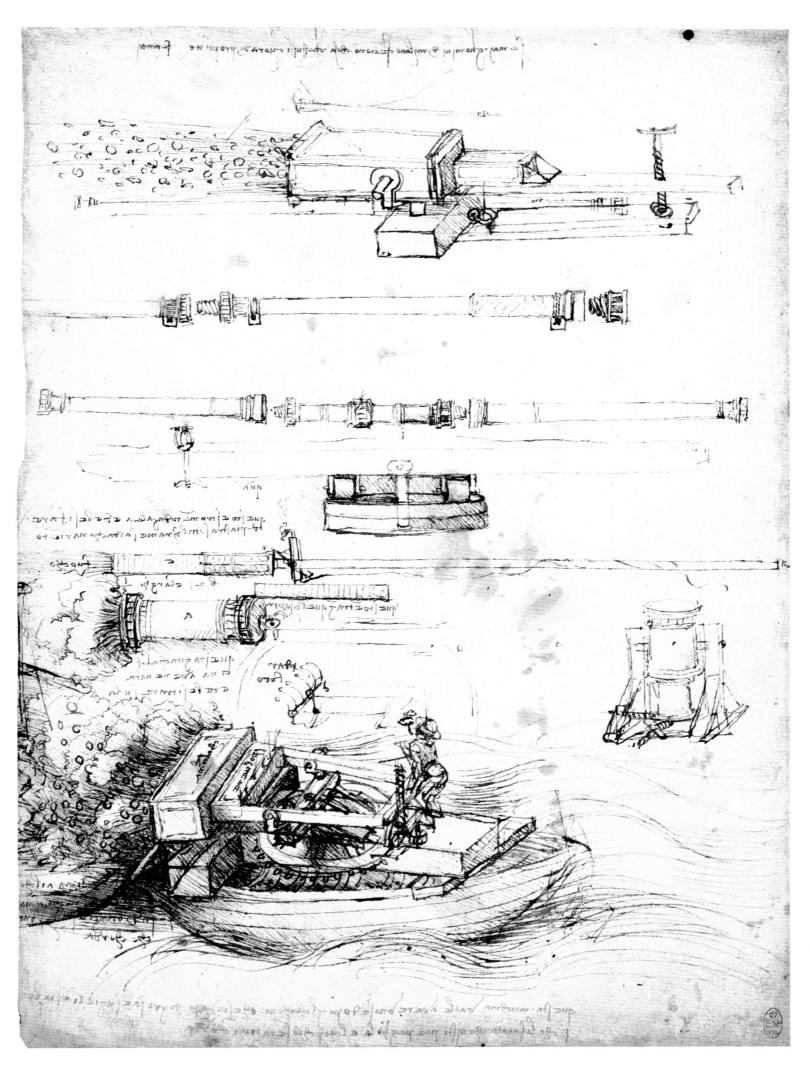

RIGHT: Leonardo's sketches of a crossbow bear the note: 'Test first and state the rule afterwards.' Biblioteca Nacional, Madrid.

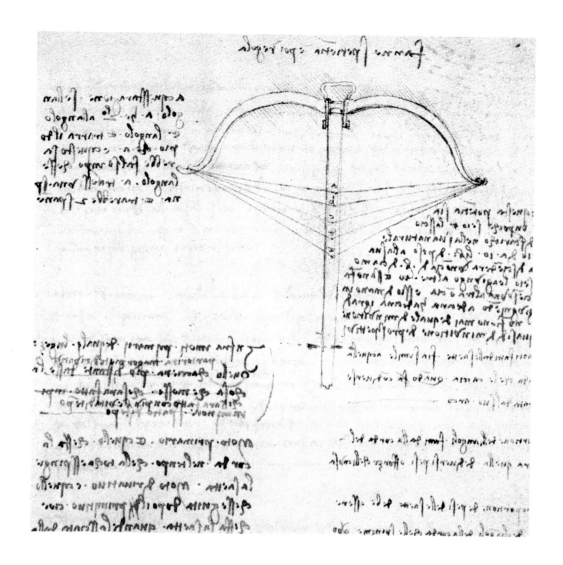

BELOW: Leonardo's drawing shows his ideas for improving the matchlock firing mechanism of a gun. The three mechanisms shown simultaneously open the powder charge and set fire to the touchhole. Biblioteca Nacional, Madrid.

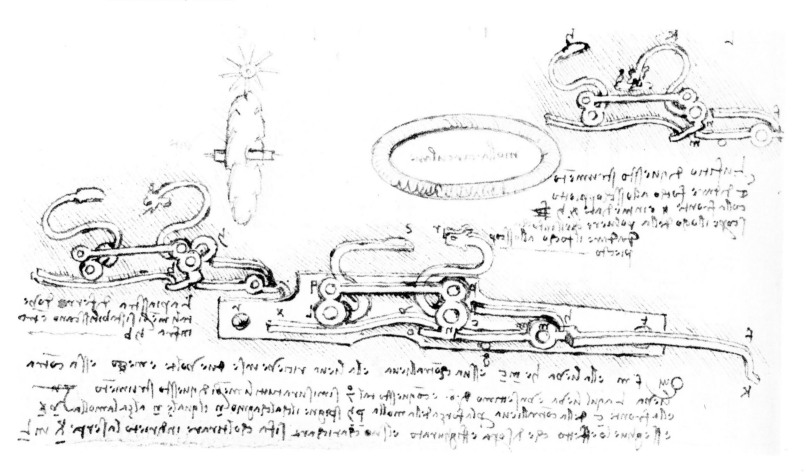

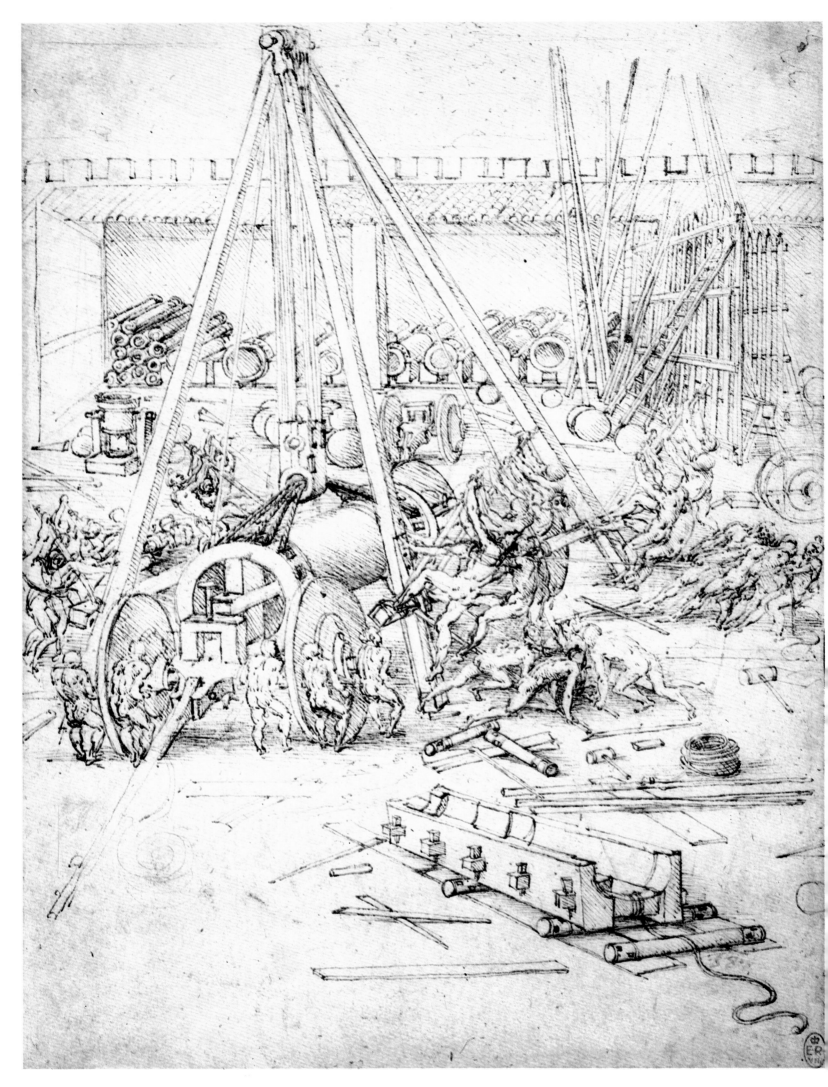

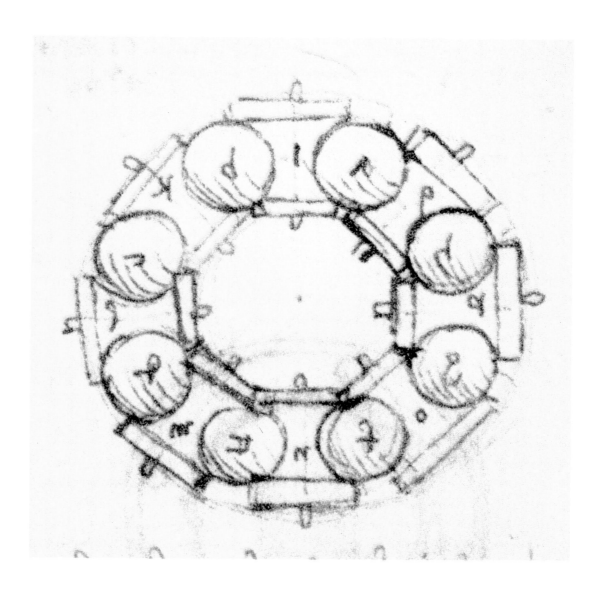

ABOVE: Leonardo devised this ball-bearing race 250 years before it was re-invented for use in vehicle wheels. Biblioteca Nacional, Madrid.

LEFT: *A Cannon Being Raised on to a Gun-Carriage (Artillery Park)*, c. 1485-88, pen and ink, 9⅞ × 7¼ inches (25 × 8.3 cm), Windsor Castle, Royal Library 12647. © 1993 Her Majesty The Queen.

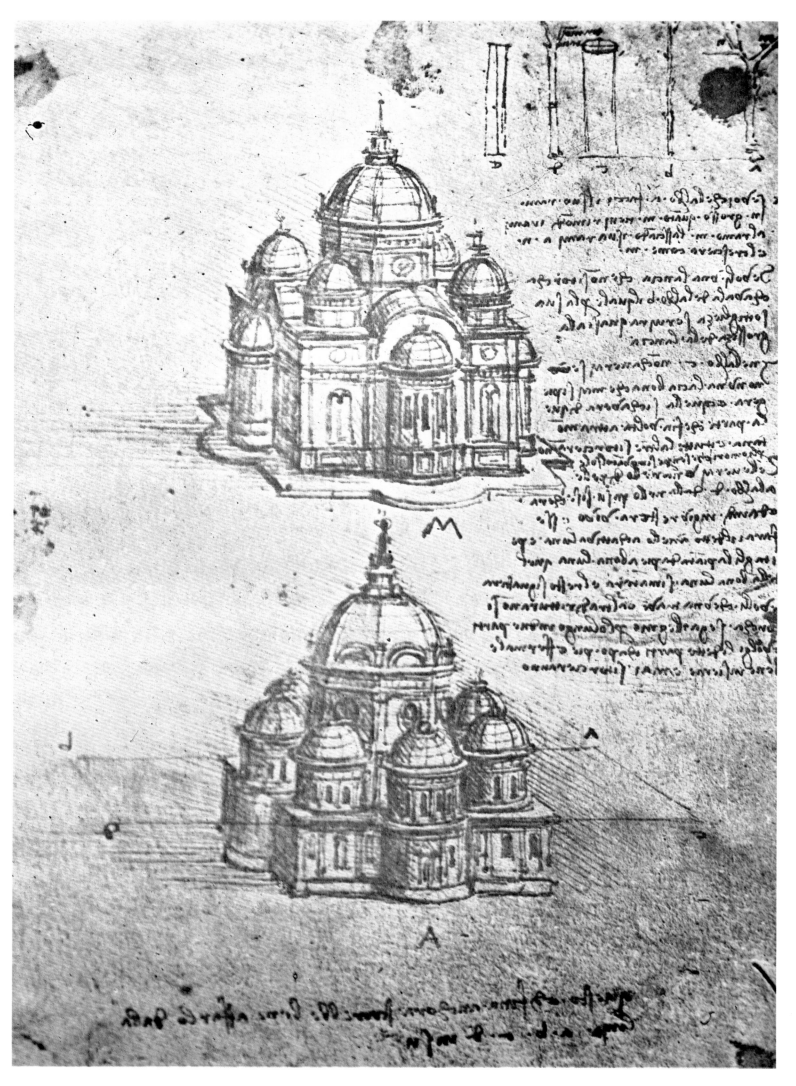

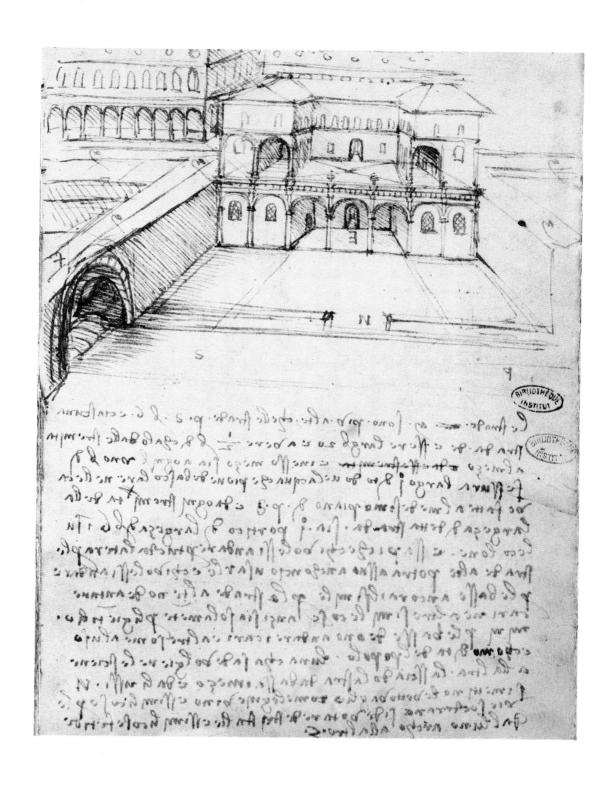

ABOVE: *Design for a Multi-Leveled Town*, c. 1488, pen and ink,
Bibliothèque de l'Institut de France, Paris.

LEFT: Two Designs for a Domed Church with Surrounding
Cupolas, c. 1488-89, pen and ink, 9 × 6¼ inches (23 × 16 cm),
Bibliothèque de l'Institute de France, Paris.

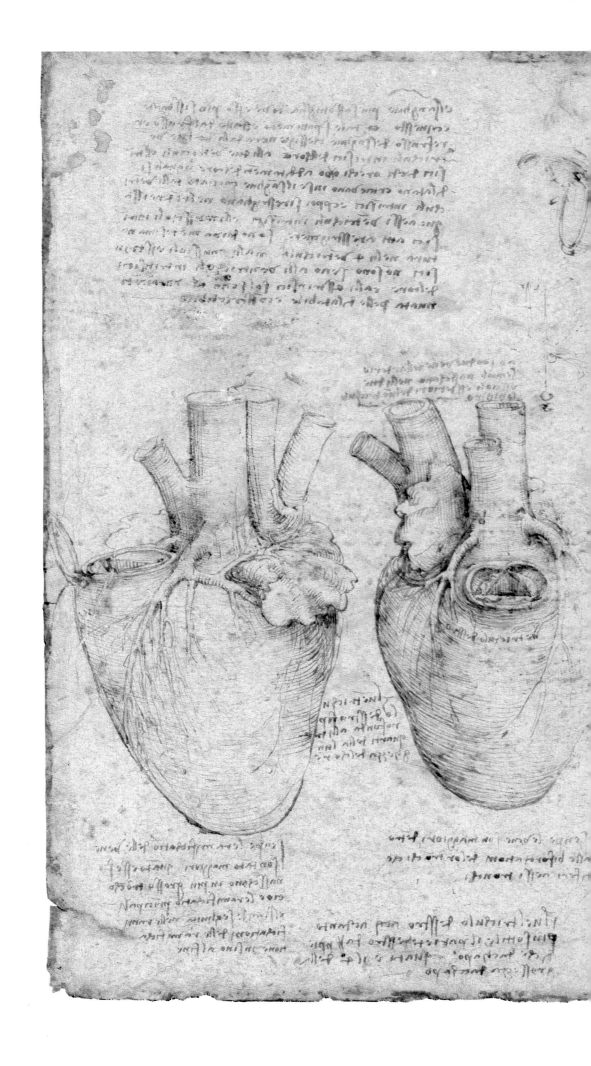

Drawings of the Heart, pen and ink on blue paper, Windsor Castle,
Royal Library 19074r. © 1993 Her Majesty The Queen.

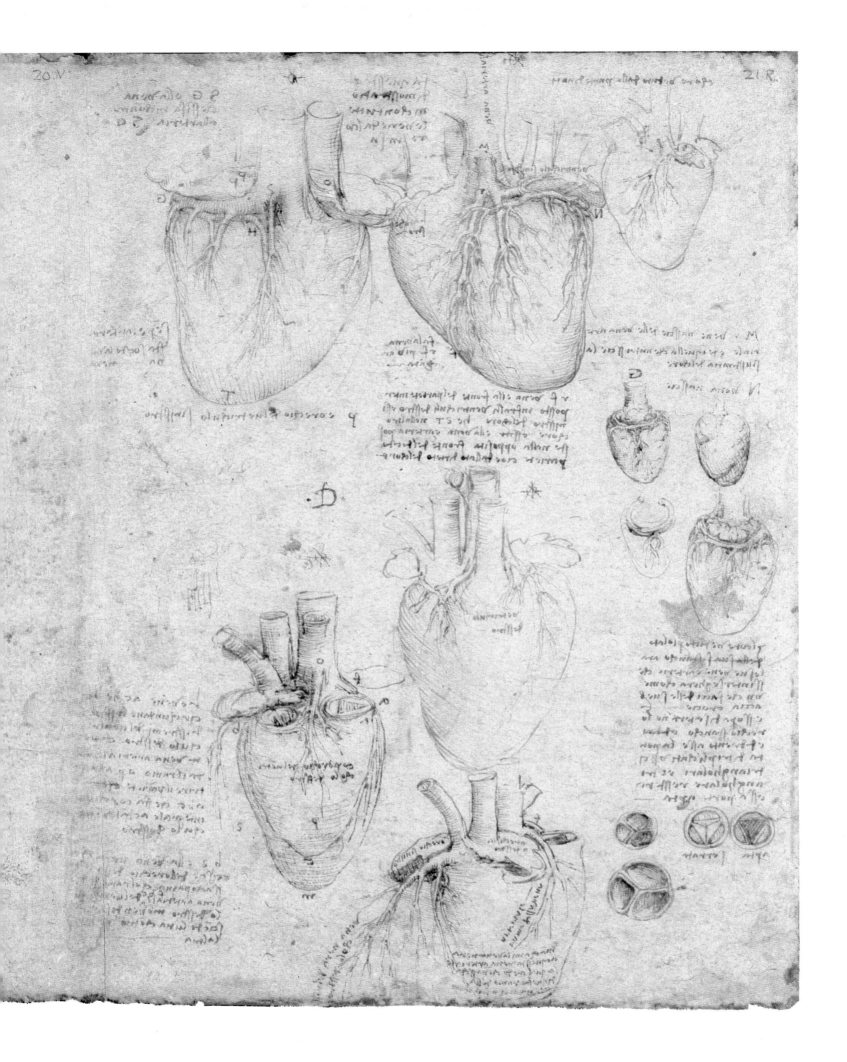

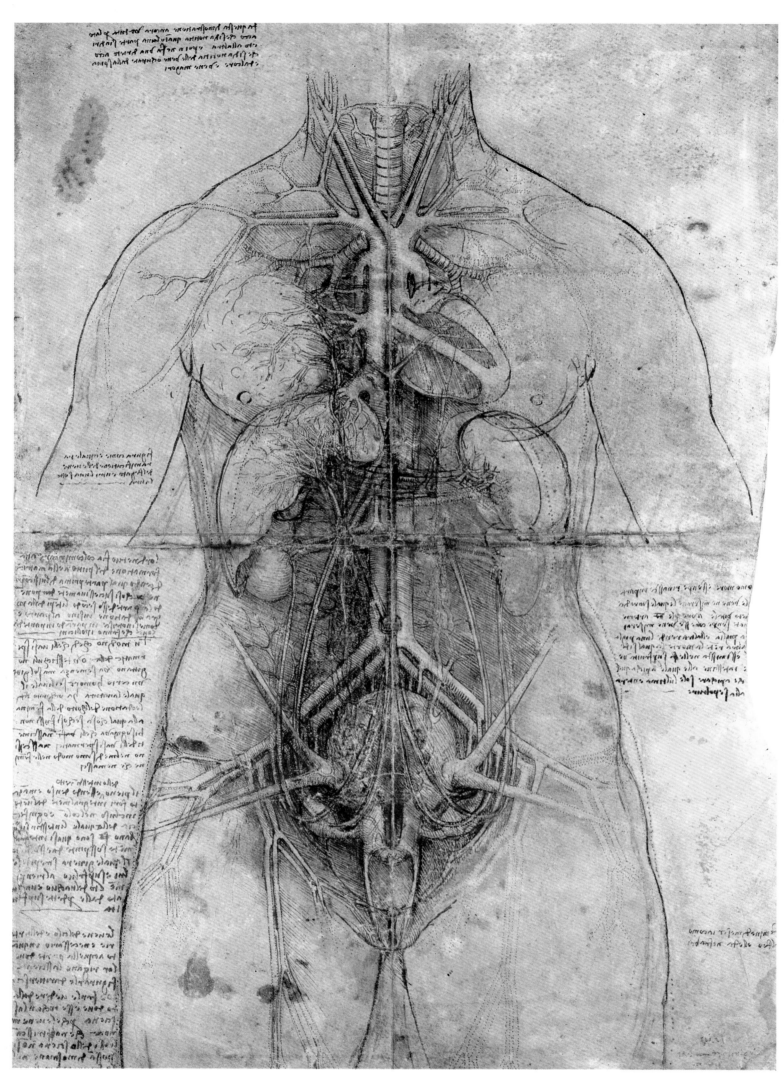

108

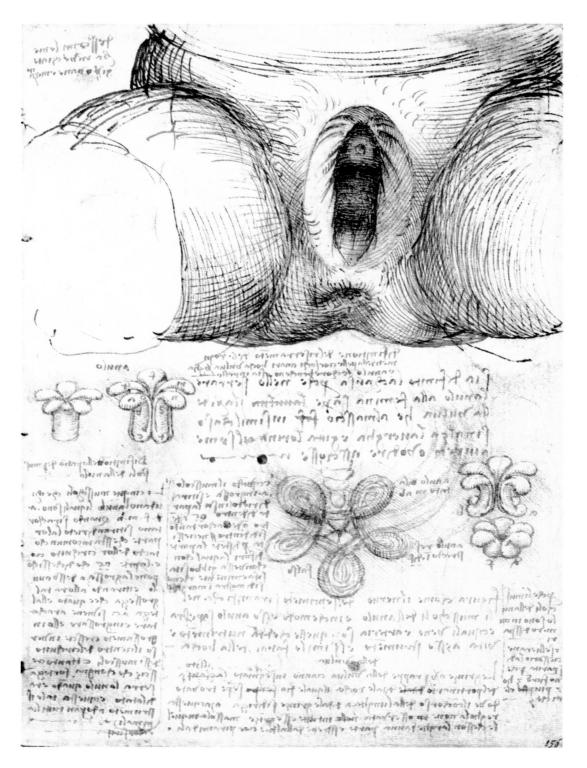

ABOVE: *Study of the Vulva*, pen and ink, Windsor Castle, Royal Library 190995. © 1993 Her Majesty The Queen.

PAGE 108: *Dissection of the Principal Organs*, c. 1510, pen, ink and wash over black chalk, 18½ × 13 inches (47 × 32.8 cm), Windsor Castle, Royal Library 12281r. © 1993 Her Majesty The Queen.

PAGE 109: *Study of the Foot and Lower Leg*, pen and ink, Windsor Castle, Royal Library, © 1993 Her Majesty The Queen.

RIGHT: *Embryo in the Uterus*, c. 1510, pen and ink, 11⅞ × 8½ inches (30.1 × 21.4 cm), Windsor Castle, Royal Library 19102r © 1993 Her Majesty The Queen.

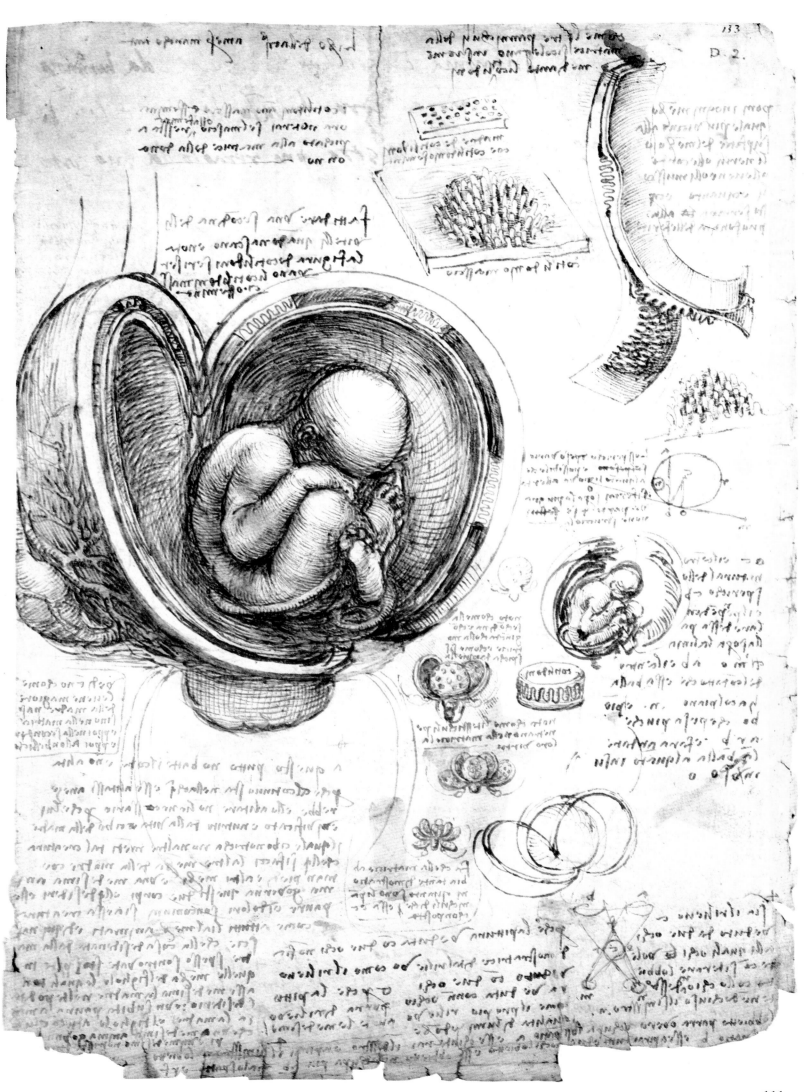

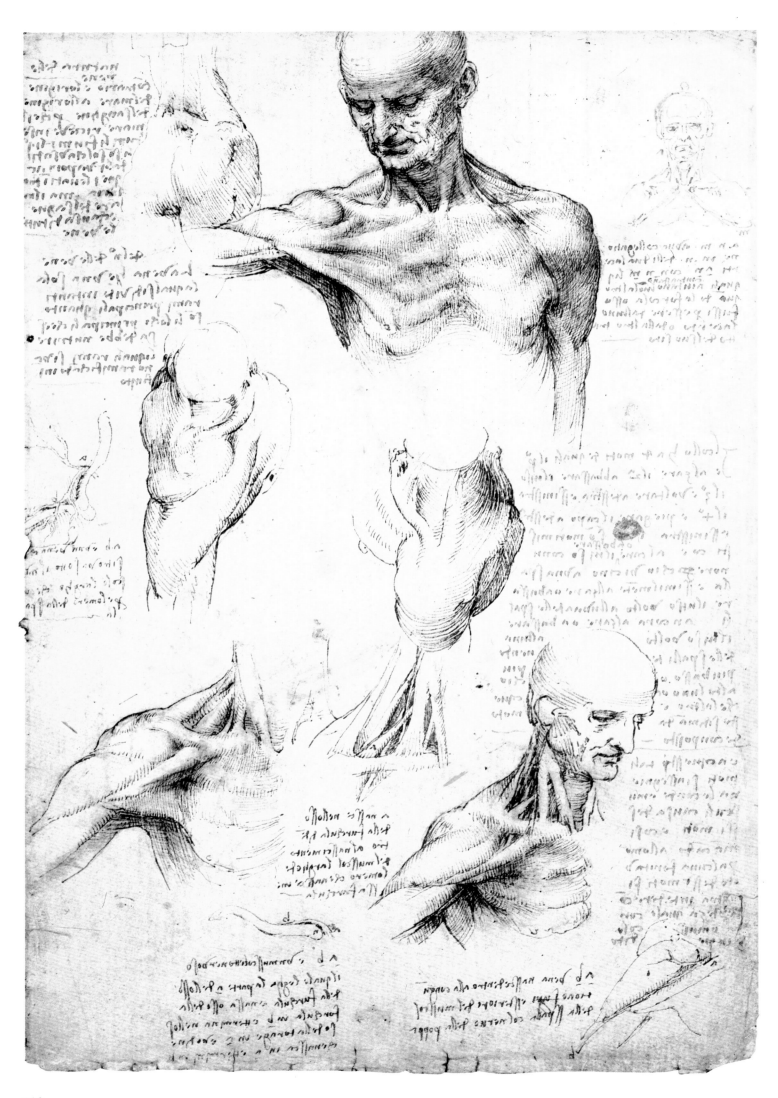

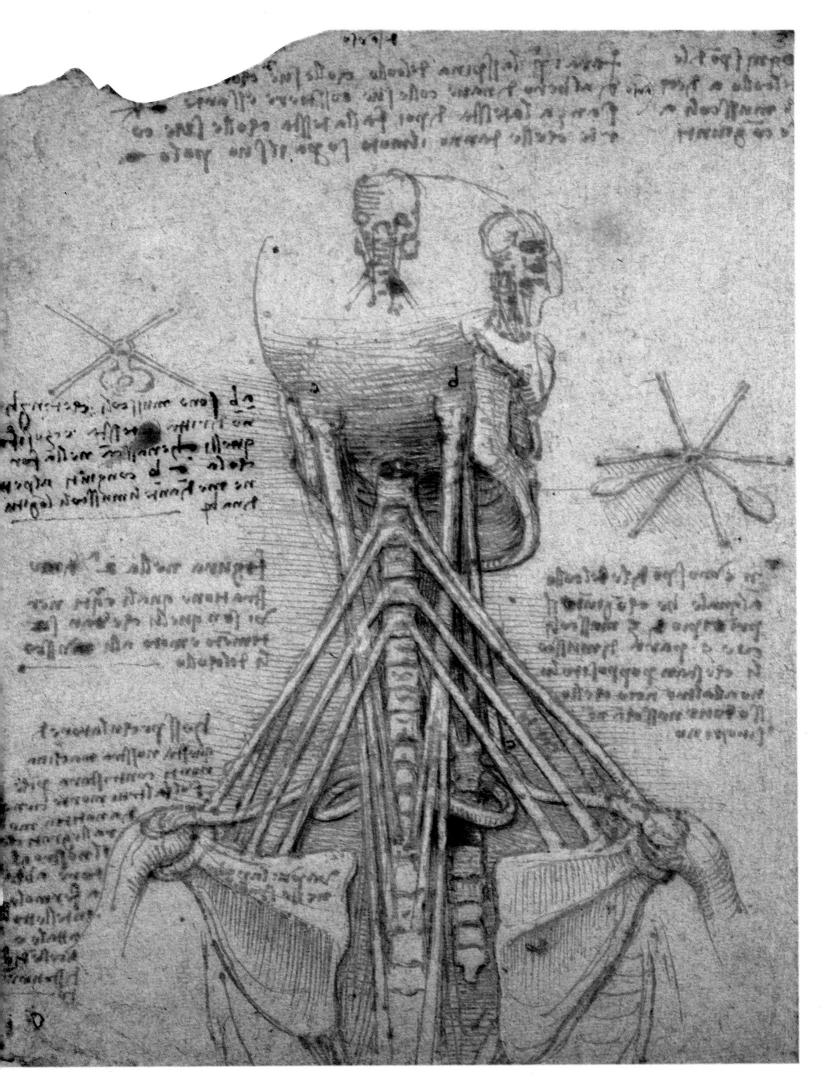

113

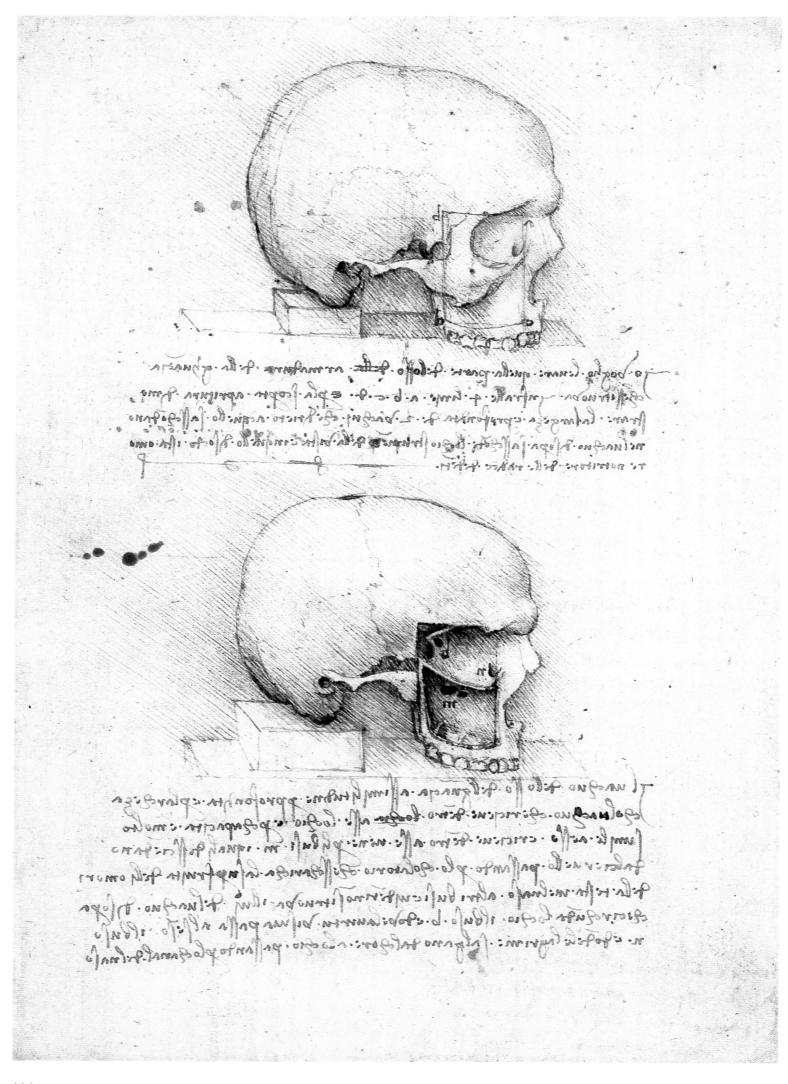

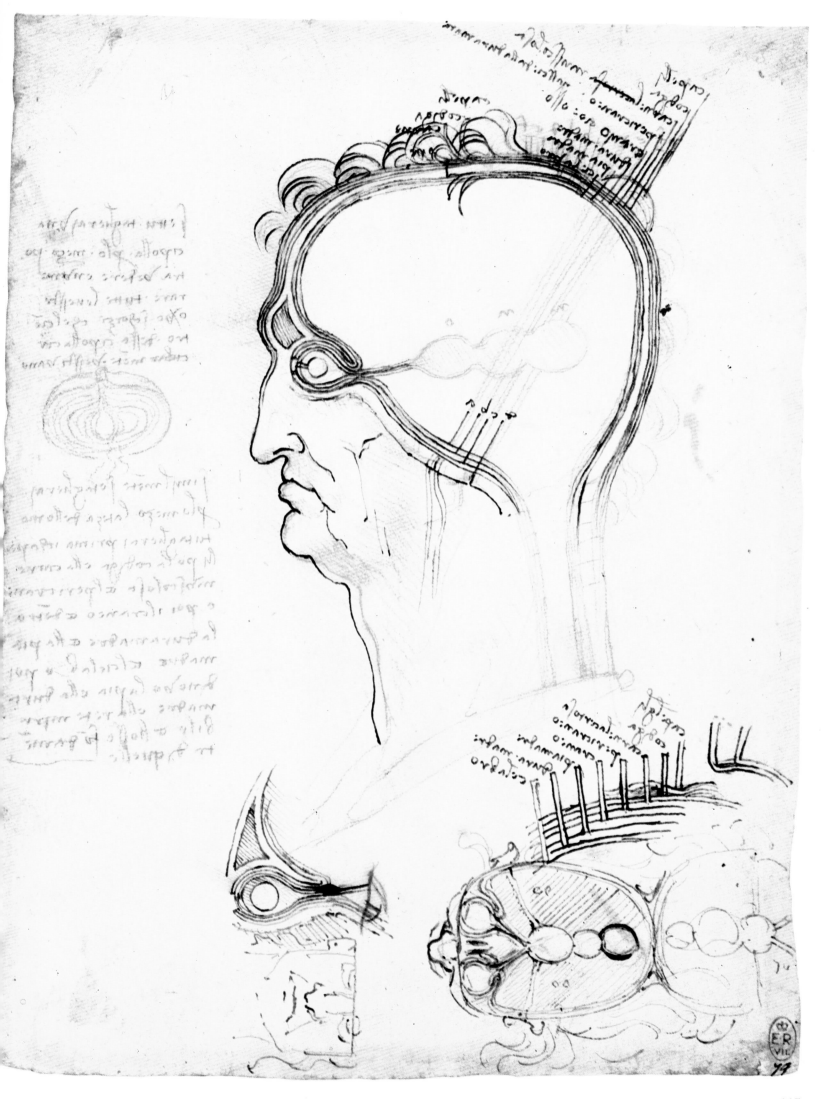

115

ABOVE: *Study of a Copse of Birches,*, c. 1498, red chalk, 7½ × 6 inches (19.1 × 15.3 cm), Windsor Castle, Royal Library 12431r. © 1993 Her Majesty The Queen.

PAGE 112: *Anatomical Drawings of a Man's Neck and Shoulders,*, 1510, pen and ink, 11⅛ × 7¾ inches (28.4 × 19.7 cm), Windsor Castle, Royal Library 19003r © 1993 Her Majesty The Queen.

PAGE 113: *Study of the Back View of a Skeleton*, c. 1513, pen and ink on blue paper, 10¾ × 8 inches (27.4 × 20.4 cm), Windsor Castle, Royal Library 19075v © 1993 Her Majesty The Queen.

PAGE 114: *Two Skulls in Profile to the Right*, 1489, pen and ink, 7 × 5 inches (18.1 × 12.9 cm), Windsor Castle, Royal Library 19057v © 1993 Her Majesty The Queen.

PAGE 115: *Section of a Man's Head Showing the Anatomy of the Eye*, 1489, red chalk, pen, and ink, 8 × 5⅞ inches (20.2 × 14.8 cm), Windsor Castle, Royal Library © 1993 Her Majesty The Queen.

Study of a Tree, c. 1498, red chalk, 7½ × 6 inches (19.1 × 15.3 cm), Windsor Castle, Royal Library 12431v © 1993 Her Majesty The Queen.

Study of a Mountain Range, c. 1511, red chalk on red prepared surface
heightened with white, 4⅛ × 6¼ inches (10.5 × 16 cm), Windsor
Castle, Royal Library 12410. © 1993 Her Majesty The Queen.

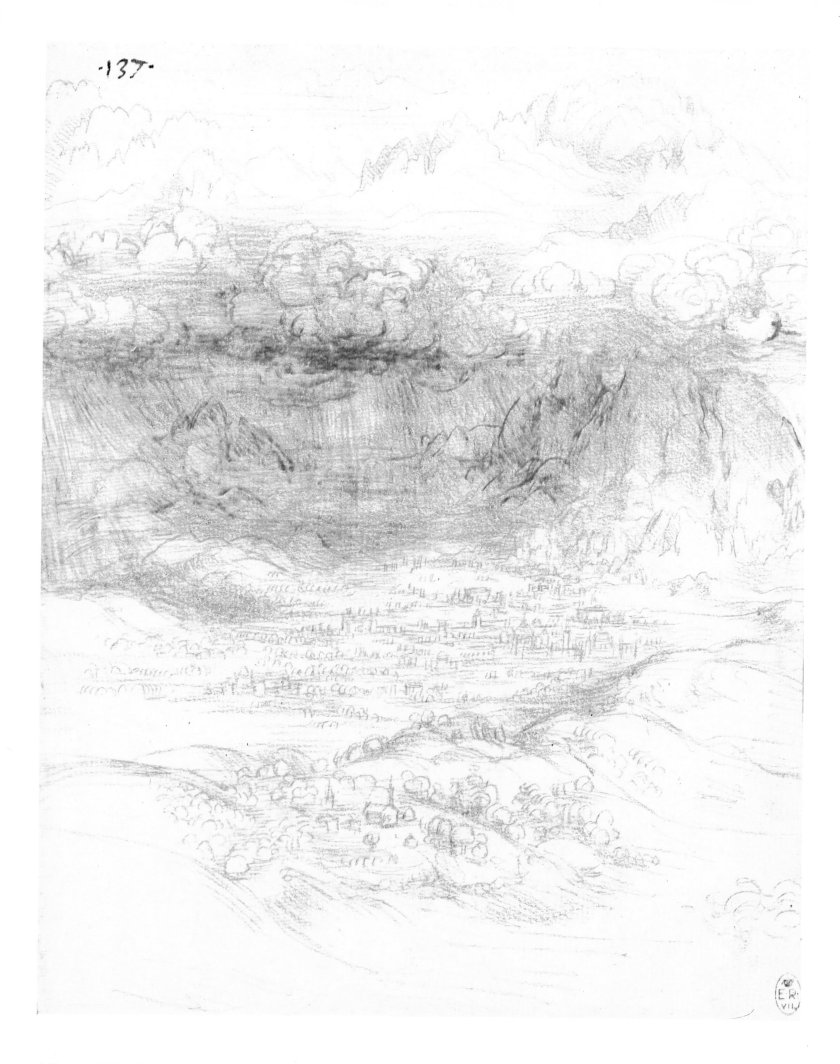

-137-

A Storm, c. 1511, red chalk. Windsor Castle, Royal Library 12409.
© 1993 Her Majesty The Queen.

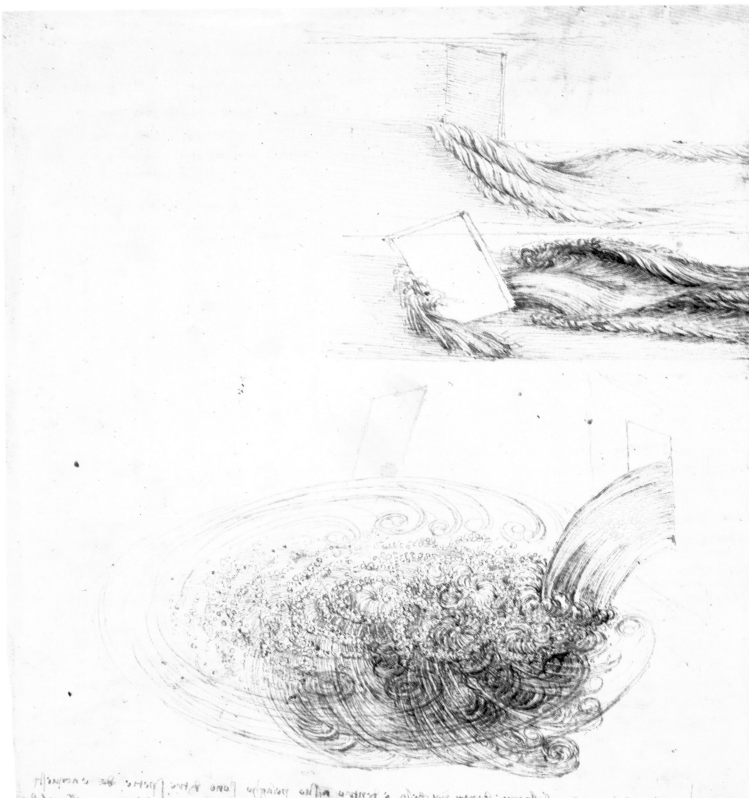

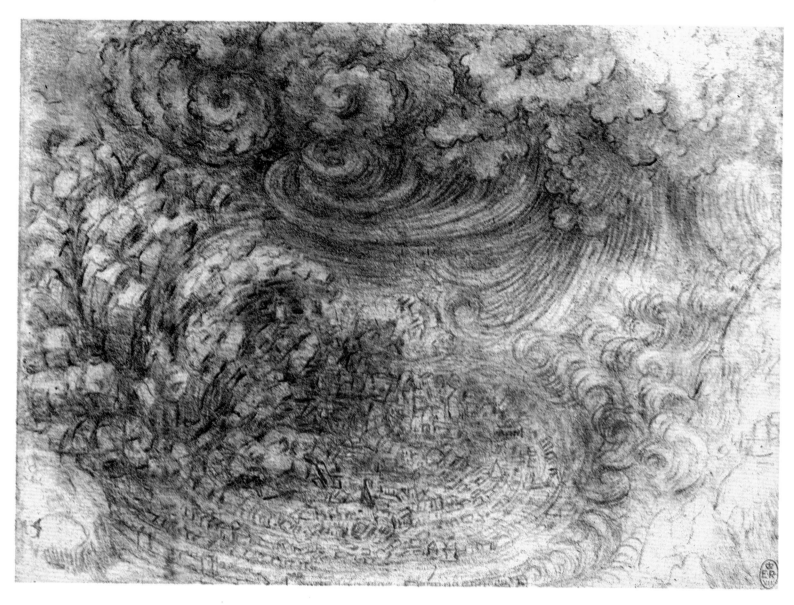

ABOVE: *Deluge*, c. 1513, black chalk, 6½ × 8¼ inches (16.3 × 21 cm), Windsor Castle, Royal Library 12378. © 1993 Her Majesty The Queen.

LEFT: *Studies of water Formations*, c. 1507-09, pen and ink, 11½ × 8 inches (20 × 20.2 cm), Windsor Castle, Royal Library 12660v. © 1993 Her Majesty The Queen.

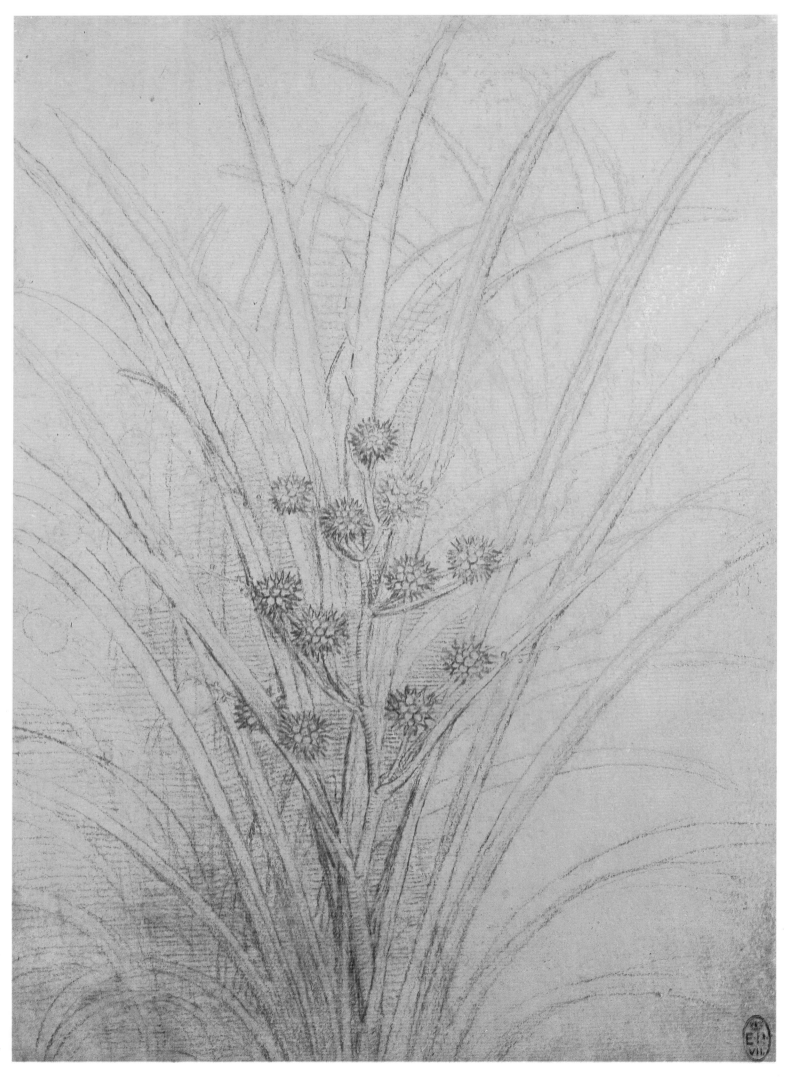

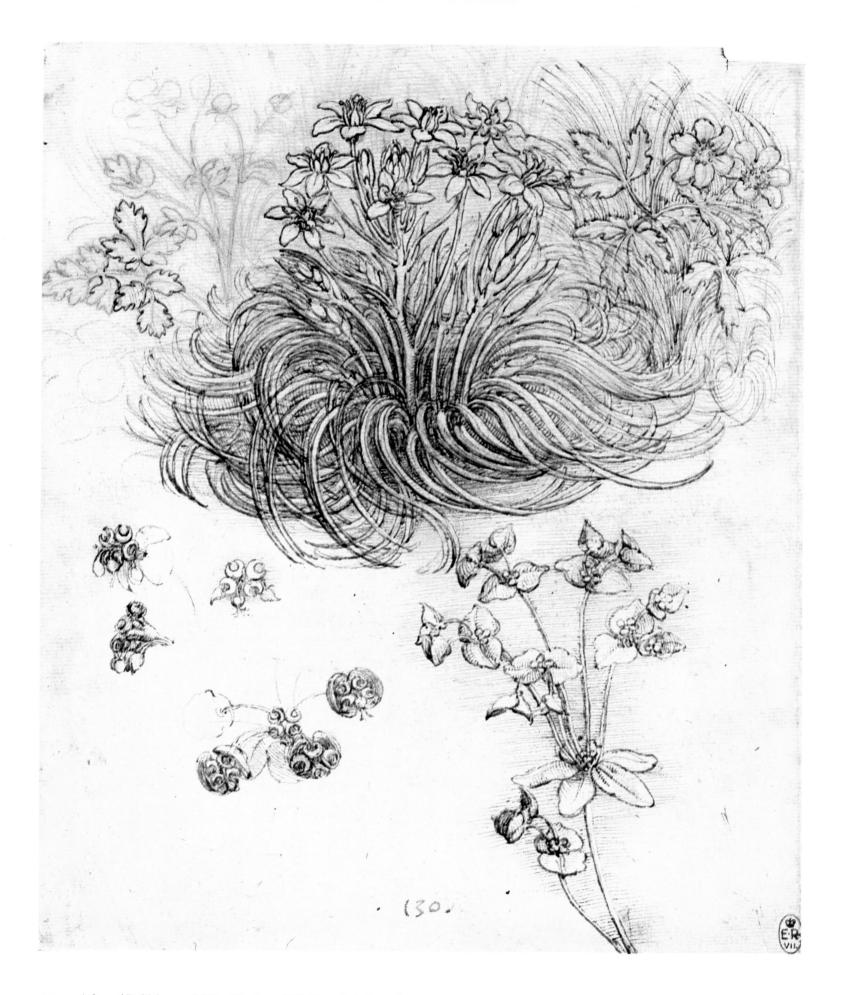

ABOVE: *A Star of Bethlehem and Other Plants*, c. 1505-80, red chalk and pen and ink, 7¾ × 6 inches (19.8 × 16 cm), Windsor Castle, Royal Library 12424. © 1993 Her Majesty The Queen.

LEFT: *Flowering Rushes*, red chalk on pink surface, 7⅞ × 5⅝ inches (201 × 14.3 cm), Windsor Castle, Royal Library 12430r. © 1993 Her Majesty The Queen.

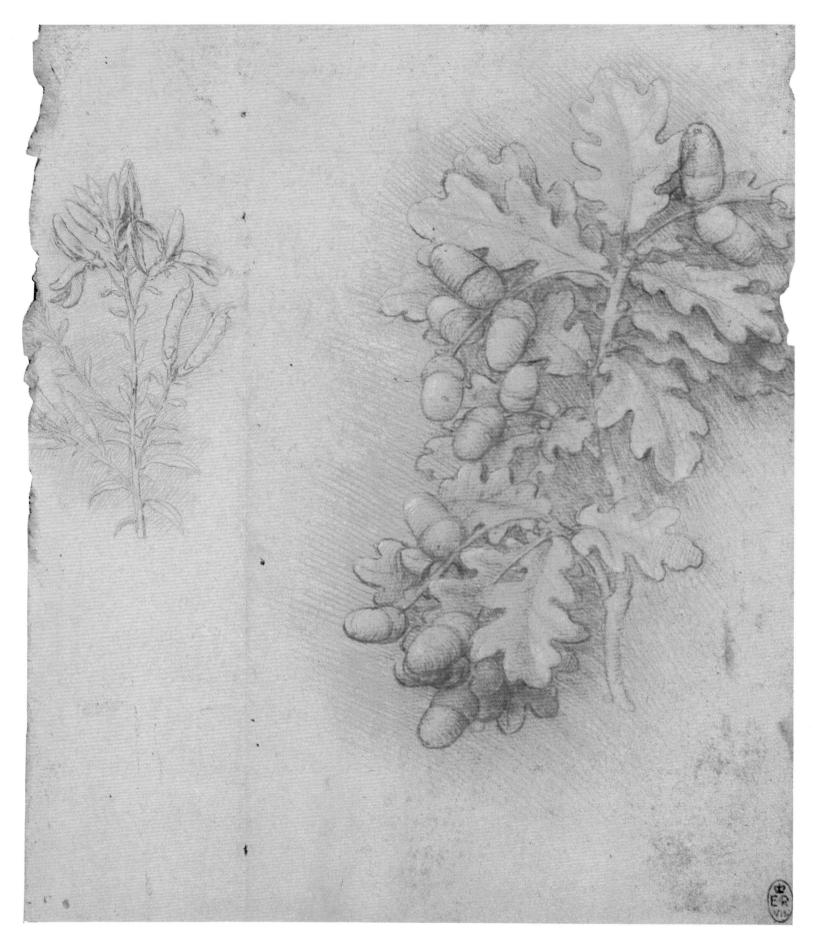

ABOVE: *Oak Leaves with Acorns and Dyers' Greenwood*, red chalk on pink surface touched with white, 7⅜ × 6 inches (18.8 × 15.4 cm), Windsor Castle, Royal Library 12422. © 1993 Her Majesty The Queen.

RIGHT: *Studies of Horses, a Cat and St George and the Dragon*, pen and ink over black chalk, 11¾ × 8⅜ inches (29.8 × 21.2 cm), Windsor Castle, Royal Library 12331. © 1993 Her Majesty The Queen.

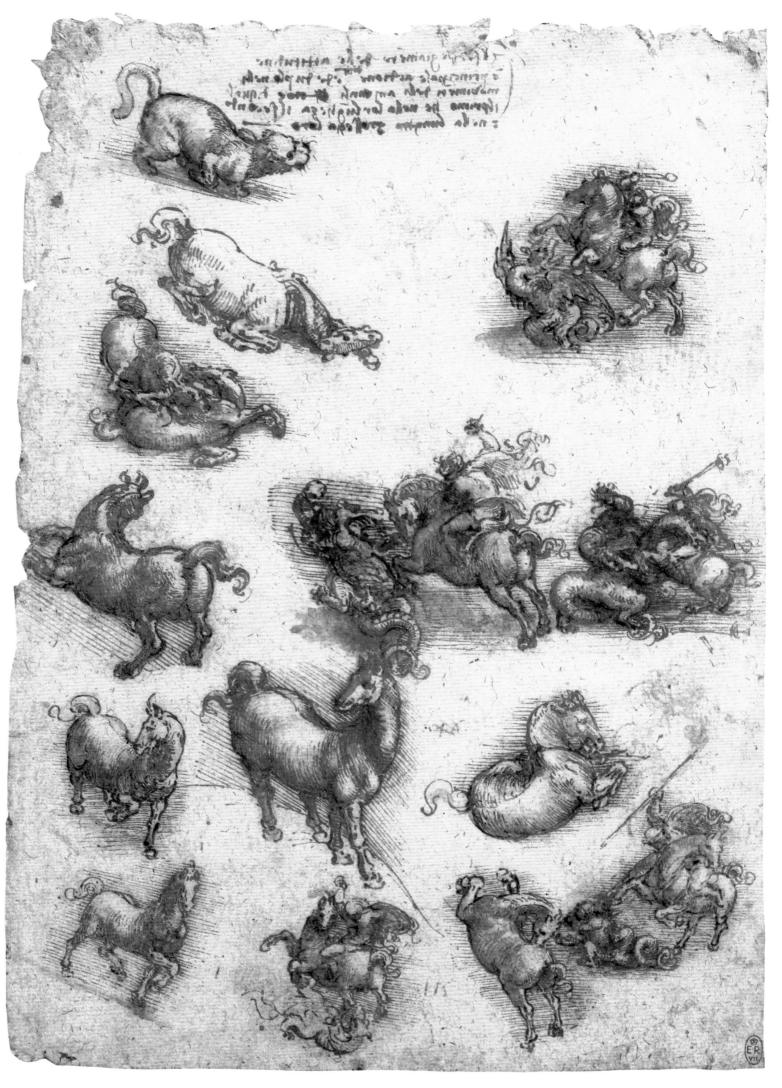

125

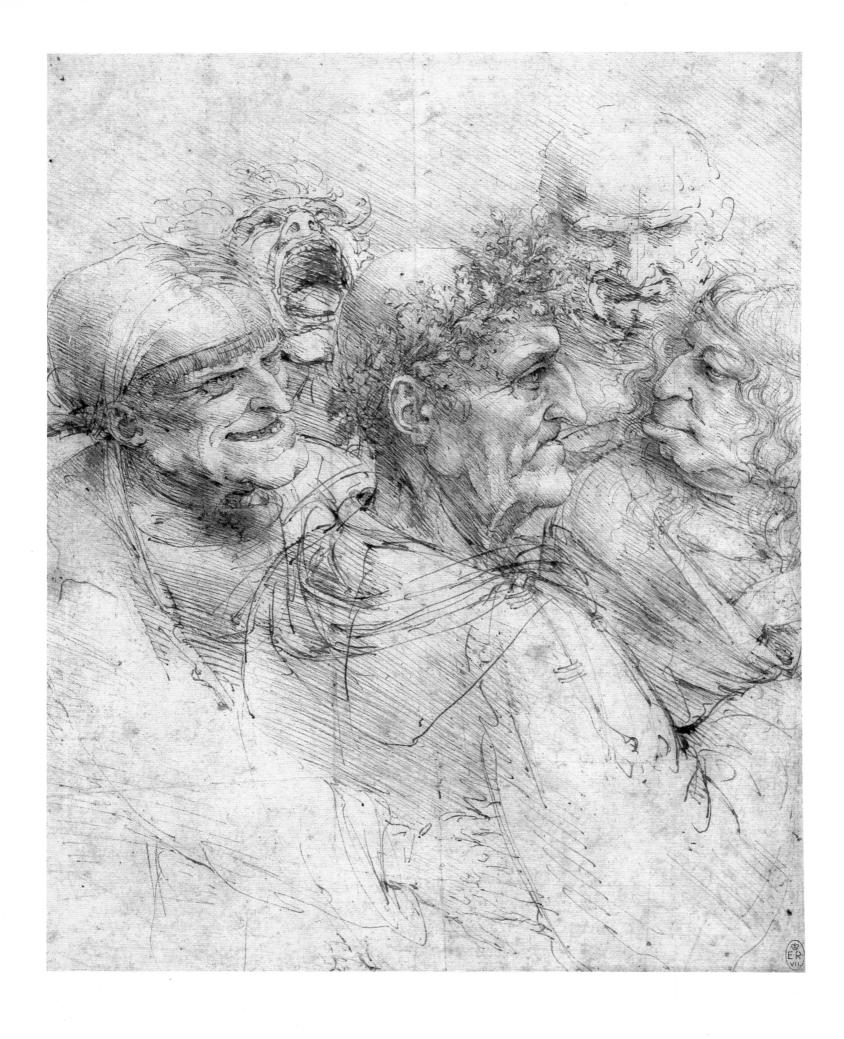

ABOVE: *Five Grotesque Heads*, c. 1490, pen and ink, 10¼ × 8 inches (26 × 20.5 cm), Windsor Castle, Royal Library 12495r. © 1993 Her Majesty The Queen.

RIGHT: A chalk drawing of an old man traditionally accepted as a self-portrait of Leonardo da Vinci from around 1516. Palazzo Reale, Turin.

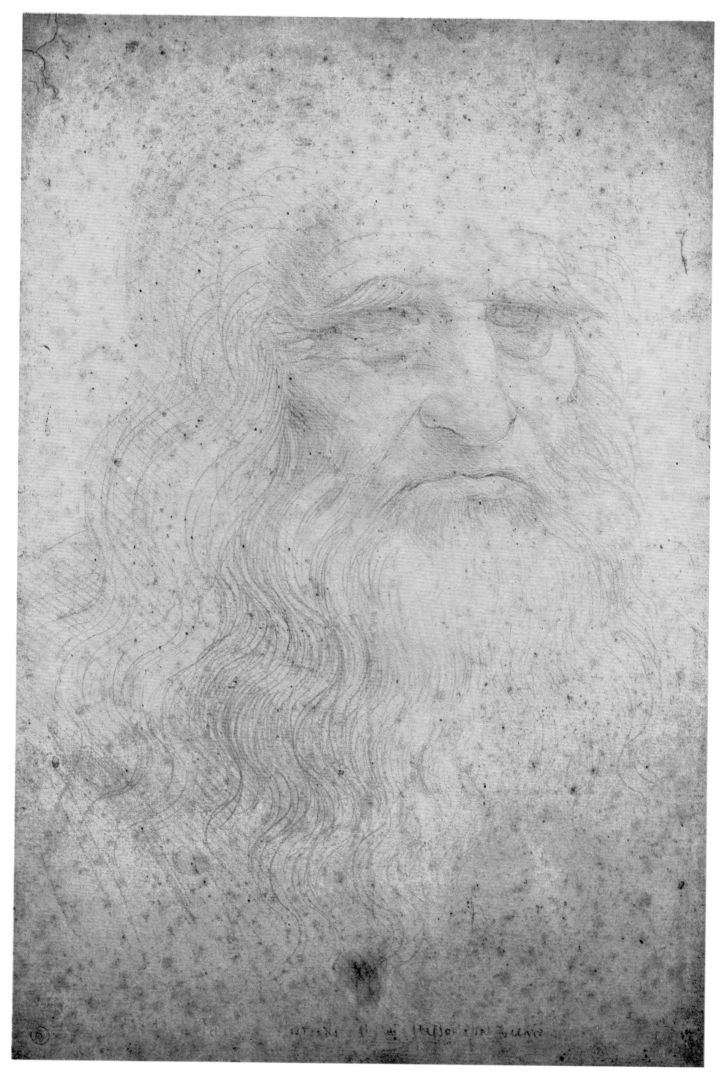

Acknowledgments

The publisher would like to thank Martin Bristow who designed this book and Aileen Reid who edited it. We would also like to thank the following individuals, agencies, and institutions for supplying the illustrations:

Alte Pinakothek, Munich/Scala, Florence: page 44
Archivio di Stato, Florence/Scala, Florence: page 10
The Bettmann Archive, New York: pages 24, 26
Biblioteca Ambrosiana, Milan: pages 15, 17, 18, 19, 20, 21, 22, 23, 27, 28, 34 (both)
Biblioteca Nacional, Madrid: pages 95 (below), 96 (both), 97 (above), 101 (both), 103
Bibliothèque de l'Institut de France, Paris: pages 104, 105
Castello Sforzesco, Milan/Foto Saporetti: page 67
In the Collection of the Duke of Buccleuch and Queensberry, KT, Drumlanrig Castle, Dumfriesshire: page 57
Courtesy of the Governing Body, Christ Church, Oxford: page 40
Courtesy of the Trustees of the British Museum, London: pages 47, 97 (both)
Czartoryski Museum, Kraków,/Scala, Florence: page 54
Devonshire Collection, Chatsworth, Derbyshire, Reproduced by Permission of the Trustees of the Chatsworth Settlement: page 84
Galleria dell'Accademia, Carrara, Bergamo/Scala, Florence : page 25
Galleria dell'Accademia, Venice: pages 70, 80, 92
Galleria degli Uffizi, Florence/Foto Ottica Europa: page 12

Galleria degli Uffizi, Florence/Scala, Florence: pages 36, 37, 38-39, 48-49, 51
Collection of the Earl of Pembroke, Wilton House Trust, Salisbury, Wiltshire: page 85
Galleria Borghese, Rome/Scala, Florence: page 88
Hermitage Museum, St Petersburg/Scala, Florence: page 46
Museum of Fine Arts, Budapest: pages 59 (below), 72, 73
Musée Bonnat, Bayonne/Scala, Florence: page 13
Musée du Louvre Paris/Réunion des Musées Nationaux: pages 31, 35, 40, 41, 45, 50, 53, 56, 66, 79, 81, 82, 83, 86, 90, 91
National Gallery, London: pages 74, 75, 76, 77
National Gallery of Art, Washington, DC: page 42 (Ailsa Mellon Bruce Fund)
National Gallery of Scotland, Edinburgh: page 11
Museo del Bargello, Florence/Scala, Florence: page 89
Palazzo Pitti, Florence/The Bettmann Archive: page 14
Palazzo Reale, Turin/Scala, Florence: pages 1, 127
Palazzo Vecchio, Florence/Scala, Florence: pages 9, 70-71
Pinacoteca Ambrosiana, Milan/Scala, Florence: page 55
Santa Maria delle Grazie, Milan/Scala, Florence: pages 3-6, 60-61, 62-63
Pinacoteca di Brera/Scala, Florence: page 16
Vatican Museum, Rome/Scala, Florence: page 52
Windsor Castle, Royal Library © **1993 Her Majesty The Queen:** pages 32, 33, 43, 58, 59 (above), 64, 65, 78, 87, 88, 93, 95 (above), 98, 100, 102, 106-107, 108, 109, 110, 111, 112, 113, 114, 115, 116, 117, 118, 119, 120, 121, 122, 123, 124, 125, 126